MONUMENTAL BEGINNINGS:
THE ARCHAEOLOGY OF THE N4 SLIGO INNER RELIEF ROAD

# Monumental beginnings:

the archaeology of the N4 Sligo Inner Relief Road

Ed Danaher

NRA SCHEME MONOGRAPHS 1

First published in 2007 by
The National Roads Authority
St Martin's House, Waterloo Road, Dublin 4
Copyright © The authors

Library of Congress Cataloging-in-Publication Data are available for this book.
A CIP catalogue record for this book is available from the British Library.

Material from Ordnance Survey Ireland is reproduced with the permission of the Government of Ireland and Ordnance Survey Ireland under permit number EN0045206.

ISBN 978-0-9545955-4-8
ISSN 2009-0471
NRA Scheme Monographs 1.
Academic editor: Eoin Grogan

Cover design: Nick Maxwell
Copy-editing: Emer Condit
Typesetting and layout: Wordwell Ltd
Book design: Nick Maxwell
Printed by Castuera, Pamplona

Front cover photographs:
    Main photograph—aerial view of test trenching and ceremonial enclosure at Tonafortes (Sl 014-224) (M. Casey).
    Bottom left—Neolithic stone axes from early Neolithic causewayed enclosure at Magheraboy (J. Hession).
    Bottom middle—aerial view of early medieval enclosure at Magheraboy and elements of early Neolithic causewayed enclosure (J. Connolly).
    Bottom right—pygmy cup vessel discovered during test excavations in Carraroe td (J. Hession).
Back cover photograph: selection of quartz from the causewayed enclosure at Magheraboy (J. Hession).

National Roads Authority
An tÚdarás um Bóithre Náisiúnta

MARY HENRY
ARCHAEOLOGICAL
SERVICES LTD.

# CONTENTS

# Contents of the CD (see inside back cover)

Lithics analysis *Bernard Guinan and Joanna Nolan*

Petrological analysis *Dr Stephen Mandal*

Radiocarbon dating results *Beta Analytic*

Burnt bone analysis *Henny Piezonka*

Wood identification *Ellen O'Carroll*

Magheraboy radiocarbon dating report *Alex Bayliss, Frances Healy and Alasdair Whittle*

**Area 2D**

Excavation report *Sue McCabe*

Wood identification *Ellen O'Carroll*

Radiocarbon dating results *Beta Analytic*

Lithics analysis *Bernard Guinan and Joanna Nolan*

**Field G**

Excavation report *Sue McCabe*

Excavation report *Sebastien Joubert*

Radiocarbon dating results *UCD Radiocarbon Laboratory*

Faunal remains *Andrea Cremin*

Burnt bone analysis *Laureen Buckley*

Petrology analysis *Dr Martin Feely*

Axehead petrology analysis *Dr Richard P. Unitt*

Prehistoric pottery analysis *A. L. Brindley*

Lithics analysis *Dr Sarah Milliken*

**Site 3/28**

Excavation report *Brian Halpin*

Wood identification *Ellen O'Carroll*

Radiocarbon dating results *UCD Radiocarbon Laboratory*

Petrology analysis *Dr Martin Feely*

**Site 6**

Excavation report *Sebastien Joubert*

Wood identification *Ellen O'Carroll*

Radiocarbon dating results *UCD Radiocarbon Laboratory*

Petrology analysis *Dr Martin Feely*

**Sligo Town**

Testing report *Steve Linnane*

**Adelaide Street**

Testing report *Robert O'Hara*

# FOREWORD

I am delighted to introduce *Monumental beginnings*, detailing the results of archaeological discovery along the N4 Sligo Inner Relief Road (SIRR). It is the first national road scheme to be brought to full publication by the NRA, complementing the several seminar monographs already produced to date. Publications such as this take time to create, involving substantial archaeological resources, specialists, scientific analysis, interpretation and post-excavation research. The results of the archaeological investigations along the N4 SIRR provide new information and afford new perspectives on the prehistoric beginnings of the north-west, and by extension the national archaeological picture. It is in collecting and disseminating this new knowledge that we feel most proud of our commitment to addressing the archaeological impact of the national roads programme. Communicating new discoveries to the public has been a key aim over the last six years and will remain so. While the N4 SIRR is the first individual scheme to be brought to publication, others are in preparation and will follow. In the meantime, archaeological findings along national roads are continually disseminated through various other means, including leaflets, posters, museum exhibitions, the internet, through the annual 'Discoveries' seminar and, most recently, the *Seanda* magazine publication that will continue to be issued on an annual basis.

Archaeology plays a key role in influencing road design, yet it is only one of numerous constraints that must be considered. The vital need for infrastructural development and the desire to preserve our archaeological heritage seem at times mutually exclusive, yet discoveries such as these made along the N4 and other road projects are dramatically changing our perception of the past. The early Neolithic causewayed enclosure at Magheraboy, built around 4000 BC, is one such site, convincing evidence—infrastructural in its own right—of communal effort and social connection at such an early stage of Ireland's prehistory. The compact and ordered Bronze Age settlement at Caltragh sheds light on the interweaving of domestic and ritual life during the period, and other sites along this route and other schemes add further pieces to the complicated jigsaw that is our shared past.

The resources that are committed to addressing the archaeological impact of the national roads programme are considerable, fully recognising both legal requirements and the immense public interest in archaeology. The N4 discoveries were made within a region already well known for its existing archaeological monuments, and it is hoped that the archaeological profession and the wider public alike will see the results of the N4 works as adding significantly to that heritage.

**Fred Barry**
**Chief Executive, National Roads Authority**

# PREFACE
## The background to the Sligo Inner Relief Road scheme

This publication sees the closure of the archaeological story of the N4 SIRR. At just 4.2km it is a relatively short length of national road upgrade but one that has produced a somewhat disproportionate number of fascinating discoveries dating back to the earliest Neolithic, some 6,000 years ago. This dissemination of the results of the N4 archaeological investigations represents an important milestone, bringing the discoveries to the attention of the archaeological profession and the wider public, explaining the work that took place and justifying the resources that were committed to the project.

*Monumental beginnings* is the culmination of several years of work by a large number of archaeologists, engineers, project managers and archaeological consultancies connected with the scheme dating back to the autumn of 2000. Archaeological work in 2000 in connection with the Caltragh Sewerage Scheme first discovered prehistoric settlement evidence at the point where the pipeline cut across the proposed N4 route. Those initial discoveries offered a glimpse of what was to become a significant area of archaeological activity at Caltragh. The initial Caltragh excavations were carried out by Mary Henry Archaeological Services Ltd (MHAS), who then proceeded to carry out linear testing of the entire greenfield section of the N4 route and resolution of a limited area at Caltragh (Field G) over 2000 and 2001.

These preliminary archaeological investigations were carried out under the direction of Sebastien Joubert, Mary Henry and Frank Ryan for MHAS Ltd. The 2001 linear testing identified a number of areas of archaeological activity along the rural section of the route. After a delay caused mainly by site access restrictions owing to the outbreak of foot-and-mouth disease, these areas became the subject of further excavations carried out by Archaeological Consultancy Services Ltd (ACS) between April and November 2003.

The excavation of Area 1A centred on a portion of a large ceremonial enclosure at Tonafortes at the southern end of the scheme and the works were directed by Ed Danaher for ACS. This site is a Recorded Monument and had been identified prior to the design of the road, the only such monument along the scheme's length. Impact on the enclosure was unavoidable, but modification of the road design, feeding from archaeological test information, reduced this impact from an initial 40% to a mere 10% of the site. A short distance to the north, Area 1B excavations centred on some anomalies identified during test excavations, though wider investigations proved these features to be largely modern and of little archaeological significance. Area 1C, further to the north, was gently undulating pasture where test investigations had identified a number of pits. Wider topsoil-stripping and excavation by Sue McCabe of ACS identified a thin cluster of settlement-associated pits dating from the Neolithic and Iron Age, as well as some post-medieval land drains.

Areas 1D and E were located in the shallow Caltragh valley, which would prove to be an area

of dense prehistoric settlement. Directed by Steve Linnane of ACS, excavations here yielded settlement and burial material from the Bronze Age. An adjoining area, F, was excavated by Sue McCabe of ACS and revealed three Bronze Age round structures. To the north, on higher ground, Area 2A, also excavated by McCabe, revealed a small number of prehistoric pits.

Moving north, on a ridge overlooking Caltragh to the south, the excavations at Magheraboy were led by Sue McCabe (2D—prehistoric burnt mounds), Tara O'Neill (2A—medieval enclosure) and Ed Danaher (2A—causewayed enclosure) of ACS.

Investigations of the northern urban section of the route were led by Steve Linnane and revealed little evidence earlier than post-medieval in date, the route avoiding, it would seem, the medieval core of Sligo and having been designed to run outside the line of the post-medieval walled town.

The programming of the N4 archaeological works well in advance of construction allowed them to take place unhindered by construction in a safe manner. That said, the archaeological works took place not in isolation but within a much broader framework of road design and construction preparation, and the successful project management of the archaeological works is due to the contribution of many over the years. The commitment and expertise of engineers and staff from the two local authorities, Sligo County Council and Sligo Borough Council (or formerly Sligo Corporation), National Roads Authority engineering and archaeological project managers, the engineering consultants, Atkins Ltd, and the goodwill of landowners in the early stages of the works have all contributed to this volume and all are acknowledged gratefully.

The N4 Sligo Inner Relief Road opened in September 2005, providing much-needed relief for the traffic of the Gateway City of Sligo. That opening marked the obvious engineering conclusion to the story of the N4. The production of *Monumental beginnings* marks another milestone, that of its archaeological story, providing vital closure on the extensive archaeological works. Interest in archaeology is driven by the simple joy of discovery. That is well manifested here in the case of the Neolithic causewayed enclosure at Magheraboy, and it is hoped that elements of that joy, experienced through the various seasons of work on the N4, are imparted through this book, as pictures of prehistoric life are shown through the N4 keyhole into the Sligo landscape.

**Michael MacDonagh**
**NRA Project Archaeologist**

# INTRODUCTION

The astonishing pace of development of Ireland's road infrastructure has provided an unparalleled series of opportunities to advance our understanding of rural archaeology following the great expansion of urban archaeology in the 1980s and 1990s.

The excavations associated with these schemes have introduced an extraordinary wealth of new data into the archaeological record. This has confirmed some well-understood trends, such as the very considerable number of *fulachta fiadh* and associated sites, but has provided some very significant fresh insights into a wide range of other issues. Indeed, the accumulation of this amount of new information has created something of a backlog in interpretative and integrated analysis.

The extent of newly identified archaeology on this and other schemes is especially remarkable given that the extensive route-planning tends, unless completely unavoidable, to avoid standing or well-documented archaeological and historical sites. This alone is a salutary reminder that the remains of our past are quite difficult to destroy or totally remove and that the evidence of many important sites survives without any surface manifestation.

The results from individual excavations, of which over 30 are detailed in this volume, form the backbone of the contribution of these schemes. But the added value of this publication is the integrated assessment of the archaeology in the context of the Cúil Irra peninsula along the route of the N4 and within the wider landscape of Sligo and the region as a whole. The partnership of the site directors and specialists, orchestrated by the author, has produced a valuable research contribution that reveals the development of, in particular, the prehistoric settlement patterns of the Sligo area. This has been achieved with an admirable balance between professional evaluation and analysis and the goal of making the archaeology accessible to the wider public.

While the N4 SIRR produced a range of site types representing much of the past human activity in this area, it is interesting to observe that, as with many linear rural schemes, it also reflects a particular character: the majority of the sites are of prehistoric date and there are no examples of, for example, rural medieval settlement. As ever, the largest group is that of the *fulachta fiadh* and burnt mound spreads, many of the latter also representing the use of hot stones. Collectively these underline a recently identified trend for an increased number of sites of this type to be dated to the final Neolithic and early Bronze Age. While the issue of the role and function of these sites remains unresolved, despite the fact that they have become the single most excavated archaeological site type in Ireland, this volume further emphasises the importance of *fulachta fiadh* in developing our understanding of settlement patterns and landscape use in the Bronze Age. The excavation of three houses of this date provides another important component of these patterns, as does the apparent continuity of land use from the Neolithic period identified at Caltragh. The author has presented an exemplary discussion of the ceremonial enclosure at Tonafortes, which produced apparently conflicting and entangled dating evidence. The early medieval ringfort at

Magheraboy provides an important insight into the settlement of this area with its rich evidence of extant sites.

Several road and other linear rural schemes have produced evidence of a particular thematic or chronological character. The predominance of prehistoric archaeology on this project has already been noted, but there is no doubt that the N4 SIRR results must give pride of place to the unexpected discovery of the Magheraboy Neolithic causewayed enclosure, the earliest dated monument in Ireland or Britain.

I am delighted to be associated with this splendid publication and congratulate those involved, the site directors and their professional staff, Archaeological Consultancy Ltd, Mary Henry Ltd, Sligo Borough and County Council, the National Roads Authority and Project Archaeologist Michael MacDonagh, Wordwell Ltd, and in particular the author, Ed Danaher, for this exciting, integrated and accessible volume.

**Eoin Grogan**
**Academic Editor**

# The N4 Sligo Inner Relief Road Archaeological Team

**N4 NRA archaeological team**
Michael MacDonagh, Project Archaeologist
Roger Linnard (to 2002)
Grainne Leamy, Assistant Archaeologist

**N4 senior archaeologists**
Ed Danaher (ACS Ltd)
Sebastien Joubert (Mary Henry Ltd)

## Archaeological Consultancy Services Ltd staff

### Excavation directors
Steve Linnane; Sue McCabe; Tara O'Neill; Ed Danaher

### Assistant director
Lydia Cagney

### Supervisors
Andrew Dicken; Gerry Mullins; Laurence McGowan; Neil Jackman; Paddy Walsh; Rossa Coughlan; Patrick Quinney

### Archaeological assistants
Aindras Stack; Alan McGowan; Andrew West; Andy Ottery; Anne Morris; Brian Corcoran; Brian Murphy; Carlos Hermo; Catriona McKenzie; Cathy Gallagher; Daniel Barraclough; Daniel Devereux; Darren Danaher; David Harrison; David Schulz; Declan Troddyn; Derek Vial; Dominick Gallagher; Mary Healy; Donnacha Hennessy; Dylan Foley; Elaine Murphy; Ellen Maeve Bergh; Elodie Rein; Esther Taboada; Helen O'Brien; James McKee; James Smith; Jennifer Randolph; Jeremy Webster; Jim Swann; John Kerrigan; John Mageen; John McKee; John Murphy; John Winfer; Julian Stroud; Kate Ferron; Katrina Topping; Kelly Davis; Kevin Spade; Linda Kerr; Malachy Curran; Margaret O'Connor; Maria Golpe; Maria Lazo; Mark Andrews; Mark Chrystal; Mark Doyle; Micael Bertheau; Morgan Bolger; Niall Jones; Nick Fitch; Nigel Paxton; Noel Jinks; Noel McCarthy; Patrick Ferguson; Richard Hinchy; Rory McBride; Sally Lloyd; Sara Ranson; Seamus O'Connor; Seán Hickey; Stephanie Paxton; Tamlyn O'Driscoll; Vanessa Salvador

## Post-excavation and draughting

Rachel Sloane; Martin Halpin; Aidan Kenny; Niall Gillespie; Killian Murray; Jose Luis Casaban; Robert Martin

## Mary Henry Ltd staff

### Excavation directors

Brian Halpin; Mary Henry; Sebastien Joubert; Frank Ryan

### Supervisors

Patrick Casey; Liam Hickey; Philip Kenny; Liam McKinstry; Gary Ryan; Seán Shanahan; Kevin Stronach; Ian Williams

### Archaeological assistants

Frank Boal; Linn Breslin; Roisin Burke; Gary Burns; Laura Claffey; Aileen Cooper; Evan Edward Donnelly; Ardrienne Dowd; Felix Fernandez; Dylan Foley; Dominick Gallagher; Joanne Hamilton; Eugene Handley; Keith Higgins; Richard Hinchy; Neil Jackman; Eddie Jinks; Martin Jones; Niall Jones; Derek Kearney; Shane Kenny; Anne Keogh; John Mageen; Martin Beranger; Bridget McCarron; Ann McClout; Cormac McConville; Ruari McGovern; Laurence McGowan; Mairead McLoughlin; Ultan McNasser; David Medlyn; Dominic Monaghan; Sam Moore; Gerry Mullins; Fergus O'Brien; James O'Hara; Seán Ramkin; Carmela Rodrigues-Pamias; Michael Rooney; Neil Ryan; Patrick Ryan; Lee Scotland; Siobhan Scully; Dominic Sheldon; Kevin Spaide; Declan Troddyn; Patrick Walsh

## Specialist reports (ACS Ltd and Mary Henry Ltd)

Allan Hall; John Carrott; Ellen O'Carroll; Bernard Guinan; Joanne Nolan; Sarah Gormley; Beta Analytic; UCD Radiocarbon Laboratory; Dr Stephen Mandal; Dr Stephen Lancaster; Henny Piezonka; Fiona Beglane; Andrea Cremin; Laureen Buckley; Dr Martin Feely; Dr Sarah Milliken; A. L. Brindley; Dr Richard P. Unitt; Dr Alison Sheridan; Alex Bayliss, Frances Healy and Alasdair Whittle

### Reports editor

Angela Plunkett, Arbutus Ltd (ACS Final Reports)

### Illustrator

John Murphy

# ACKNOWLEDGEMENTS

Archaeological works on the N4 first began during 2001 and a large number of people were involved in all stages of the process. I hope I have included all the archaeological personnel on the previous pages and I would like to thank them for all their hard work and dedication. I apologise for any omissions. I would also like to thank the various directors from both Mary Henry Ltd and Archaeological Consultancy Services Ltd for allowing me access to their final results and for their input along the way: Mary Henry, Sebastien Joubert, Brian Halpin, Frank Ryan, Steve Linnane, Tara O'Neill, Rob O'Hara and Sue McCabe. While excavating we were delighted to receive visits from Professor George Eogan, Professor Gabriel Cooney and Dr Stefan Bergh, whose comments and suggestions were gratefully accepted. Many thanks are due to Paul Canning and Paul Cunningham of the Sligo County Council N4 Site Team for providing every assistance during the excavations.

I would like to express my gratitude to the following people for their kindness in helping with advice, material, reading sections of the text and permission to reproduce illustrations: to Alison Sheridan for her excellent report on the Caltragh beads and her comments on Chapter 5; to Alex Bayliss, Frances Healy and Alasdair Whittle for their comments on Chapter 6, the Magheraboy radiocarbon dating report and their permission to reproduce the tables within this dating report; to Christina Fredengren for the information on the Mesolithic in Sligo; to Dr Stefan Bergh, Professor Gabriel Cooney, Professor Peter Woodman and Martin Timoney for all their advice along the way; to Abigail Walsh for the additional illustrations; to John Murphy for the revealing artwork; to Jonathan Hession for the finds photographs; and to Marcus Casey and James Connolly for the aerial photographs. I would also like to express my sincere thanks to Martin Reid, Paul Logue and James Eogan.

I am grateful to the office staff of ACS Ltd, in particular Martin Halpin for the illustrations, Rachel Sloane for all her hard work during post-excavation, Niall Gillespie, Killian Murray in the draughting department, Aidan Kenny for the accessible CD-rom, and John Stirland, Anne Brennan, Ciaran McGuinness and Madeleine Hill for their work behind the scenes. I would also like to express my gratitude to both Donald and Deirdre Murphy for allowing me the time to work on such an exciting project as the N4.

I am particularly indebted to Michael MacDonagh, without whose vision and persistence there would be no publication; to Eoin Grogan for all his advice, suggestions and encouragement; and to my wife, who has read this manuscript more than most and is subsumed within its authorship. I would like to acknowledge and thank Dáire O'Rourke and Rónán Swan for their support, and the NRA for the funding of this publication. Finally, I would like to thank Wordwell, Nick Maxwell and Emer Condit for their help along the way in getting this publication to print.

# Acknowledgements from Michael MacDonagh

Between 2001 and 2005 the N4 archaeological works involved a large project team, without whose support the retrieval of archaeology would have been a lot more difficult. On behalf of all the N4 archaeologists I would like to express my grateful thanks to the N4 SIRR site staff, led by Project Resident Engineer Paul Canning and Tony Mortimer of Atkins Ltd. Behind the smooth execution of the pre-construction archaeological works lay a huge amount of programming, budgeting and project management by a large team of individuals, engineering and administrative, from Sligo County Council, Sligo Borough Council and the National Roads Authority and consulting engineers, Atkins Ltd. I would like to express my thanks to the staff of Mary Henry Ltd and ACS Ltd; my predecessor, Roger Linnard; Dáire O'Rourke and Rónán Swan of NRA Archaeology; my NRA engineering colleagues, Michael Nolan, Tom Carr, Harry Cullen, Donal Clear, Kieran Kelly and Tom McCormack (RIP); and Sligo County Council staff, notably Seamus Concannon, Tommy Carroll and Tom Brennan.

My final acknowledgements are to the publication team: to Nick Maxwell and Eoin Grogan and lastly to Ed Danaher, who has done the archaeology of the N4 and its archaeologists proud in writing *Monumental beginnings*.

# 1

# OUTLINE

This publication draws together the information gleaned from 30 distinct archaeological sites spread across eight separate areas, final reports for which are held on a compact disc at the back of this monograph. While a synopsis of the findings from these sites is offered here, a more comprehensive account of each individual site may be examined by accessing this disc. References to reports held on this CD are written as (McCabe, see CD), (Guinan and Nolan, see CD), etc.

The N4 Sligo Inner Relief Road and County Extension (N4 SIRR), which was officially opened in September 2005, comprises a new dual carriageway extending north from Carrowroe Roundabout in Tonafortes townland. It proceeds through a rural environment at first, and then continues through the Sligo urban area, terminating at the Michael Hughes Bridge at the junction of Custom House Quay and Ballast Quay in Rathedmond townland (Fig. 1.1). The development covers a distance of 4.2km and, interestingly, all the archaeological sites discussed in this volume were discovered along the rural stretch of this road, which accounted for 3.5km of the total. In fact, the vast majority of the sites occurred within three townlands: Tonafortes, Caltragh and Magheraboy (Fig. 1.1).

With the exception of an early medieval ringfort, all of the sites were prehistoric in origin, predominantly Neolithic and Bronze Age. Of these only a single site can be clearly interpreted as settlement; three contiguous round houses and associated boundaries were discovered in the townland of Caltragh, though a probable Iron Age hut was identified at Magheraboy. Spreads of burnt mound material and *fulachta fiadh* accounted for seventeen of the sites recorded, while a causewayed enclosure, a ceremonial enclosure, a drystone-walled enclosure, six cremations, a possible megalith and two clusters of late Neolithic pits accounted for the remainder. These were mainly ritual in nature, forming a significant component of the much wider ritual landscape; intriguingly, the causewayed enclosure at Magheraboy may be the point of origin of this vast archaeological landscape.

While most of the sites are of regional and national interest, some are undoubtedly of international importance, the foremost of these being the unprecedented segmented ditched and palisaded enclosure at Magheraboy. This is not just early Neolithic in date but represents the earliest known Neolithic monument in both Ireland and Britain. Its presence on the eastern edge of the Cúil Irra peninsula raises a number of important questions, many of which are addressed in this publication, while paving the way for further discussion and research on the origins of the

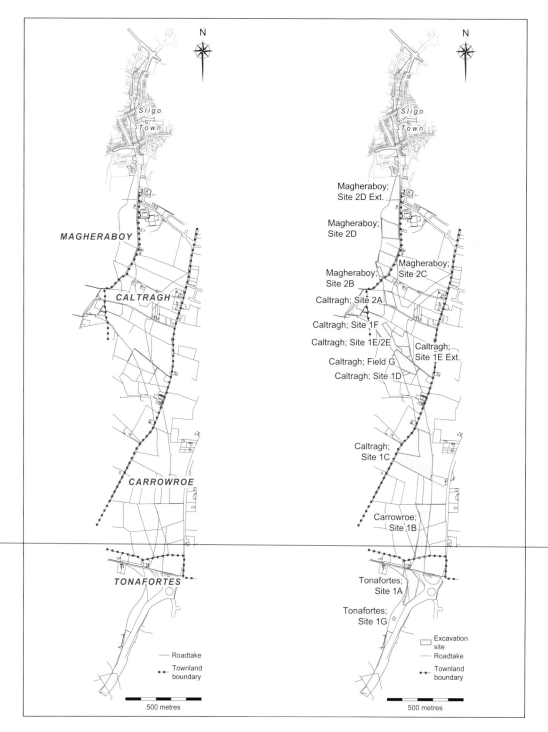

*Fig. 1.1—Townlands along the route (left) and detailed location of archaeological sites (right).*

Neolithic in Ireland. Excavation of the drystone-walled enclosure at Caltragh and the earthen embanked enclosure at Tonafortes enhances our knowledge of such sites. The settlement at Caltragh provides further insights into the social and physical organisation of middle Bronze Age life, in which the secular and ritual were clearly interwoven.

The results of the archaeological investigations are presented on a townland basis, with the archaeology of each separate townland being discussed chronologically. As spreads of burnt mound material and *fulachta fiadh* were the most common site type encountered, however, a separate chapter has been dedicated to these enigmatic monuments. While it is intended that the archaeology of each townland be presented in individual stand-alone chapters, a discussion on the broader context and implications of these sites is offered in Chapter 8. In addition, a background to the region is provided by a brief outline of the landscape of the study area in Chapter 2, which addresses the geology and topography as well as the prehistoric and early historic landscapes of this region. Following this there is an overview and discussion of the burnt mound spreads and *fulachta fiadh* encountered along the scheme, followed by the archaeology of the townlands of Tonafortes, Caltragh and Magheraboy.

# 2

# THE LANDSCAPE OF THE STUDY AREA

## Geography, geology and land use

The N4 SIRR runs in a roughly north–south direction through a diverse topography of undulating terrain interspersed with rolling valleys and hills (Figs 2.1 and 2.2). Placing this area within its broader biogeographical region on the Atlantic fringe, we see a landscape characterised by upland and mountainous ground that is mainly underlain by acid rocks. Good land-use potential is restricted, particularly within the study area (Cooney 2000a).

Sligo city itself, situated at the mouth of the Garvoge (Garavogue) River, is the second town of Connacht. It is a prosperous market town, seaport and borough. The frequently tumultuous Garvoge River runs from the picturesque Lough Gill, located to the south-east of the town, to Sligo Bay towards the west. The limestone massifs of Ben Bulben (527m) dominate the views to the north, while the Ballygawley Hills extend this mountainous spectacle along the north-eastern horizon. To the west are Knocknarea, Sligo Bay and the Atlantic Ocean. Knocknarea, a protruding limestone block, stands to a height of 331m, while the smooth-sloped hills of the Ox Mountains, composed of gneiss and schists, dominate to the south and south-east.

Carboniferous limestone, more specifically Dartry limestone, underlies this area. The Dartry Formation derives its name from the area in the Dartry Mountains where it typically occurs in cliffs and slopes. The oldest rocks in Sligo are those forming the Ox Mountains and Rosses Point Inliers (inliers are areas of older rock surrounded by younger rocks). These are metamorphic rocks and date from 1,700–700 million years ago. Carboniferous rocks, which underlie most of Sligo, date from about 355–310 million years ago (MacDermot *et al*. 1996). Carboniferous limestone is the most abundant rock type in Ireland. It varies in texture, colour and components from fine calcite mud to calcite ooliths or coarse corals and shells, compact calcareous blue limestone and the hard blue-grey siliceous variety, and the black softer shaley beds of the Calp Formation. Most Irish limestone originated in the Carboniferous period of the Palaeozoic era 360–286 million years ago.

Much of western Sligo contains an arrangement of rock layers similar to that on Ben Bulben; 'limestone-capped mountains and plateaux are separated by the Glencar and Glenade valleys which are floored by soft shales' (MacDermot *et al*. 1996). Situated along the coast are Dartry and Glencar limestones forming rocky shorelines from Streedagh Point westwards to Serpent Rock, at

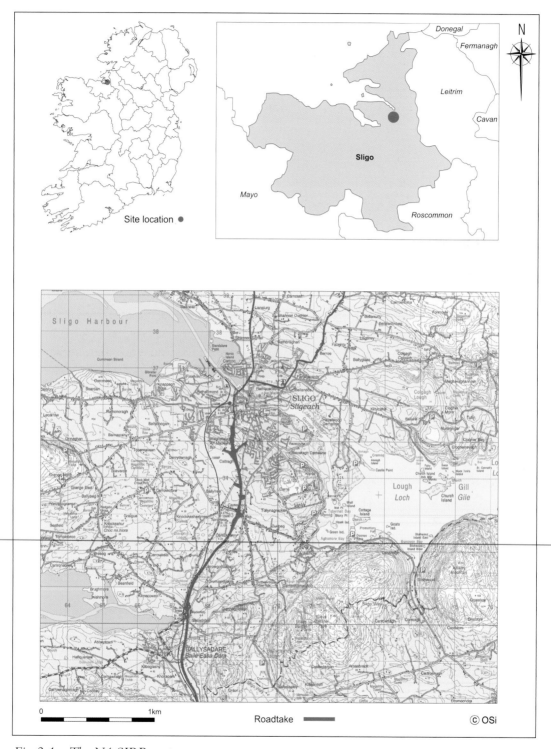

*Fig. 2.1—The N4 SIRR route.*

Aughris Point, and along the north of Dromore West and Easkey. Moving inland from the coast there is an irregular blanket of glacial deposits, predominantly till.

While the various mountains, such as the Ox and Ben Bulben ranges, dominate the landscape, glacial deposition has shaped the lowlands of Sligo with extensive drumlin beds and morainic and esker ridges. Broad bays and estuaries are the dominant features of the coastline, such as at Drumcliff, Sligo and Ballysadare. The Garvoge, Ballysadare and Moy rivers are the three principal rivers of the county, while Lough Gill, Lough Arrow and Lough Gara are the main inland waters. It is the combination of all these elements that provides 'a wide variety of ecological zones which attracted intense prehistoric settlements to the region' (Condit and Gibbons 1991).

The main soil type in County Sligo is Brown Earths, a soil mostly found on glacial drift where the parent material is limestone. It is a moderate to well-drained soil that is a good all-purpose agricultural resource suitable for pasture, while also moderately useful for tillage. Owing to the topography of the area, however, tillage farming is somewhat restricted. The boggy marshy soils present within confined areas of the townlands affected by the development, such as parts of Caltragh, Tonafortes and Magheraboy, have very limited potential, and the widespread presence of *fulachta fiadh* within the townland of Caltragh—and to a lesser extent Magheraboy—suggest that this might also have been the case in prehistory. This may not be true of the other townlands along the development route, however. A climatic change that occurred at around 1000 BC with a subsequent growth of blanket bog affected much of the west of Ireland, concealing many earlier habitation sites (Thorn 1985).

## The prehistoric and early medieval landscapes

Pollen diagrams and linear developments, such as the N4 SIRR, can be useful sources of information about the archaeological landscape. Compared to northern and other parts of western Ireland, very little is known about the vegetational history of this region. Pollen diagrams can be used to reconstruct an area's vegetational history, but only a few exist for this region. These include studies at Cloverhill, Carrowkeel and Ballygawley (Goransson 1980; 1981) and at Slish Lake and Union Wood (Thorn 1985). A picture of the prehistoric landscape in this region can be pieced together from a combination of these pollen diagrams and a study of the archaeological sites excavated in the area.

Linear developments such as the N4 SIRR provide a transect through the archaeological landscape. The overall context of the sites encountered along this road development is primarily prehistoric, with a Neolithic and Bronze Age bias. In relation to the landscape of the study area, the N4 SIRR provides only a small cross-section, with just 3.5km of the overall 4.2km extending through a rural setting; the remainder runs through the urban part of Sligo town. The development is contained in an area known as Cúil Irra, which translates as 'the remote angle' (Wood-Martin 1882–92, vol. 1). The district of Cúil Irra takes in the parish of St John's; the N4 SIRR is confined within this parish.

*Fig. 2.2—Known sites within the study area.*

## The Mesolithic landscape

To date, with the exception of a wooden brushwood platform and associated activity on the shore of Lough Gara (Fredengren 2002), no Mesolithic settlement site has been identified in County Sligo, though the hinterland of Lough Gara near the Roscommon border provides the most significant evidence for Mesolithic activity in the county. A number of chert 'Bann' flakes and other chert artefacts suggest the presence of hunter-gatherer communities exploiting the hinterland of Lough Gara. Most of the datable material from this area can be assigned to the latest phases of the Mesolithic (Woodman 1978). More recently, however, early Mesolithic stones have come to light at Lough Gara (see O'Sullivan 1988). Some residual Mesolithic activity was also identified within the Carrowmore passage tomb cemetery (Burenhult 1980; 1981; 1984).

While the precise date of the Carrowmore tombs has still not been satisfactorily established (see Caulfield 1983), the tombs have produced grave-goods (pottery, pins etc.) that are of the same cultural assemblage as the material in the Boyne Valley and Loughcrew cemeteries. These passage tombs and the associated material are firmly dated to the middle Neolithic period (33/3200–29/2800 BC) and, in the absence of any compelling evidence to the contrary, this is the context within which the Carrowmore tombs should be assessed (J. Sheridan 1985/6; Eogan 1986). This is not to deny the interesting possibility—identified, for example, at Dissignac in Brittany—that the sites of the tombs had already been established as sacred places in the late Mesolithic and were chosen as the tomb locations for that reason.

## The Neolithic landscape

The numerous megalithic tombs located throughout much of County Sligo stand as a constant reminder of the social organisation, ritual duties and engineering abilities of early prehistoric communities. This region has a large number of megalithic tomb types, with *c.* 82 passage tombs, 60 court tombs, 11 portal tombs, 38 wedge tombs and 53 unclassified examples, while there are also 78 megalithic structures which could be tombs (Condit and Gibbons 1991; Alcock and Tunney 2002).

Sligo contains two of the four major megalithic cemeteries in Ireland: Carrowmore and Carrowkeel. The other two are in the Boyne Valley at Newgrange and Loughcrew, Co. Meath. The cemetery at Carrowmore is among the finest examples of a passage tomb cemetery in Europe. Just over 30 individual tombs now survive, compared to more than 100 recorded in the nineteenth century (Herity 1974). Many of the tombs at Carrowmore consist of a boulder circle with a polygonal chamber covered by a capstone at the centre of the circle. Some have short passages. Of the *c.* 230 passage tombs identified in Ireland, 75 (30%) are located within the Cúil Irra peninsula to the west of Sligo town (Bergh 2002). At Carrowkeel over a dozen round cairns are sited on several high limestone ridges of the Bricklieve Mountains.

As mentioned above, just under a third of all Irish passage tombs are in County Sligo. Many of

these dominate the local landscape with their typical hilltop setting, such as at Carrowkeel, Knocknarea, Knocknashee, Cairns Hill, Kesh, and several on the Ox Mountains extending into Slieve Deane and Slish Wood (Thorn 1985; Herity 1974). At the summit of Knocknarea, a huge flat-topped cairn overlooks the Carrowmore cemetery to the east. This is known as Maeve's Cairn and probably contains a passage tomb, and there are the remains of at least four satellite monuments in the immediate vicinity. There is much debate about whether these passage tomb cemeteries originated on the east or west coast, and the early Neolithic dates obtained for the causewayed enclosure at Magheraboy ensure that this debate will continue. Of the approximately 390 court tombs in Ireland, 60 are in Sligo. These are located across much of the county, for example at Creeveykeel, Treanmore, Bunduff, Moneylahan, Deerpark, Gortnaleck, Carrowgillpatrick and Carrowreagh. The classic trapezoidal full court tomb at Creeveykeel is one of the finest examples in the country. Excavation of this site produced a large number of grave-goods, such as early Neolithic (Carinated Bowl) pottery, leaf-shaped arrowheads, hollow scrapers and polished stone axeheads (Hencken 1939).

The current archaeological evidence indicates that portal tombs are related to court tombs. In particular, this applies to the subsidiary chambers, or galleries, inserted in the cairns of court tombs, possibly to provide additional space for burials, thereby reducing the need to build additional court tombs (Flanagan 2000). Of the approximately 174 Irish portal tombs, eleven are in Sligo. One such is Tawnatruffaun, a classic example whose name translates as 'grassy mound by the stream', a typical setting for these tombs.

Megalithic tombs are the traditional indicators of Neolithic settlement. Neolithic hut sites appear to be associated with a number of the hilltop tombs of Sligo. At Knocknarea Bergh (1995) excavated a number of hut sites, which he concluded were sites of specialised activity. The excavation of these lightweight timber-built huts revealed an exceptionally large number of concave scrapers. It is suggested that the upland location might indicate seasonal hunting or grazing, while the hollow scrapers imply some sort of cutting or paring. The huts may also be associated with the nearby tombs. At Mullaghfarna, to the east of the Carrowkeel cemetery, Bergh surveyed in excess of 130 hut sites that may be associated with the cemetery and are likely to have been seasonal in nature (Stefan Bergh, pers. comm.). At Knocknashee Burenhult (1984) investigated a number of hut sites possibly associated with the tombs at this location. Additional evidence of seasonal activity is also visible around the coastline of the Knocknarea Peninsula in the form of shell middens. The shell midden at Culleenamore was comprised mainly of oyster, with some cockles, mussels, periwinkle, scallop and limpet. A hearth associated with this midden produced a fourth-millennium BC radiocarbon date.

No rectangular houses of the early Neolithic are known from Sligo. While a rectangular structure was excavated in association with the causewayed enclosure at Magheraboy, this is unlikely to have been a permanent dwelling (Danaher, see CD). Field systems composed of stone walls have been identified at Drommore West/Easkey, and during the course of archaeological works associated with the N4 SIRR Neolithic stone walls were investigated at Caltragh (Joubert, see CD; McCabe, see CD).

Eight ceremonial enclosures have been recorded for Sligo (Condit and Gibbons 1991; Alcock and Tunney 2002). These ritual/ceremonial monuments, sometimes referred to as henges or earthen-banked enclosures, are of prehistoric date and some are as early as the middle to late Neolithic. A characteristic feature of most Irish embanked enclosures is a bank composed of material scarped up from inside the enclosed area, creating a domed interior (G. Stout 1991; Condit and Simpson 1998). A small number of enclosures in Ireland are defined by an internal ditch and external bank, thus conforming to the type of henge found in most areas of Britain.

A marked concentration of embanked enclosures has been recorded in the Boyne Valley (G. Stout 1991), some in association with the passage tombs, but only three have been recorded in Sligo. Two of these conform to the classic Irish henge type (embanked enclosure). The smaller of the two is situated at Knockatober, south of Lough Gill, and consists of a circular earthen enclosure, 60m in diameter. The second is at Lisnalurg, just north of Sligo town, and comprises a large circular enclosure, 150m in diameter, formed by an earthen bank 25m wide and up to 5m high on the interior; a second earthen enclosure, 75m in diameter, is placed centrally within this larger one. The third Sligo monument has a very similar morphology to the British type of henge and is located in the townland of Tonafortes in a low-lying drumlin valley 2km east of Carrowmore (Condit and Gibbons 1991). This enclosure has an overall diameter of approximately 85m. It consists of a circular central area, 45m in diameter, and is enclosed by two banks with an intervening ditch.

While 'henges' appear to be middle to late Neolithic in date, there are two other chronologically very diverse expressions of this general site type that date from the middle–late Bronze Age and the Iron Age. These are briefly outlined in Chapter 4.

The pollen diagrams from Carrowkeel and Ballygawley (Goransson 1980; 1981; 1984; 2002) provide some environmental information on the prehistoric landscape in this region. The elm decline, which many archaeologists and vegetational historians had attributed to major forest clearance by Neolithic farmers, was recorded in pollen diagrams as having occurred sometime around 5150 BP. This assertion has been contested in favour of the weakening of the forest ecosystem, which would have resulted in the annihilation of the elm forests, owing to disease that may have been precipitated by human interference, i.e. coppicing (see for example Cooney and Grogan 1999, 28–33; Goransson 1984). Climatic changes may also have occurred, activating the *Scolytus* beetle and thus spreading Dutch elm disease. Therefore the elm decline, in Goransson's view, was not contemporary with the early Neolithic either in Ireland or in north-west Europe. Waddell (1998, 27) also refutes the human causes for the elm decline by arguing that 'elm also declines in various localities where it was clearly a minor component in the wooded landscape, and was thus unlikely to be targeted by farmers or their cattle'.

Another conclusion arrived at by Goransson (1984) was that garden cereal cultivation was taking place in the Sligo area as early as in the south-west and north of Ireland. This was substantiated by the discovery of cereal pollen grains at Ballygawley Lake and the Strand Hill area; these dated from 5800 BP and also pre-dated the elm decline. Regeneration of the elm forests 500–600 radiocarbon years later resulted in the re-institution and intensive use of coppicing once

more. The pollen diagram from the Cloverhill Lough area demonstrated that 'the area during the time span covered by the diagram was primarily used as pasture land' (Goransson 1984). Grazing appeared to have been extremely important in this area during the early Neolithic, and the introduction of domesticated animals into the region at around *c.* 4000 BC is reflected in the significant values of ribwort plantain evident from the pollen diagrams of this period. While it is practically impossible to ascertain how important cereal-growing was to the Neolithic peoples of this region, it is clear that cereal cultivation took place during the whole of the Neolithic (Goransson 2002).

## The Bronze Age landscape

While some megalithic tombs continued to be the focus of ritual activity into the late Neolithic and succeeding periods, other forms of ritual expressions emerged. So did a major technological breakthrough—metalworking. This technology had an important impact not just on society and economy but also on the ritual practices of Bronze Age people. In terms of monuments dating from this period, wedge tombs, barrows and stone circles are the most visible while *fulachta fiadh* are the most numerous, with over 7,000 examples recorded throughout the country (Power *et al.* 1997). These cannot all be assigned to the Bronze Age, however.

Wedge tombs are the most numerous megalithic tombs in Ireland. Of the 500 recorded examples, 38 are found in Sligo. These tombs derive their name from a narrow wedge-shaped or trapezoidal chamber that decreases both in height and in width from front to rear. This main chamber is constructed of orthostats and roofed with one or more capstones. Some tombs have an antechamber at the front, while others have a small closed chamber at the rear. Excavation of a wedge tomb at Moytirra, Co. Sligo, yielded the unburnt bones of six individuals as well as fragments of Beaker pottery (Cremen Madden 1969). At Breeoge, Co. Sligo, both cremated and unburnt human remains were retrieved from the site of a destroyed wedge tomb (Waddell 1998).

A large number of barrows have been recorded in Sligo. Condit and Gibbons (1991) identified over 110 such sites and these show a wide variety of types and locations. Some may be associated with the Bronze Age settlement sites such as Lough Gara. In the vicinity of Ballymote, a portion of a Bronze Age landscape has been identified, consisting of Bronze Age barrows, field walls, enclosures, cliff-edge forts and a circular house site. In contrast to the large number of barrows, other Bronze Age ritual monuments, such as standing stones, stone alignments and stone circles, are comparatively sparse (Grogan 2005b, 176–82; Condit and Gibbons 1991).

In a distribution map of *fulachta fiadh* in Ireland Buckley (1990b) entered only twelve examples for Sligo. As a result of subsequent development within the county, this number has increased significantly (Grogan 2005b, figs 10.1a, 10.2a). The Archaeological Inventory for South Sligo lists 37 examples (Egan *et al.* 2005). As the N4 archaeological investigations passed through some tracts of marshy ground, *fulachta fiadh* emerged as the most common site encountered and are dealt with in detail in Chapter 3. Within the townland of Magheraboy there is a cluster comprising three sites

that have been interpreted as *fulachta fiadh*. A possible *fulacht fiadh* was uncovered in the course of monitoring ground disturbance on the Caltragh Sewerage Scheme (Henry 2002). Some clusters of burnt mound spreads were excavated in the townland of Caltragh; most of these were interpreted as *fulachta fiadh* (Joubert, Linnane and McCabe, see CD). These *fulachta fiadh* formed part of a wider Bronze Age settlement pattern in the Caltragh area and were broadly contemporary with the three middle Bronze Age circular timber-built round houses that were sited in close proximity to them (see Chapter 5). Two other *fulachta fiadh* were situated within the townland of Tonafortes (Chapter 4). The remains of one possible and one definite *fulacht fiadh* were identified *c.* 500m from the roadtake in the townland of Carrowroe (Sue McCabe, pers. comm.). Bronze Age activity in the form of pits was unearthed in the townlands of Magheraboy and Caltragh. A number of pre-bog and habitation sites have been identified in the county. At Carrownagloch, Bunniconlon, on the Sligo/Mayo border, an oval stone enclosure surrounds extensive cultivation ridges that have been dated to the second millennium BC (Herity 1971–6).

Pollen evidence, which can be used to reconstruct the vegetational history of the Bronze Age, is extremely limited within this area. Goransson (1984) suggests that the inclusion of *Sorbus* in the pollen diagram for the Treanscrabbagh Bog at Carrowkeel may be indicative of a decline in grazing and a slight forest regeneration that took place at *c.* 4500 BP. He believed that grazing continued to take place up until 4000 BP, however, after which the growth of blanket bog began. An example of a *fulacht fiadh* (Goransson 1984) that was cut into the Treanscrabbagh Bog at this level provided information supporting Goransson's hypothesis of coppicing in this area from 4500 BP.

## The Iron Age and early medieval landscape

Evidence from the pollen record from around the country suggests that there was a significant decrease in agricultural activity during the Iron Age. Investigation of the later prehistoric pollen records in Louth by Weir (1995) and research conducted in the Galway region by O'Connell and Molloy (2001) implies a low level of agricultural activity for the Iron Age compared to other periods and, in particular, the early medieval period, which saw an intensification of agriculture.

As with the Bronze Age, pollen diagrams pertaining to the Iron Age period are rare for Sligo. While Goransson's (1984) work predominantly focused on the Mesolithic and Neolithic periods, any changes in the pollen diagrams throughout the prehistoric and historic periods were noted. Conclusions drawn about the pastoral nature of Cloverhill Lough and the minor role of cereals in this area throughout the whole of prehistory right through to the nineteenth century AD imply that no change occurred during the Iron Age. A brief reference to this period is made in relation to the Treanscrabbagh Bog at Carrowkeel. Here, the 'destruction phase' was characterised by high values of herbs (*Plantago lanceolata*, Cerealea and *Rumex acetosella*), and the low values of trees were followed by the regeneration of forest during the Iron Age (Goransson 1984). This would appear to support the country-wide trend of a decrease in agricultural activity during this period.

The Iron Age is possibly the most obscure period in Irish prehistoric archaeology. At present,

many counties show little evidence of a significant Iron Age presence. Settlement sites are few and far between, as well as being difficult to identify (Woodman 2000). Only 80 hillforts have been identified in Ireland, with at least seven of these in Sligo (Raftery 2000; Grogan 2005b, 111–29). The univallate hillfort at Knocknashee is the largest example of its class in the country, covering 22ha, and may date from the late Bronze Age/Iron Age period. Other hillforts are located at Muckelty Hill, near Tobercurry, and Carrownrush, near Easkey. Twenty promontory forts, mainly coastal, have been recorded in the county of the 250 known sites in the country. These sites are known from Aughris Head and the island of Inishmurray. A possible Iron Age linear ditch, extending for a length of 3km, is situated in the southern Ox Mountains near the Sligo–Mayo border. Known as the Black Ditch, this may be the remains of an ancient 'droveway' but may also have functioned as a property division or a frontier boundary.

The N4 SIRR excavations revealed very few traces of Iron Age activity. At Magheraboy a small circular structure of Iron Age date was unearthed adjacent to the early Neolithic causewayed enclosure. At Cornageeha there was a pit of similar date (McCabe, see CD).

On the other hand, evidence for early medieval settlement is commonplace within the locale. Ringforts are the most common monument type in the parish of St John's, with over 30 examples being known. In total, 1,703 ringforts are recorded for County Sligo (Alcock and Tunney 2002). A large percentage of a ringfort (O'Neill, see CD) was excavated at Magheraboy within the confines of the much earlier Neolithic causewayed enclosure, and in 1995 a ringfort was excavated at Carrowgobbadagh as part of the Collooney–Ballysadare Bypass (Opie 1996).

# 3

# BURNT STONE TECHNOLOGY

## Introduction

*Fulachta fiadh*, together with spreads and pits of burnt mound material, are the most common archaeological features encountered in large-scale rural developments, in particular linear transects such as roads and pipelines. A large number of all sites excavated in connection with road jobs are *fulachta fiadh*. Archaeological works along the N4 SIRR did not reveal the same high proportions of these sites as elsewhere in the country, but they nevertheless represent by far the most common site type encountered within the scheme. At least eight *fulachta fiadh* and eight spreads of burnt mound material were excavated within the 3.5km of the roadtake. Clearly, burnt stone technology was an important component of prehistoric life in Sligo.

Given the large number of *fulachta fiadh* and spreads of burnt mound material identified, these sites are dealt with together in a single chapter exploring location, form, function and origin; this section will also explore whether they formed part of the domestic or ritual landscape. This chapter does not attempt to offer a definitive critique of these enigmatic monuments but rather a synopsis of the N4 SIRR results.

## *Fulachta fiadh*, burnt mounds and related sites

It would be useful to begin with a clarification of what constitutes a *fulacht fiadh* or burnt mound, as they are also called, as distinct from a spread of burnt stone or a pit containing burnt stone. A *fulacht fiadh* generally consists of a flat-bottomed pit or trough, sometimes lined with timber planks or occasionally stone slabs, in which water is heated or boiled through the introduction of stones heated in a nearby fire. The most frequent explanation for these sites is that the heated water was used to boil joints of meat that may have been wrapped in a covering of straw or other organic material. The function of these sites will be discussed in greater detail later, but alternative explanations—for example, use as saunas or sweat-houses or for bathing, or for industrial purposes such as the dyeing of cloth, brewing, the treatment of hides in leather production or the manipulation of timbers—have come to the fore in recent years.

On the ground, the classic *fulacht fiadh* is a relatively low grassy mound of crescent or U-shaped

plan (Waddell 1998). Ploughed-out examples are often revealed as large spreads of burnt stone and charcoal in the ploughsoil. They are usually, though not exclusively, close to water—often a stream, lake, river or marsh. The *fulachta fiadh* and spreads of burnt mound material excavated in association with the N4 SIRR were all sited close to water. They sometimes occur in groups, clusters of two to six occasionally being located within quite a small area. Little is known of the chronological sequencing of many such clusters, but recent excavations of *fulachta fiadh* may help to provide a chronological framework that will enhance our understanding of such groupings. Examples of recent investigations include those carried out on the N22 Ballincollig Bypass (E. Danaher 2004a; 2004b; Russell 2004a; 2004b) and the Bord Gáis Éireann Pipeline to the West (Grogan *et al.*, forthcoming). The dates obtained from the various sites excavated within the above projects, as well as those from the N4 SIRR, make for interesting analysis and will be dealt with later.

*Fulachta fiadh* are generally recognised through a number of consistent features: a mound of heat-fractured stones, a trough and traces of fires, sometimes represented by a formal hearth. Other components, such as post-built structures and roasting-pits, can also be associated with these sites (Waddell 1998). Generally, for a site to be called a *fulacht fiadh* it should contain a spread of burnt mound material and an associated trough (see Brindley and Lanting 1990, 55). Owing to the nature of development-led archaeology, however, some sites are not fully exposed and important features such as troughs may lie outside the roadtake. Therefore spreads of burnt mound material discovered without an associated trough may originally have formed part of a *fulacht fiadh*; alternatively, portable troughs may have been used, leaving no trace in the archaeological record. Water may have been boiled in containers of wood, bronze or leather; the shallow circular pits associated with many burnt mound spreads may have acted as receptacles for these containers. There were no cut features associated with many of the N4 SIRR sites, while others contained troughs. For the purposes of discussion in this volume, any site not containing these two elements (a spread of burnt mound material and a trough) will not be referred to as a *fulacht fiadh* but as a spread of burnt mound material. This, however, does not imply that these sites did not originally function as *fulachta fiadh*. Likewise, some of the N4 SIRR sites that were previously termed *fulachta fiadh* have been reinterpreted and are subsequently referred to as spreads of burnt mound material (see Table 3.1).

## Distribution

Burnt mounds are known from Scandinavia, Wales, Scotland, Orkney, the Shetland Islands and parts of Cumbria (Buckley 1990a, 9). *Fulachta fiadh* have been identified throughout Ireland and are the most common prehistoric monument in the country. At present, over 7,000 examples have been recorded (Power *et al.* 1997), although this number will undoubtedly increase as a result of further field survey and development-led excavation. The largest concentrations of these sites are in Munster, with over 2,500 examples alone in County Cork (Buckley 1990a, 3), approximately one per 2.97km$^2$. Power (1990) notes that in Cork, as elsewhere in the country, *fulachta fiadh* show a preference for streamside locations. They are also found close to other water sources such as lakes, rivers and marshes. The sites within the N4 SIRR are no exception, being sited close to lake or

marshy environments along the route, such as those within the valley of Caltragh, at Tonafortes and also at Magheraboy.

*Table 3.1—List of* fulachta fiadh *and burnt mound spreads.*

| Townland | Licence no. | Director | *Fulacht fiadh/* spread no. | Identified in reports as: | Trough |
|---|---|---|---|---|---|
| Tonafortes | 03E0535 | Ed Danaher | Tonafortes 1 | *Fulacht fiadh* 1 | Y |
| Tonafortes | 03E0535 | Ed Danaher | Tonafortes 2 | *Fulacht fiadh* 2 | Y |
| Tonafortes | 03E1414 | Sue McCabe | Tonafortes 3 | Area G | N |
| Caltragh | 00E0819 | Sebastien Joubert | Caltragh 1 | Site 6 | N |
| Caltragh | 01E0395 (ext.) | Sebastien Joubert | Caltragh 2 | C1128 | N |
| Caltragh | 01E0395 (ext.) | Sebastien Joubert | Caltragh 3 | C1098 | N |
| Caltragh | 01E0395 (ext.) | Sebastien Joubert | Caltragh 4 | C1064 | N |
| Caltragh | 03E0542 | Sue McCabe | Caltragh 5 | Area 1E ext. | Y |
| Caltragh | 03E0542 | Steve Linnane | Caltragh 6 | Site 1D | Y |
| Caltragh | 03E0543 | Steve Linnane | Caltragh 7 | Area 1F, spread A | Y |
| Caltragh | 03E0543 | Steve Linnane | Caltragh 8 | Area 1F, spread B | N |
| Caltragh | 03E0543 | Steve Linnane | Caltragh 9 | Area 1F, spread C | N |
| Caltragh | 00E0859 | Brian Halpin | Caltragh 10 | Site 3 | N |
| Caltragh★ | 00E0859 | Sebastian Joubert | Caltragh 11 | Site 2 | N |
| Magheraboy | 03E0547 | Sue McCabe | Magheraboy 1 | *Fulacht fiadh* 1 | Y |
| Magheraboy | 03E0547 | Sue McCabe | Magheraboy 2A | *Fulacht fiadh* 2 | Y |
| Magheraboy | 03E0547 | Sue McCabe | Magheraboy 2B | *Fulacht fiadh* 2 | Y |
| Magheraboy★★ | 03E0547 | Sue McCabe | Magheraboy 3 | *Fulacht fiadh* 3 | ? |
| Magheraboy★ | 00E833 | Mary Henry | Magheraboy 4 | Site 1 | N |

★ These sites were associated with the Caltragh Sewerage Scheme.

★★ Magheraboy 3 was preserved *in situ*, hence it was not determined whether this site contained a trough.

Table 3.2—*List of radiocarbon dates obtained for* fulachta fiadh *and burnt mound spreads.*

| Site no. | Licence | Submitter's no. | Laboratory no. | 2 sigma cal. BC | cal. BP |
|---|---|---|---|---|---|
| Tonafortes 2 | 03E0535 | 03E535:C536S7 | Beta-196297 | 2400–2380/ 2360–2140 | 4350–4330/ 4300–4090 |
| Caltragh 1 | 00E0819 | 00E819:11:62 | UCD-0239 | 1680–1430 | 3305–3215 |
| Caltragh 1 | 00E0819 | 00E819:10:20 | UCD-0240 | 1737–1459 | 3265–3365 |
| Caltragh 2 | 01E0395 | 01E395:1128:1148 | UCD-0237 | 2195–1861 | 4145–3725 |
| Caltragh 3 | 01E0395 | 01E395:1098:1195 | UCD-0249 | 2194–1834 | 3600–3700 |
| Caltragh 5 | 03E0542 Ext. | 03E542:F402S55 | Beta-194435 | 1910–1410 | 3860–3360 |
| Caltragh 6 | 03E0542 | 03E542:F143S5 | Beta-197658 | 1630–1400 | 3580–3350 |
| Caltragh 7 | 03E0543 | 03E543:F219S1 | Beta-197659 | 1000–800 | 2950–2750 |
| Caltragh 10 | 00E0859 | 00E859:126:159 | UCD-0241 | 1741–1516 | 3385–3285 |
| Magheraboy 1 | 03E0547 | 03E0547:F6S6 | Beta-194430 | 2580–2200 | 4530–4150 |
| Magheraboy 1 | 03E0547 | 03E547:F39S42 | Beta-194429 | 2630–2450 | 4580–4400 |
| Magheraboy 2A | 03E0547 | 03E547:F166S29 | Beta-194428 | 2120–2090/ 2050–1890 | 4070–4040/ 4000–3840 |
| Magheraboy 2B | 03E0547 | 03E547:F302S51 | Beta-194427 | 1270–910 | 3220–2860 |

## *Fulachta fiadh* and related sites on the N4 SIRR

All the *fulachta fiadh* associated with the N4 SIRR were contained within three townlands: two in Tonafortes and at least three in both Caltragh and Magheraboy. All three townlands contained varying numbers of spreads of burnt mound material. The hot stone technology that produced this material is the common denominator shared by all of these sites.

### The Tonafortes sites

Two of the three Tonafortes sites (Tonafortes 1 and 2) were located in low-lying pastureland at a height of about 25m (82ft) OD, over 120m north-west of the ceremonial enclosure (see Chapter 4, Fig. 4.1). These occurred less than 10m apart in recently reclaimed marginal land. Prior to reclamation the sites were separated by a pond and their original setting consisted of a wet and marshy environment. A spread of burnt mound material, Tonafortes 3, was identified to the south of the ceremonial enclosure.

The first of these to be investigated, Tonafortes 1, was severely damaged by an early modern field-clearance pit: all that remained was a small quantity of *in situ* burnt mound material, redeposited material within the ploughsoil, and the northern edge of the trough. While little can

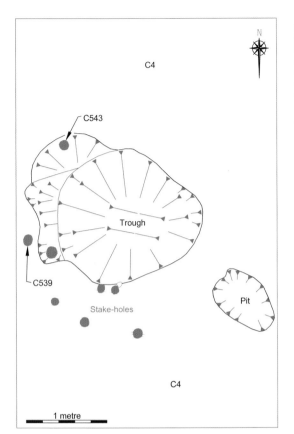

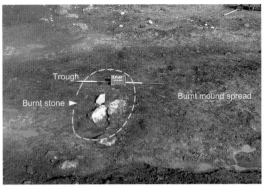

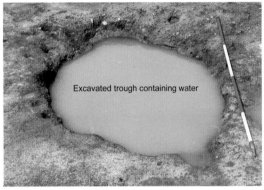

*Fig. 3.1—Tonafortes 2: post-excavation plan of zone C. Upper photograph: pre-excavation detail. Lower photograph: post-excavation detail.*

be deduced from this site, Tonafortes 2 was much better preserved and is examined here in more detail. It produced evidence for a suboval trough, a series of stake-holes and a pit (Fig. 3.1). The burnt mound material partly covered some of these features, having been spread throughout much of the site. Sealing the burnt mound material was a peaty layer, which was sandwiched between the main spread of burnt mound material and the topsoil.

The trough was located directly south-east of the main burnt spread, while its western extent was partly sealed by it (Fig. 3.1). This pit was cut into impermeable marl, and there were stake-holes along its southern and south-western edges. A small number of other cut features, mainly stake-holes, a trough and a pit, were identified beneath the burnt mound spread. This *fulacht fiadh* dated from the final Neolithic/early Bronze Age period (Table 3.2). The levelled spread was probably the result of slippage and agricultural activity such as ploughing. Prior to these events this material probably survived as a low mound. It appears that the main mound concentration of discarded heat-shattered stone and charcoal probably lay to the north–north-east of the trough.

The trough consisted of a suboval pit over 2m long and over 1m wide that was dug into the

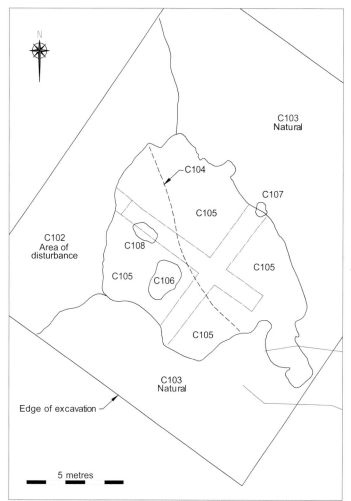

*Fig. 3.2—Tonafortes 3: pre-excavation plan of burnt mound.*

subsoil to a depth of 0.38m. As it was dug into an impermeable clay layer it held water naturally without the aid of a lining (Fig. 3.1). Stake-holes around the southern and south-western edges of the trough, however, may have secured a lining, possibly of timber, wicker or leather. Alternatively, although less probably, a canopy or tent may have at least partly covered the trough. Stake-holes along the outside of a trough are often seen as evidence for a directly associated superstructure and have been used to promote the hypothesis that these features were sweat-lodges or bathing places. In the case of Tonafortes 2 it is improbable that the trough was used as a sauna given the scant nature of the evidence: nearly all of the stake-holes were sited to the south of the trough, while modern and ethnographic parallels for this type of site require no pit—water is simply poured onto hot stones. A second pit, *c.* 0.3m to the south of the trough, occurred at Tonafortes 2. This much smaller feature contained some heat-shattered stone as well as redeposited marl.

The truncated remains of a burnt spread (Tonafortes 3, Fig. 3.2) were located less than 150m

south-east of the ceremonial enclosure. It is possible that its close proximity to the enclosure may be purely coincidental, with its location having been chosen to avail of the pond to the west. Alternatively, it may have been associated in some way with the ritual activities of the ceremonial enclosure, as has been suggested for similar features identified in close proximity to an embanked enclosure at Darragh South, Co. Clare (Connolly 2001). It is also feasible that hot stone technology may have played a part in ceremonies conducted within the enclosure, and although these functions may not have differed from typical *fulacht fiadh* activities, a new significance might be inferred from burnt mound activity when considered in the context of the ceremonial enclosure. The archetypical use of these monuments may have taken on more spiritual connotations, although the function remained the same.

## The Caltragh sites

A shallow stream now flows through the wide shallow valley of Caltragh; as mentioned previously, this marshland is the remnants of a prehistoric lake. All ten burnt mound spreads excavated within this landscape were sited within low-lying fields, with a distance of only 360m separating the most southerly and northerly sites. Of these only three (Caltragh 5, 6 and 7) can be identified as *fulachta fiadh* with any degree of certainty. The rest have been classified as burnt mound spreads as they did not contain any troughs or cut features. Only two of the sites were discernible above ground (Caltragh 1 and Caltragh 10). The rest were levelled, possibly as a result of agricultural activities. As expected, all of the mounds comprised a combination of heat-shattered stones mixed with charcoal-rich soil but varying in size from 2.8m by 1.2m (Caltragh 4) to 11m by 14m (Caltragh 1). Radiocarbon analysis (Table 3.2) of the various charcoal samples taken from these sites returned dates spanning a period of over 1,000 years, indicating at least three separate phases of use.

Three of the burnt mound spreads overlay a probable Neolithic stone wall that may originally have been built along the edge of this lake (see Chapter 5). Peat had already begun to form over the wall prior to the deposition of the burnt mound spreads (Joubert, see CD), demonstrating that a considerable period of time had elapsed between the end of use of the wall and the formation of the burnt mound spreads.

The largest and most impressive of the burnt mounds was Caltragh 1, a well-preserved example that survived to a height of 1.2m and covered a portion of a Neolithic stone enclosure (Chapter 5; see Pl. 5.6 and Fig. 5.2). Within this mound three successive accumulations of build-up comprising a mixture of burnt stone, ash and charcoal were identified; it was also noted that the earlier two phases were confined to the west of the enclosure. The excavator observed that the mound had been well ordered and maintained up until its abandonment (Joubert, see CD). No formal hearth or trough was discovered, and owing to the central position of this site within the roadtake it is unlikely that such associated features lay outside the excavated area. Interestingly, numerous animal bones, some with butchery marks, and a small number of lithics were found within the mound. The other burnt mounds overlying the Neolithic stone wall—Caltragh 2 and 3—lay north-west and south-east of Caltragh 1. Caltragh 2 was a small low mound (6m by 6m by 0.28m high) consisting of a mixture of heat-shattered stone, ash and charcoal, with a high peat

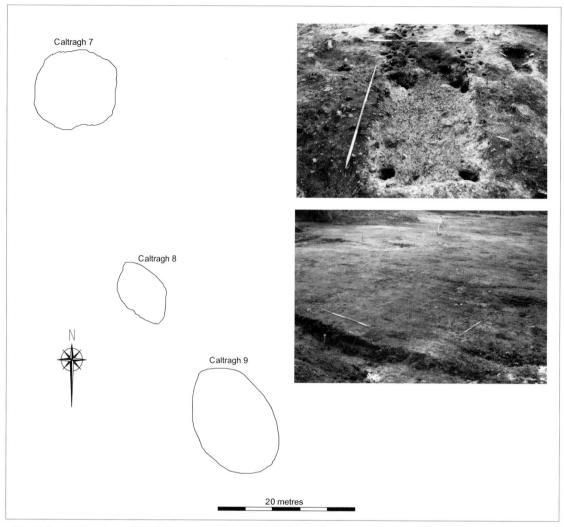

*Fig. 3.3—Caltragh 7, 8 and 9: extent of sites. Top inset: Caltragh 9, rectangular trough with post-holes located in each of its four corners. The feature was present underneath the burnt stone spread of the* fulacht fiadh. *Lower inset: Caltragh 8 before excavation.*

content in the basal layer. A formal hearth constructed within the drystone wall is likely to be associated with this spread as the excavator maintained that they were stratigraphically associated: no trough or any other cut features were identified. This mound also produced fragments of animal bone (some with butchery marks), burnt animal bone and some worked chert and flint. Caltragh 3 was slightly smaller and also consisted of heat-shattered stone, charcoal and ash. There was no evidence of a hearth, trough, artefacts or animal bone within the mound.

Of the other spreads of burnt mound material, Caltragh 4 was located 15m north of the

western end of the drystone wall; this was the smallest spread encountered, covering an area of less than 3.5m², and the northern side was delineated by a stream. It appeared to have been severely truncated by a modern boreen and there were no associated cut features or artefacts. Caltragh 10 consisted of an impressive burnt mound with dimensions of 22m east–west by 18m north–south by 0.66m high. Forty distinct deposits of burnt mound material were identified, although no trough or related cut features were found: the excavator suggested that they exist outside the roadtake (Halpin, see CD).

Three contiguous spreads of burnt mound material, Caltragh 7–9 (Fig. 3.3), formed the most northerly examples within the valley. Of the three, only Caltragh 7 contained a trough. The excavator suggested that Caltragh 8 and 9, which produced no troughs, may originally have formed part of one substantial mound associated with site 7, which was levelled in order to reclaim ground from the margins of the adjacent bog (Linnane, see CD). Caltragh 8 was *c.* 25m to the south of site 7: the general stratigraphy consisted of peat and topsoil overlying the mound, which in turn overlay an earlier layer of peat lying on the subsoil. The spread extended in an irregular oval, *c.* 16.5m east–west by *c.* 11.5m north–south by *c.* 0.25m high (Linnane, see CD). Caltragh 9 (Fig. 3.3) lay *c.* 20m to the south of Caltragh 8, with almost identical stratigraphy and dimensions. The spread consisted of black silty clay with high concentrations of heat-shattered stone, mostly sandstone but occasionally limestone and granite. Although sites 8 and 9 may represent redeposited material from Caltragh 7, it is more probable that these three sites existed independently of each other. The substantial size and shape of each site as well as the distances separating them, together with the absence of any burnt stone material linking them, indicate that Caltragh 8 and Caltragh 9 were sites in their own right.

Of the three *fulachta fiadh* the most recent in date is Caltragh 7, which consisted of a burnt spread (13m by 11m by 0.2m high) that covered a rectangular pit with corner posts as well as associated stake-holes. These posts would have been designed to support planked sides, while the size of the posts and the shallowness of the pit suggest that the planking would have been raised above ground level in order to create a functional water-container. A complex of stake-holes was positioned around the trough: the large number of these made it very difficult to identify a pattern or explanation for their use. It is possible that they represent a screen or maybe multiple screens used during the lifetime of the trough (Linnane, see CD).

Caltragh 6, situated over 300m south of Caltragh 7, contained a more unusual trough. Again this was sealed by a burnt mound: the surviving extent measured *c.* 10m north–south by *c.* 25m west–east with a maximum height of *c.* 0.3m (Fig. 3.4). Extending northwards from the circular bowl-shaped trough is a feature that has been interpreted as a drain; this would have required the use of a stone placed in the channel to retain water within the trough. The slight raising of the stone would have released water to drain away from the pit, a useful detail: the addition of stones to the water-filled pit would have caused it to overflow and flood the surrounding ground, but the drain would have eliminated that problem. The stake-holes to the east of the pit may have supported a screen, possibly of hide, to protect the pit and its user from wind (Linnane, see CD). An alternative interpretation for this trough and associated drain is that they were used in the

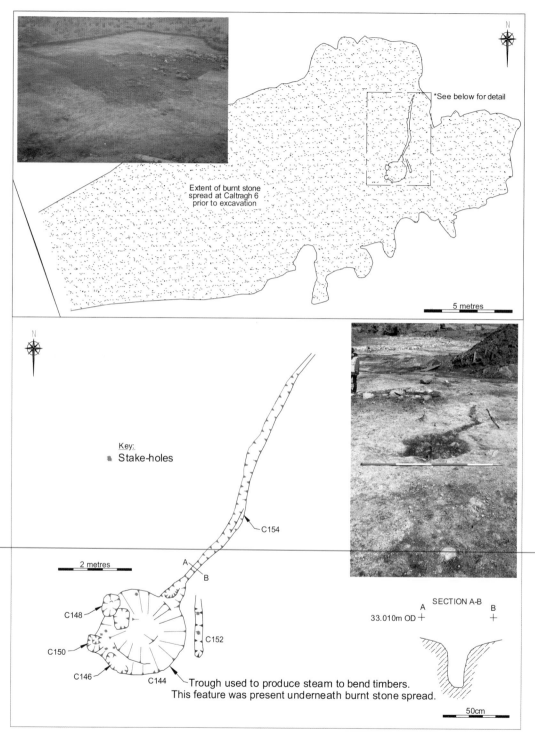

*Fig. 3.4—Caltragh 6: burnt spread and underlying trough. Upper inset:* fulacht fiadh *before excavation. Lower inset: the associated trough before excavation.*

production of steam to manipulate timbers into shape. Rather than being a drain emanating from the trough, this deep, narrow curvilinear gully may have been constructed to contain split timbers or rods. Steam would then have been directed down the gully, softening the timbers, which could then have been bent into the shapes required for the production of circular roofs in round houses, etc. The production of boiling water in this process would have been easily achieved, and it would have been possible to create and vent steam down the gully by covering both the trough and gully with either sods or hides. This design of trough is not unique to Sligo; many other examples have been noted around the country, such as the four recent examples discovered in association with the M3 Clonee to North of Kells Motorway Scheme (Eoin Grogan, John O'Neill, Stuart Elder and Stuart Rathbone, pers. comm.). In addition to sealing associated *fulacht fiadh* features, this spread also sealed what the excavator believed to be a subsidiary wall of the main Neolithic drystone enclosure.

### The Magheraboy sites

Two definite *fulachta fiadh* sites (Magheraboy 1 and 2), the latter of which comprised at least two separate *fulachta fiadh* (Magheraboy 2A and 2B), and a third possible *fulacht fiadh* site (Magheraboy 3) were located in an area of marshland along the eastern margins of a localised concentration of peat (Fig. 3.5). The Magheraboy sites were just beyond the northern base of the Magheraboy ridge at an elevation of 23m OD. Magheraboy 1 and 2 were 60m apart; the more northerly of the two included the remains of two distinct *fulachta fiadh* within a confined area measuring roughly 18m by 15m. A possible *fulacht fiadh*, Magheraboy 3, was preserved *in situ* as it lay east of the roadtake within an area designated for landscaping. Archaeological works associated with the Caltragh Sewerage Scheme[1] revealed a burnt mound at Magheraboy 4 (12.5m east–west by 3.9m north–south by 0.24m high). No other features were discovered in association with this burnt spread. It lay to the south of Magheraboy, close to the townland of Caltragh, in marshland with a stream 10m to the north.

Excavation of the *fulachta fiadh* within Magheraboy 2D revealed a variety of different cut features associated with these sites. Magheraboy 1 comprised a burnt mound (13m by 13m and up to 0.2m high) that covered an array of pits and stake-holes as well as a deposit of ash. In all, fourteen pits were revealed, varying from circular to suboval in shape, and a number of these have been interpreted as possible troughs (Fig. 3.6). Despite being closely spaced, there was only a single instance where one pit truncated another. It is probable that they were not all in use at the same time, as this would have left little space for associated activities: it seems that they developed sporadically over the life of the site. Once a pit was abandoned, a new one was dug close by, indicating that the same people were using the site as they were aware of the existence of the disused pits. Many of the pits were similar in shape and scale and none showed signs of being recut: once a pit was abandoned it was not reused.

Two types of pit were present within the site: those with and those without associated stake-holes. The excavator has suggested that the former group contains the pits most likely to have functioned as troughs (Fig 3.6; Pls 3.1–3.3), while the latter group may have been employed as

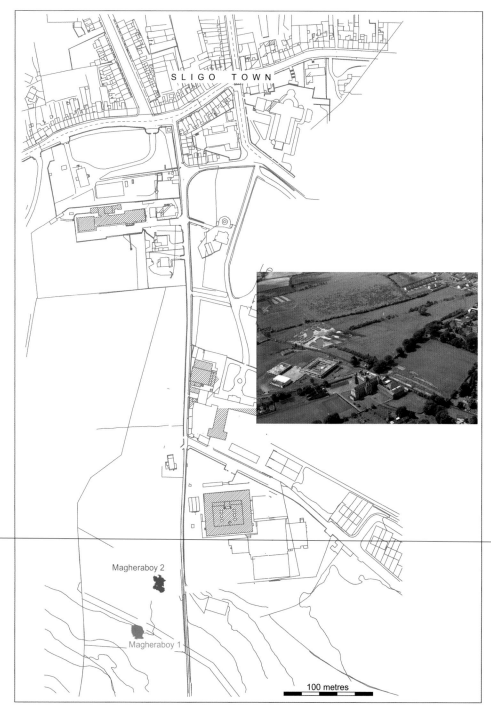

*Fig. 3.5—Magheraboy 1 and 2: location of* fulachta fiadh. *Inset: Magheraboy 1 (red) and 2 (blue), aerial view.*

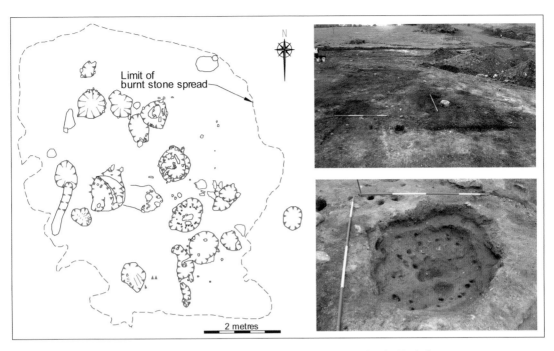

*Fig. 3.6—Magheraboy 1, post-excavation detail. Top inset: the* fulacht fiadh *before excavation. Bottom inset: the* fulacht fiadh *after excavation.*

hearths or as storage pits (McCabe, see CD). Although many of these pits did not display signs of intense *in situ* burning, they were nevertheless heat-affected. It is also possible that those with stake-holes were associated with boiling while some of the others may have functioned as roasting-pits.

Small quantities of knapping debris from stone tool manufacture in the form of cores and debitage, mainly chert but with some flint, were contained within a number of these pits, indicating that core reduction took place on site. The presence of point striking platforms among this material suggests a late Neolithic/early Bronze Age date for the assemblage (Guinan and Nolan, see CD). This was confirmed by dates from the burnt mound (2580–2200 cal. BC, Beta-194430) and from one of the underlying pits (2630–2450 cal. BC, Beta-194429). Although the date for the pit appears to be significantly earlier than the date obtained for the burnt mound spread, there is a considerable overlap between the two, possibly indicating a date for this activity of *c.* 2500 BC. The wood species used for dating the pit was oak, which can reach an age of 300–400 years, in comparison to the relatively short-lived hazel used to date the burnt mound spread. The 'old wood' effect must therefore be taken into consideration when discussing this date. For instance, if the oak used for dating was 100–200 years old at the time of burning, this would make it contemporary with the date obtained for the burnt mound.

Some pits had a large number of stake-holes cut into the base and around the outer edge. Those around the outside suggest the presence of a superstructure, possibly a spit or hoist for the insertion

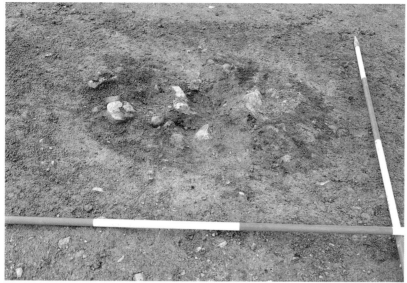

*Pl. 3.1—Magheraboy 1: a pit used as a trough (C45), before excavation, from east.*

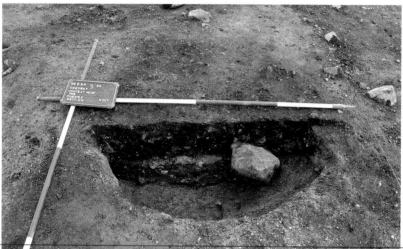

*Pl. 3.2—Magheraboy 1: one of the pits (C31) used as troughs, during excavation, from south.*

or removal of hot stones or meat (McCabe, see CD). Alternatively, these stake-holes may have supported a windbreak that would have afforded protection against the elements. The excavator also suggested that some of these pits could have formed part of a sauna or bathing area. As with the trough associated with Tonafortes 2, however, this is unlikely given the small size of the pits, *c.* 1m in diameter: a person would be extremely cramped in such a tight area, especially if there was a surrounding canopy. No trace of wood lining was evident within any of the pits but during the wet days of the excavation most held water naturally, while some contained evidence of a waterproof clay lining. Those containing the numerous stake-holes within the base may have had a wicker or timber lining secured in place by small stakes.

The partly levelled burnt mound at Magheraboy 2 also covered numerous pits (Fig. 3.7). These were quite different in size, shape and morphology from those associated with Magheraboy 1,

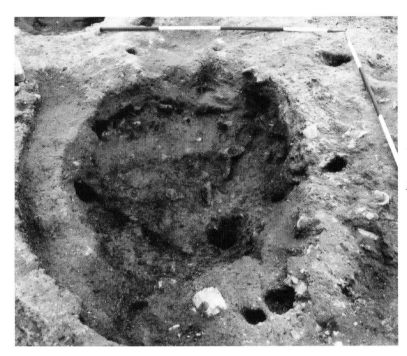

*Pl. 3.3—Magheraboy 1: a trough (C39) with associated post- and stake-holes, after excavation, from south.*

however. The mound (17m north–south by 13m east–west) consisted of black charcoal-rich soil mixed with frequent heat-shattered stones and survived to a maximum height of 0.3m. There were five possible troughs, pits and stake-holes, with further pits, including a hearth, beyond the mound on all sides. These features appear to relate to two distinct *fulachta fiadh* (Magheraboy 2A and 2B) that were situated in the same place but possibly separated by over 900 years. This is by no means a unique occurrence. Similar sites excavated in recent years contained more than one *fulacht fiadh* at the same location and were not contemporaneous: one example is Ballinaspig More 7, Co. Cork (E. Danaher 2004b).

While it was not possible to identify precisely to which *fulacht fiadh* all of the features at Magheraboy 2 belonged, a certain number could be separated stratigraphically, and radiocarbon analysis also assisted with the task. The older of the two sites comprised at least three if not four troughs, one of which, possibly an oven, showed evidence of *in situ* burning. An earth-cut hearth pit lay slightly to the east of these troughs. Several layers of hearth material, some of which were oxidised indicating *in situ* burning, occupied this pit and suggest that it was reused a number of times without being cleaned or recut. A relict stream (Fig. 3.7) situated to the north-east of these features would have been an ideal water source. The ergonomics of this site were excellent, with the hearth, troughs and water all within easy reach of each other. Three of the troughs associated with this phase were positioned contiguously in a north-east/south-west direction (Fig. 3.7; Pls 3.4–3.6). They shared a number of similar fills and appear to have gone out of use at the same time. A narrow band of subsoil separated each of the troughs, suggesting that the presence of one trough was known when a new one was dug. The excavator believes that these three troughs were used

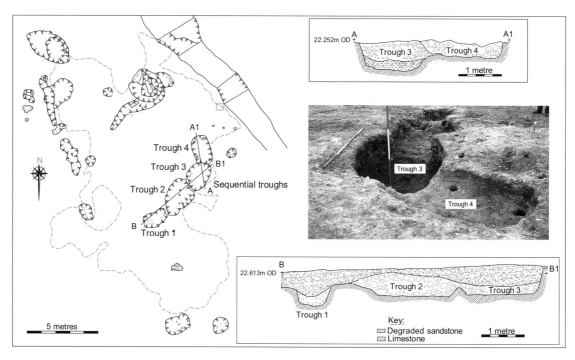

*Fig. 3.7—Magheraboy 2: troughs and other cut features. Most were located under the spread of burnt mound material. Top inset: section through troughs 3 and 4. Middle inset: sequential troughs after excavation, looking south-east. Bottom inset: section through troughs 1, 2 and 3.*

concurrently and that all would have held water naturally (McCabe, see CD). There was a group of stake-holes to the west of the northern trough, while stake-holes around the south-western trough may represent a superstructure overlying this feature; alternatively, these stake-holes may represent the remains of a leather or wicker lining that was pegged into place. A radiocarbon date of 2120–2090/2050–1890 cal. BC (Beta-194428) came from the hearth to the east of these features. It is thought that the troughs are contemporary with the hearth.

The trough (Fig. 3.7) of the more recent site truncated the most north-easterly of these three troughs, and radiocarbon determination from a charcoal sample returned a date of 1270–910 cal. BC (Beta-194427). This was shallower and more regular in shape, forming a subrectangle with a post in each of its four corners that would have supported pegs to secure the timber sides of the trough: none of this timber lining survived. A probable fifth trough was also present on site, and *in situ* burning suggests that it may have been reused as a hearth. This showed evidence for the restructuring of an earlier feature from a possibly narrow deep pit into a wider one, the base of which was lined with stones. These may have been bonded with clay to form a waterproof lining.

A burnt mound, Magheraboy 4 (12.5m east–west by 3.9m north–south and 0.12–0.24m high), excavated during the Sligo Main Drainage scheme close to the Caltragh valley did not contain any cut features (Henry 2002).

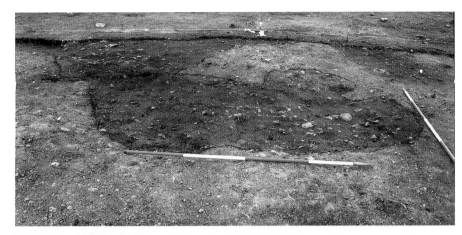

*Pl. 3.4—
Magheraboy 2:
troughs 2, 3 and 4
before excavation.*

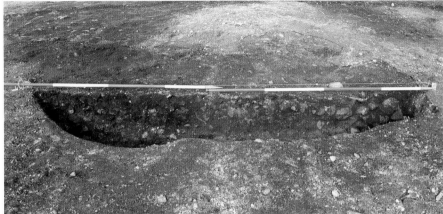

*Pl. 3.5—
Magheraboy 2:
east-facing section
through trough 4
cutting trough 3.*

## Function, construction and layout

The basic function of a *fulacht fiadh* was to provide hot or boiling water. To achieve this, three key elements were needed: firewood, stone and water. Archaeological evidence for the former two materials is present within nearly all *fulachta fiadh* and burnt spreads, while the location of these sites in wet areas accounts for the third. Where troughs are not present, however, it is possible that the burnt stone represents alternative functions such as roasting. Of course, the possibility of above-ground portable troughs cannot be ruled out in the instances where spreads of burnt mound material exist without subsurface troughs. Excavation of *fulachta fiadh* around the country has shown that a diverse range of troughs was used, ranging from simple unlined or clay-lined pits to wooden plank-lined troughs and stone-lined tanks. Dugout canoes were reused as troughs at Curraghtarsna, Co. Tipperary (Buckley 1990a, 5), and Killalough, Co. Cork (Cotter 2002). The digging implements, such as antler picks and shovels fashioned from ox shoulder bones, employed in creating many of the N4 SIRR subsurface troughs would not have been radically different from those used during the Neolithic.

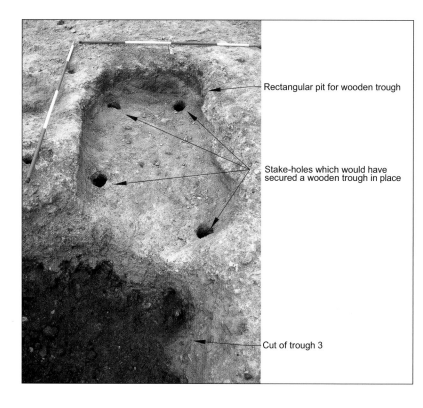

Rectangular pit for wooden trough

Stake-holes which would have
secured a wooden trough in place

Cut of trough 3

*Pl. 3.6—Magheraboy 2:
trough 4 after excavation,
looking north.*

Once the trough had been constructed and filled with water, the primary operation of the *fulacht fiadh* could begin. Although formal hearths have been identified at a number of sites around the country, they are not a very common phenomenon. These features must, by definition, include a defining edge around their perimeter if they are not to be confused with the more ephemeral or ad hoc fire-spots present on many site types. While the former examples signify a clear intention to build a fire at a specified location, the latter may be indicative of a more impromptu occurrence. Most hearths would probably have been placed close to the trough to allow for the easy transportation of the heated stones. Although very few formal hearths were identified during the excavation of the N4 SIRR sites, a number of examples were uncovered during the excavation of Magheraboy 2 and Caltragh 2. The absence of these features at other locations, however, may be a consequence of agricultural activity, with intensive ploughing accounting for the removal of many of the more shallow types of features on archaeological sites. Alternatively, some sites may never have contained formal hearths but may instead have favoured the more temporary type of fireplace. These types of hearth may have been ephemeral features that could possibly have been lit on the mounds themselves (generally the driest part of the site), leaving little or no archaeological trace. This process is exemplified by deposits of ash and charcoal, by-products of burning, which were located within the spreads of burnt mounds in a number of instances, such as at Magheraboy 1.

Analysis of the charcoal from the N4 SIRR sites shows that at least five species were used as

firewood: hazel, alder, blackthorn/cherry, willow/poplar/aspen and oak. The range of wood species includes larger trees such as oak and smaller species like alder and hazel, as well as scrub such as blackthorn/cherry. These four species demonstrate a varied environment, with oak and cherry indicating deep dry soils while hazel suggests thinner, wetter terrain and alder indicates wetter conditions. Blackthorn can be found along the edges of woodland or amongst hedges. All of this suggests the location of the *fulachta fiadh*, and the burnt mounds or spreads, at the margins between dryland and wetland, with the fuel being gathered from mixed woodland. The properties of both oak and hazel made them ideal constructional timbers, while alder was often used to line troughs. It is also likely that the species identified were probably available and closest to hand for use as firewood.

The stones within the burnt mound material consisted mainly of coarse quartzite with small quantities of limestone and coarse hornblende schist. Granite chips were also used within the burnt mound process at Caltragh (Caltragh 10). These rock types, in particular the quartzite, are found in *fulachta fiadh* in many parts of Ireland, while excavation has shown that coarse-grained rock types such as quartzite, granite and dolerite are very commonly used. The material is generally available as bedrock, or in the local glacial tills, and these rock types appear to function better in terms of the absorption and discharge of heat (Mandal, see CD, Area 1A, Tonafortes 2). Excavation of another burnt mound at Magheraboy 4, close to the Caltragh valley (Henry 2002), revealed that sandstone was the predominant stone; the closest known source of this material is along the Sligo–Leitrim border, over 10km to the north-east. The sourcing of this stone suggests that it may have been favoured over the local limestone and quartzite. From experimental testing of shatter variation in different rock types, Buckley (1990b, 172) concluded that drift-derived stones were most commonly used, with sedimentary rocks being preferred; experimentation also showed that igneous and metamorphosed rocks did not shatter as easily and were therefore very reusable, showing few signs of being fire-affected. After use the stones were removed from the trough and discarded close to the site, often forming a horseshoe-shaped mound, concentrated around three sides of the trough and nearby hearth.

## Operation and role

The precise role of burnt mounds is as yet not fully clear, though a divergence of opinion regarding the function of these sites has emerged amongst the academic community in recent years. As the quantity of excavations of this site type has increased rapidly in proportion to the onset of growth in developments, some of the results obtained have both altered and augmented more traditionally held beliefs. Three predominant hypotheses have thus emerged and, although the theories held are not mutually exclusive, have been the subject of ongoing debate.

The most commonly held view is that *fulachta fiadh* were cooking sites. The meat-broiling process involved the digging of a pit or trough that may have been lined with clay or timber (Buckley and Sweetman 1991, 88). This was filled with water, and stones were heated in a nearby

fire until red-hot. These stones were then placed into the water, bringing it to the boil. In 1952 O'Kelly (Buckley 1990a; Waddell 1998) demonstrated this process when a 4.5kg leg of mutton wrapped in straw was cooked in three hours and 40 minutes. After the meat was cooked, the burnt stones were removed from the trough and dumped on three sides of the hearth and trough, giving rise to the characteristic shape of the mound (Buckley and Sweetman 1991, 88).

Although the cooking hypothesis is the most widely accepted, it has come under increasing scrutiny because of the scarcity of food waste and artefacts associated with excavated *fulachta fiadh*. More recently, however, a growing number of sites have produced animal bone, such as Fahee South, Co. Clare (D. Ó Drisceóil 1988), and Curraheen 4, Co. Cork (Russell 2004a).

Alternative functions have also been proposed, including brewing, textile-processing and leather-working (e.g. Jeffrey 1991; E. Dennehy and L. O'Donnell, pers. comm.). Others, however, are of the opinion that there is little sustainable evidence to support these suggestions (e.g. D. Ó Drisceóil 1988).

A strong case for the interpretation of burnt mounds as prehistoric saunas or bathing places has been put forward by Barfield and Hodder (1987) after examination of numerous excavated burnt mounds, and they use ethnographical and historical evidence to support their argument. There are two main types of bath: dry-heat sweat baths and baths that use water to produce steam. The use of hot stones is the most common method of heat production in sweat baths. Stones heated in an open fire can be brought into simple tented structures with wooden tongs or can simply be rolled in. An alternative method is to light a fire, heat the stones, remove the ashes and then erect a structure covered with skins above the hot stones (Barfield and Hodder 1987). These steam or sweat baths were likely to have had a practical, ritual and social role.

An examination of the archaeological, literary, experimental and ethnographical evidence for the possible uses of these sites would suggest that cooking was the primary function, while bathing by immersion or sweating may have been a secondary activity. Although this suggests that the sites were multifunctional, some may have had a single role, i.e. either as a sauna or for cooking (see D. Ó Drisceóil 1998; O'Neill 2005).

## A wider perspective

While *fulachta fiadh* cannot be described as occupation sites, they may indicate settlement patterns. A wider picture of settlement in the Bronze Age may be gleaned from the more precise dating of settlement sites and *fulachta fiadh*, as is the case with areas such as Curraghatoor and Ballyveelish, Co. Tipperary, Carrigillihy, Co. Cork, and now Caltragh, Co. Sligo. The suggestion that *fulachta fiadh* are evidence for transient settlement appears to be untenable (Buckley 1990a, 7), though it is still widely believed that they were used seasonally in marginal areas. Grogan (2005b) has stated that these two explanations—(1) *fulachta fiadh* as indicators of Bronze Age settlement versus (2) the seasonal use of these sites in marginal areas—may not be mutually exclusive. Cooney and Grogan (1999, 141) propose that these sites may be part of an integrated system including domestic and

burial sites, as is evident in south Limerick, where 'a complex landscape organisation with extensive cemeteries, domestic sites and *fulachta fiadh* form an integrated pattern'. At Caltragh, houses, cremations and *fulachta fiadh* were all present within the valley, and the majority of these features were contemporaneous.

Connolly (2001) has suggested that spreads of burnt mound material at Darragh, Co. Clare, together with similar material from a number of sites in County Kerry, were spatially related to other monuments in the wider area, and in particular to embanked enclosures. In addition to having been associated with *fulacht fiadh* activities, these spreads may have had alternative or secondary functions related to the ritual connotations of the embanked enclosures/henge monuments. The possibilities are numerous: steam may have been created on a large scale for effect, water may have been boiled in movable containers for use in the enclosures, or, as Connolly (2001) tentatively suggests, the users of this technology may have 'walked on hot coals'. At Tonafortes 3 a similar spread of burnt material *c.* 100m south of the ceremonial enclosure was excavated as part of the N4 SIRR excavations by McCabe (see CD). It is not interpreted as a *fulacht fiadh* as no defining features were present, but it may have had a similar function to the spreads identified in Clare and Kerry by Connolly. Although no date was obtained for this spread, radiocarbon determination provided a date of 2400–2380 and 2360–2140 cal. BC (Beta-196297) for Tonafortes 2. This implies that this latter site was contemporary with the ceremonial enclosure, which produced a date of 2460–2140 cal. BC (Beta-199778). Whether all of these features within Tonafortes were associated with the same ritual activities can only be a matter of speculation, but it appears likely that they each formed component parts of the wider ritual landscape. Though the *fulachta fiadh* and burnt mound spreads were widely distributed across the study area, they were predominantly present in clusters close to other contemporary sites, such as the houses at Caltragh or the ceremonial enclosure at Tonafortes. None were discovered in isolation. This close spatial patterning of sites between *fulachta fiadh*, usually in clusters, and other potentially contemporary sites such as standing stones and habitation sites has been noted elsewhere (Grogan 2005a; O'Neill 2005), while it also implies the 'ordering of society and the management of the landscape' (Grogan 2005a).

Rather than being the cooking places of roving hunters, *fulachta fiadh* may reflect the distribution of more settled communities. If these sites are a feature of more permanent settlement, is there any way of knowing how many people would have used a particular site and what would have been its life-span? Excavation, as well as experimental archaeology, shows that the size of most troughs would allow the cooking of large quantities at one time. If large quantities of food were indeed cooked within the trough at each episode, the sites may have been used in communal, ceremonial or even ritual cooking rather than in everyday food preparation for small groups (D. Ó Drisceóil 1988).

The excavation of sixteen relevant sites within a narrow transect spanning 3.5km offers the chance to pose a series of questions. First, considering that half of the sites did not contain cut features, is the term *fulacht fiadh* too loosely applied when dealing with these spreads of burnt material? Second, do they all share a common function? Finally, are the clusters contemporary?

The post-excavation objectives of many *fulachta fiadh* sites focus on the technological aspects: how long it took to cook a particular type and quantity of meat in such a place under specific conditions, etc. When this is applied to some of the N4 SIRR sites, problems are encountered. As it is proposed that cooking may have been the primary function of many of the N4 SIRR sites, it is possible to give a very crude estimate of the minimum number of uses of these sites, based on the volumes of burnt mound material and the capacity of the trough. Likewise, this same process can be applied to the sites that are interpreted as saunas or bathing sites. The evidence used to ascribe a sauna or bathing interpretation is based largely on the type of trough construction and any signs of a superstructure directly associated with the trough. While these estimates are important in reconstructing the use of *fulachta fiadh*, this approach may detract from undertaking a wider approach to the study of these sites.

There are radiocarbon dates for nine of the burnt mounds and *fulachta fiadh* excavated in association with the N4 SIRR (Table 3.2). These show at least four separate periods of use, the earliest of which can be assigned to the final Neolithic/early Bronze Age. Apart from Tonafortes 2, Magheraboy 1 and 2 also produced early dates. Two charcoal samples from Magheraboy 1 were dated to the final Neolithic/early Bronze Age, while a charcoal sample from Magheraboy 2 produced an early Bronze Age date. A late Bronze Age date was also obtained for a trough associated with this site. Excavation of a cluster of *fulachta fiadh* and burnt mound spreads within the townland of Caltragh produced a range of dates spanning the Bronze Age. The earliest pertained to two burnt spreads, Caltragh 2 and 3, while burnt mounds Caltragh 1 and 10 and the *fulacht fiadh* Caltragh 5 all produced middle Bronze Age dates contemporary with the three houses also discovered within this townland (McCabe, see CD). Interestingly, of the six spreads and three *fulachta fiadh* excavated within Caltragh, these three dated sites (Caltragh 1, Caltragh 10 and Caltragh 5) were in closest proximity to the three houses, which further substantiates a direct association. Radiocarbon determination of the *fulacht fiadh* Caltragh 7 returned a late Bronze Age date.

## Comparative material

*Fulachta fiadh* and spreads of burnt mound material are both known throughout the country. While there is little variation among burnt mound spreads except in the type and size of the stone used, numerous types of troughs are evident and lightweight timber structures, pits and hearths form part of many *fulachta fiadh*. Here some comparisons are offered with the types of features identified in association with the eight N4 SIRR *fulachta fiadh*.

A suboval trough was associated with Tonafortes 2, Area 1A, and was dated to the final Neolithic/early Bronze Age. Three troughs of similar shape were also discovered at Magheraboy 1, one of which produced a late Neolithic date. Suboval troughs are known from numerous sites throughout the country; for example, at Rathbane South, Co. Limerick, a suboval pit was one of three troughs found within the site and contained a subcircular arrangement of stake-holes within its base (E. O'Donovan 2002). Excavation at Clare, Co. Mayo, revealed a suboval wooden trough

*Panel 3.1—The historic context of* fulachta fiadh.

## Historic references to *fulachta fiadh*

The terms *fulacht fiadh* and *fulacht fian* may have been in use in Ireland for over a millennium (D. Ó Drisceóil 1988). When translated, the word *fulacht* originally meant 'recess' or 'cavity' but later came to mean 'cooking place'. *Fiadh* can be translated as 'of the deer' or 'of the wild', while *fian* means 'of a roving band of hunters or warriors' or also 'of the Fianna' or Fionn Mac Cumhail, mythical figures of Irish folklore. The above terms are referred to in the literature of ancient Irish law-tracts prior to AD 800. Of the many references, one in particular stands out. Geoffrey Keating in *The History of Ireland*, written in the early seventeenth century, refers to the Fianna thus:

> 'And it was their custom to send their attendants about noon with whatever they had killed in the morning's hunt to an appointed hill . . . and to kindle raging fires thereon, and put into them a large number of emery stone; and to dig two pits in the yellow clay of the moorland, and put some of the meat on spits to roast before the fire; and to bind another portion of it with sugans in dry bundles, and to set it to boil in the larger of two pits, and keep plying them with the stones that were in the fire . . . until they were cooked. And these fires were so large that their sites are today in Ireland burnt to blackness, and these are now called Fulacht Fian by the peasantry.
>
> As to the Fian . . . each of them stripped off, and tied his shirt around his waist; and they ranged themselves around the second pit . . . bathing their hair and washing their limbs, and removing their sweat, and then exercising their joints and muscles, thus ridding themselves of their fatigue' (D. Ó Drisceóil 1988).

Keating's description of the cooking pit and cooking process matches the archaeological evidence. From the text, it is clear that cooking is the primary function of the site but that bathing also occurs. This dual function is referred to in other Irish texts. Keating's account sees the site as being used by hunters, but the large number of these sites and the density of their distribution cannot be explained by hunting alone. This would give us an abundance of evidence for hunting, with little evidence for the presence of more permanent settlement.

While these historic descriptions are interesting, the general absence of *fulachta fiadh* in the archaeological record of the period raises an even more fascinating aspect of the references. It is possible that Keating and others are relating long-preserved folk memories about sites that had long since gone out of use.

that was held in place at each end by a series of short stakes hammered into the underlying boulder clay (Zajac 2000). At Killoran, Co. Tipperary, the *fulacht fiadh* consisted of a suboval trough backfilled with burnt fire-cracked stone and charcoal that was partially sealed by a spread of burnt mound material (Stevens 2005). A suboval pit of similar morphology to the one at Tonafortes 2 was also excavated at Ballinaspig More 7, Co. Cork (E. Danaher 2004b). This was the earliest of three troughs within the site and was also dated to the final Neolithic/early Bronze Age.

Circular troughs are probably the least common type encountered, but there are still a large number of excavated examples. At Carrigrohane 1, Co. Cork, three circular pits, all covered by upstanding spreads of burnt mound material, were interpreted by the excavator as troughs (Murphy 2003). Two roughly circular troughs associated with a spread of heat-shattered stone at Ballinafad, Co. Sligo, were excavated within the Curlew Bypass Project (Channing 1998). Excavation at Castleview, Co. Cork, revealed two adjoining circular troughs; the smaller of the two had a diameter of 1.45m and a depth of 0.5m, while the larger had a diameter of under 2m and a depth of 0.24m. Both were stone-lined and linked with burnt mound material (McCarthy *et al.* 2000).

Subcircular troughs have been found on many sites. At Dromvane, Co. Cork (Tobin 2002a), for example, a subcircular trough was one of two troughs on the site, while a trough of similar shape occurred at Teadies Upper, Co. Cork (Tobin 2002b). At Flemby, Co. Kerry (Dunne and Dennehy 2002), there was a subcircular trough surrounded by a horseshoe-shaped deposit of burnt mound material. An oval trough at Caltragh 5 produced a middle Bronze Age date. At Deerpark East 1 an oval wood-lined trough occurred beneath a horseshoe-shaped mound (Gillespie 2003), while the Coolgariff, Co. Kerry, *fulacht fiadh* had an oval trough to the east of the mound (Kiely 2003) and a burnt mound at Site J, Richmond, Co. Tipperary, covered an oval trough (Murphy 2002).

Subrectangular troughs have been found on many sites throughout the country. At Derry, Co. Laois (Duffy 1996), three areas of *fulacht fiadh* revealed a pit-trough that measured 2.3m by 1.5m by 0.4m deep. A similar trough was also located at Mell 5, Co. Louth (Campbell 2002), where burnt mound material covered a number of pits, one of which was interpreted as a subrectangular trough (2.6m by 1.8m by 0.6m deep). The *fulacht fiadh* at Dooradoyle, Co. Limerick, had two subrectangular troughs. One was clay-lined while the other contained a stake in each corner, suggesting that it may have contained a small wooden frame (McConway 1998). At Farrendreg, Dundalk, Co. Louth, excavation of two *fulachta fiadh* revealed two troughs, at least one of which was subrectangular with dimensions of 3.6m by 1.2m by 0.8m (Bolger 2002). Within the townland of Ballinaspig More, the troughs unearthed at Sites 6 and 3 were both subrectangular, while two of the three troughs at Ballinaspig More 7 were also of this shape (E. Danaher 2004a; 2004b).

Two of the N4 SIRR *fulachta fiadh* revealed subrectangular troughs that contained timber post-holes in each corner: both were dated to the late Bronze Age. Apart from the Dooradoyle example mentioned above, similar troughs are abundant in the archaeological record. At Farrandreg, Co. Louth, a similar shallow trough with corner posts was excavated (E. Danaher 2003): a late Bronze Age date was also obtained for this feature. A shallow trough (2m long by 1.5m wide) with four circular corner post-holes was associated with a *fulacht fiadh* at Broadlough 2, Co. Louth (Seaver

2000). Similar examples have been discovered at Graigueshoneen, Co. Waterford (Tierney 2001), and Rathmore, Co. Wicklow (McLoughlin 2003).

Stake- or post-hole arrangements are a common feature of *fulachta fiadh*, with examples being widely distributed around the country. Leaving aside stake-hole arrangements within troughs, which may have been associated with wooden frames, many stake-holes within these sites did not form any discernible patterns, while others may have formed circular structures or fence lines/windbreaks. At Site 2, Coolfore, Co. Louth, a thin deposit of burnt mound material covered a network of nineteen stake-holes. These did not appear to form any coherent arrangement, though eight were found surrounding a discrete deposit of peat measuring 1.9m by 1.7m. This peat overlay the remaining eleven stake-holes (C. Ó Drisceóil 2002a). Located north of this site were a number of other *fulachta fiadh*, one of which (Site 3, Newtown-Monasterboice) contained 21 stake-holes that formed no clear pattern (C. Ó Drisceóil 2002b). At Kilnacarrig, Co. Wicklow, a large number of stake-holes, again not defining any recognisable plan, were found in association with one round and five rectangular wood-lined troughs; a large hearth and eighteen pits of various sizes and shapes occurred beneath the mound (Hayden 1995). At Gortnaboul, Co. Clare, a series of stake-holes appeared to form a fence line (windbreak?) to the west of the trough; a general scatter of smaller stake-holes was also identified (Hanley 2000a). A similar pattern of stake-holes occurred in the first phase of activity at Ballinaspig More 7 (E. Danaher 2004b).

Although fireplaces are frequently suggested as an integral component of *fulachta fiadh*, the physical evidence for such features is not always recovered from sites, possibly because they are often not represented by any formal feature or structure. Large numbers of excavated *fulachta fiadh* have produced fireplaces, however. Among the above-mentioned sites, Kilnacarrig, Farrandreg, Newtown-Monasterboice 3, Killoran, Ballinaspig More 6 and Ballinaspig More 7 all had traces of such features.

## Conclusions

The remains of sixteen sites representing evidence of burnt stone technology were discovered along the route of the N4 SIRR. All were sited within wetland, which is the typical location for these sites. Eight are interpreted as *fulachta fiadh* and the other eight as burnt mound material. While many of the sites were originally interpreted as *fulachta fiadh* during excavation, some have been reclassified here (see Table 3.1) as burnt mounds as they did not appear to have associated troughs. Although such troughs and other cut features may have been present outside the roadtake for some of the sites, this scenario cannot explain their absence in every case. On the *fulachta fiadh* most of the troughs and other cut features were either sealed or partly covered by the burnt mounds, with the sites occupying relatively small self-contained areas. It would therefore appear that some of the sites never contained earth-cut troughs, pits, post-holes or stake-holes, and, unless portable water-containers played the role of the subsurface troughs, these spreads may have had a different function. As mentioned elsewhere, hot stones have numerous applications and not all have

to be associated with boiling water.

The results of the dating analysis from this scheme, as well as from other road projects such as the N22 Ballincollig Bypass, are providing invaluable information on the origins and development of these sites. Consequently, our understanding of the chronological framework for clusters of *fulachta fiadh* has been altered dramatically. Rather than looking at the dates for sites in isolation, it is useful to place them within a broader geographical context including the immediate and wider environs. From these dates it is clear that Tonafortes, Caltragh and Magheraboy were considered to be suitable locations for *fulacht fiadh* activities and that these same areas were chosen time and time again from the late Neolithic/Beaker period right up into the late Bronze Age, a period in excess of 1,500 years.

The *fulachta fiadh* and burnt mound material that formed the clusters identified in Magheraboy, Caltragh and Tonafortes were not all in contemporaneous use, indicating that the appearance of these sites on the landscape would have been a slow process occurring over a long period of time. The broad range of dates may also suggest that they are not as firmly rooted within the second millennium BC as once imagined, while the large numbers of these sites suggest an increasing spread and density of activity (Cooney and Grogan 1999, 124). Evidence from an increasing number of sites such as Caltragh as well as a number of sites excavated in association with the Bord Gáis Éireann Pipeline to the West shows 'that *fulachta fiadh* form an integral part of the domestic landscape and were in close spatial proximity to settlement sites, and also in some cases to funerary and other ritual sites' (Grogan *et al.*, forthcoming).

The evidence for middle Bronze Age life revealed at Caltragh, comprising round houses, associated boundaries, cremation pits and numerous burnt spreads as well as *fulachta fiadh*, should enhance our understanding of settlement patterns. Of the various burnt mound spreads and *fulachta fiadh* excavated within Caltragh, the three sites in closest proximity to the three Bronze Age houses appear to have been contemporary, suggesting that they were components of a more permanent settlement pattern. Domestic cooking or bathing may have been the function of these three sites, while it is possible that Caltragh 6 may have featured in the production process of these three huts, with timbers used in the construction of the roofs of these round houses perhaps being fashioned at this site.

Caltragh 1 and 2 both included butchered bone within their mounds, while Caltragh 1 and Caltragh 10 were both of considerable size, suggesting either prolonged or intense use. Although no troughs were discovered in association with these mounds, the evidence would suggest that cooking was the principal use, particularly in light of the butchered bone. No animal bone had been discovered in any of the sites classified as *fulachta fiadh*; in relation to many of the burnt spreads, therefore, roasting the meat in a covering of hot stones may have been the preferred option. Aternatively, the meat may have been boiled in portable containers. The latter two sites were in close proximity to the three houses, with which they were probably contemporary, and it is feasible that the boiled water produced at these sites may have been carried to the houses in containers. Caltragh 8 and 9 further highlight the fact that spreads of burnt stone not containing associated features occupy the same locations as sites interpreted as *fulachta fiadh*, but whether they

were constructed for separate purposes remains unknown. Investigation of the small burnt mound at Tonafortes 3 suggests that this may have been formed on an ad hoc basis to satisfy a specific need at a particular time, as the site is more ephemeral in nature than any of the other burnt spreads found throughout the route of the N4 SIRR.

When comparing the *fulacht fiadh* evidence with the evidence from the burnt mound spreads, we can see that chronologically they span the same period while functionally they may only differ slightly, if at all. The activities within *fulachta fiadh* appear to have been carried out within the confines of a designated and possibly controlled area, while at the site of the burnt spreads some elements of the process, i.e. some of the hot stones, boiled water and cooked food, may have been carried away for use or consumption elsewhere, possibly the habitation sites that were located upslope from these wet areas.

At Tonafortes, by comparison, the *fulachta fiadh*, the ceremonial enclosure and possibly the burnt mound located south of the enclosure may all be associated with each other, forming component parts of the wider ritual landscape in this area. Although difficult to prove, the burnt mound sites in this area may have performed a ritual rather than a domestic role.

Magheraboy 1 and 2 provide an excellent case-study for *fulachta fiadh* activities, as highlighted by Figs 3.5, 3.6 and 3.7. At this wetland location two distinct and non-contemporaneous sites were positioned only 60m apart. Though these sites shared a number of parallels, they were remarkably different in other ways. The construction and shape of the troughs of the earlier Magheraboy 1 site were quite different to those within the more enduring Magheraboy 2. At the former site fourteen pits were revealed, varying from circular to suboval in shape, with five of these containing associated stake-holes within the base. Those containing stakes probably held some sort of timber or wicker lining and may have functioned as troughs, while the pits without stakes may have had separate functions as storage pits or hearths. The fourteen pits would not all have been present simultaneously and would appear to be sequential in nature: when an old pit was abandoned, a new one was formed close by. At Magheraboy 2 there were five mainly subrectangular possible troughs: as with Magheraboy 1, most of these appeared to be sequential in nature, but in these instances new troughs truncated older examples. As much as 900 years may have separated the first and last troughs in the sequence, suggesting that this site was returned to time and time again, with successive generations knowing exactly where the operational area of this site was and deliberately selecting the same area.

When comparing the troughs at these two sites, does the different morphology of these features suggest different uses? Are we observing a possible chronology of troughs spanning almost 1,500 years, with circular and suboval troughs being the earliest and rectangular examples with corner stake-holes coming later in the sequence? It is interesting to note that the only other dated suboval trough discovered on this scheme produced a late Neolithic/early Bronze Age date, while the other example of a rectangular trough with corner stake-holes was late Bronze Age in date. Investigation of similar troughs excavated elsewhere in the country would appear to confirm such a trend, though much more work is needed before this information can be regarded as truly conclusive.

# 4

# THE ARCHAEOLOGY OF TONAFORTES

## Introduction

Prior to archaeological testing, the only known site associated with the N4 SIRR was recorded within the townland of Tonafortes. This was a ceremonial enclosure or henge monument (Record of Monuments and Places (RMP) Site No. SL014-224). Testing revealed the existence of at least two *fulachta fiadh* and a spread of burnt mound material within the locale (see Chapter 3), and excavation showed that at least one of the *fulachta fiadh* was contemporary with the ceremonial enclosure.

## Location

The Tonafortes ceremonial enclosure is located in a low-lying drumlin valley at a height of 24m (79ft) OD. It lies in a hollow below the embankment of the existing N4 Sligo–Collooney Road and is overlooked by a small hill to the north-west. The surrounding landscape comprises the Ox Mountains to the south and south-east, Knocknarea to the west, Ben Bulben to the north and the Ballygawley Hills along the north-eastern horizon. The monument thus appears to be centrally located within a natural amphitheatre, enclosed not only by its bank but also by the surrounding landscape. In effect, this is an enclosed enclosure. In the embanked enclosure at Lisnalurg, just north of Sligo town, a similar impression is created by the construction of a smaller enclosure with a diameter of 75m within a much larger enclosure, 150m in diameter with banks almost 5m high and 20m wide. The small hill to the north of the Tonafortes monument overlooks the interior of the enclosure.

## The excavation

The site, first noted from aerial photographs, is recorded in the RMP for County Sligo as a 'ceremonial enclosure' (SL014:224) and has an overall diameter of approximately 85m. It consists of a circular central area, 45m in diameter, enclosed by two banks with an intervening ditch (Fig. 4.1). Archaeological test excavations carried out on the enclosure and its environs (Joubert 2003)

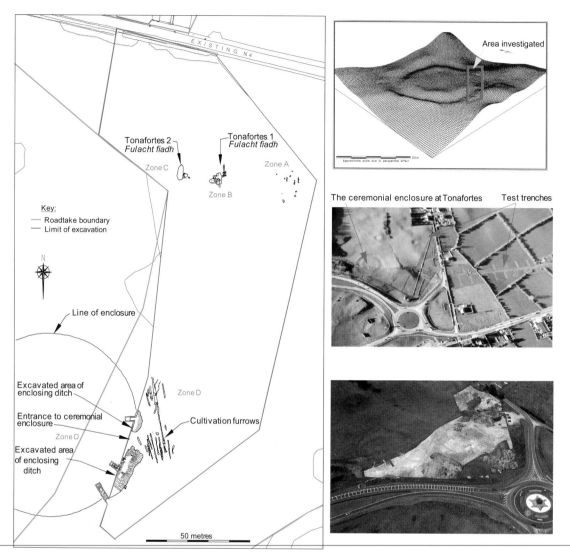

*Fig. 4.1—Tonafortes 1 and 2: the ceremonial enclosure and* fulachta fiadh. *Top photograph: Tonafortes, digital terrain model of the ceremonial enclosure (after Masterson 1998). Middle photograph: Tonafortes (Marcus Casey). Bottom photograph: Tonafortes, overview of the ceremonial enclosure and* fulacht fiadh *(Marcus Casey).*

revealed the dimensions of the banks and ditch, while a number of potential features were identified to the north and east of the enclosure. Prior to excavation the monument was used for pasture; its circular ditch was clearly discernible as a wide shallow depression accentuated by two low earthen banks that flanked either side, the outer bank being much more pronounced. A small number of corresponding gaps were noted within the ditches; the most pronounced occurred to the east of the monument.

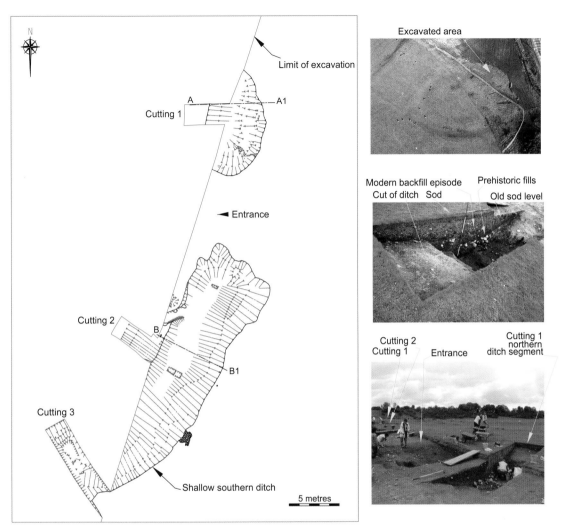

*Fig. 4.2—Tonafortes: the ditch of the ceremonial enclosure after excavation. Top photograph: the ceremonial enclosure. Middle photograph: view of northern section of ditch. Bottom photograph: the ceremonial enclosure during excavation.*

During this testing it was envisaged that around 40% of the monument was to be affected by the development; this was greatly reduced, however, and less than 10% of the entire enclosure was excavated, as the construction plan was altered to preserve more of the site. Consequently, only the eastern quadrant of this circular enclosure was stripped of topsoil. The excavation concentrated on the sections of the ditch to the north and south of the eastern entrance feature. The depth was considerably greater on the northern side of the causeway than on the southern side. To help elucidate the ditch morphology and subsequent depositional history, three extended cuttings, numbered 1–3, were placed across the ditch in order to provide complete profiles: two to the south

of the entrance and one to the north. The fills within the northern cutting fell into three distinct groups while only the upper two of these groups were present to the south.

### The entrance

The entrance comprised an 8.2m-wide causeway of undug soil between the ditch termini (Fig. 4.2). There were no other associated features. The morphology of the ditch differed greatly on either side of the causewayed entrance, although both sides shared a similar depositional history, with the exception of the basal fills present within the ditch to the north of the entrance. The ditch terminal to the north was steep-sided and, like the ditch in this area, was much deeper than the shallow southern terminal, where the sides sloped more gently and gradually gave way to the flat ditch base. It is possible that different working parties were responsible for the creation of these ditch sections and that this may account for the deeper northern ditch.

### The ditch to the north of the entrance, cutting 1

Cutting 1, to the north of the entrance feature, provided two complete profiles across this area of the ditch (Fig. 4.2). It was aligned radially to the centre of the monument, as were cuttings 2 and 3. Both faces of the section revealed a broad V-shaped ditch, 6.3m wide, 1.9m deep and containing fills that could be identified as three distinct groups (1, stony basal fills; 2, buried topsoil; 3, redeposited material; Fig. 4.3). The stony basal fills (C80, C81) appeared to be the product of rapid slippage from either unstable ditch sides or from the upcast bank. The absence of silting or any other deposits at the base of the ditch suggests that formation of C80 and C81 occurred shortly after ditch construction. Radiocarbon analysis of charcoal from C81 returned a date of 2460–2140 cal. BC (Beta-199778). These deposits were affected by surface-water gleys and consequent iron panning, which hampered the excavation. 'Gleying is a process by which waterlogging leads to the mobilisation and transport of iron in a soil. In this particular case, the ditch has acted as a sump for the surrounding land and the upper fills have become waterlogged. The water has drained down through the ditch fills, leaching iron from the upper stone-free soil layer and transporting it into

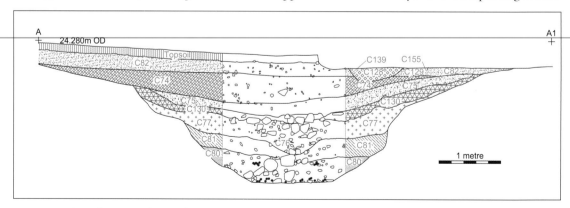

*Fig. 4.3—Tonafortes: south-east-facing section of cutting 1.*

the stony lower fills where the oxides have precipitated, creating widespread convoluted iron pans and zones of iron-impregnated sediment. This process has tended to obscure any pre-existing stratigraphy in the ditch and also made it hard to follow the ditch cut as iron pans passed through the position of the cut' (S. Carter, pers. comm.).

The exact cut of the ditch was eventually established, while some charcoal lenses towards its base were the only evidence for internal stratification. These stony (mainly sandstone) basal fills were only apparent in this cutting, although a similar but smaller event was evident in cutting 3. This may be accounted for by the greater depth of the ditch to the north of the entrance. A number of localised deposits (C78, C79, C76 and C148) consisting of concentrations of stones appear to be the product of rapid infilling. C148 returned a date of 1760–1610 cal. BC (Beta-196296). There are some difficulties in resolving the evidence of the radiocarbon dates from the ditch and these are detailed below (pp 49–50).

Sealing the basal fills throughout the excavated area was a grey stone-free layer (C75), the remains of buried topsoil. This horizon reflects a period of consolidation within the ditch and would have formed the grass-grown surface in the enclosure ditch until recent levelling buried it.

The uppermost ditch fill (C74) was a stony layer of compact brown-orange silty sand with a high stone content and moderate inclusions of post-medieval pottery, glass and iron. This appears to be the product of a deliberate effort to backfill the ditch, with much of C74 deriving from the levelled banks within this area. Prior to excavation there were no surviving banks in the eastern part of the enclosure, although they remained largely intact throughout the rest of the monument. This intentional levelling probably accounts for the absence of banks and the masking of the ditch in this area of the site. A number of cultivation furrows (C139, C155, C147, C150, C152 and C154) were cut into the upper ditch fill.

In summary, the stratigraphical sequence of the ditch to the north of the causewayed entrance suggests that, after it was formed, the sides and/or bank were slightly unstable, resulting in material rolling into the base of the ditch. This material contained small amounts of charcoal. Soon after, the sides and/or bank became stable and a topsoil layer began to develop. These events may have occurred during the final Neolithic/early Bronze Age or in the succeeding middle Bronze Age (see p. 50 below). The next verifiable event occurred during the post-medieval period when this area of the ditch was deliberately backfilled, perhaps to facilitate the subsequent cultivation of the area.

*The ditch to the south of the entrance, cutting 2*
Cutting 2 was positioned 12m south of the entrance. The profile of this portion of the ditch was a broad U-shape, 7.6m wide at the top, 4.8m wide along the base and 0.96m deep (Fig. 4.4). The peaty basal layer suggested particularly poor drainage conditions within the shallower sections of the ditch. The upper layers mirrored those in cutting 1, including an apparently lengthy period during which a sod layer developed within the ditch. These deposits were to remain largely undisturbed until the post-medieval period, when a number of field-clearance pits (C127, C144 and C118) truncated the ditch to the south of the causeway. These pits were in turn covered with

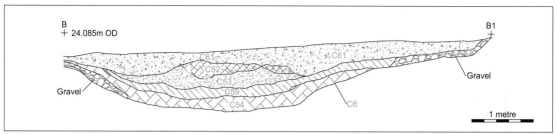

*Fig. 4.4—Tonafortes: south-facing section of cutting 2.*

deliberate backfill in more recent times. The basal layers within the ditch to the south of the entrance had an average depth of 0.2m, and these represent the sum of the prehistoric material accumulated in this area of the ditch. The radiocarbon dating of charcoal from these deposits proved inconclusive in terms of providing a construction date for the henge, however.

### The ditch to the south of the entrance, cutting 3

The excavation of cutting 3 was the second part of the investigation into the ditch south of the entrance. Owing to the nature of the area under investigation, only a slight portion of the ditch was exposed to the south, mainly the area along its eastern edge. Like the other two cuttings, it extended outside the roadtake in order to establish the complete profile of the ditch, which was 8.8m wide at the top, 3–5.2m wide at the base and 1.2–1.6m deep. The basal fills were largely intact and a sherd of prehistoric pottery and a concave scraper came from C142. A number of layers representing slight variants of the same events filled the ditch base. A large socket near the base on the western side appears to be a void created by the removal of a boulder that was prised out of position during the formation of the ditch; this was subsequently filled by a combination of slip material and silting. The surrounding bedrock showed signs of breakage that was probably contemporary with the removal of the boulder. Above this was a chaotic stony fill (C142), perhaps the result of an unstable ditch side or collapse from an upcast bank. Layers C135 and C136 were sealed by the *in situ* prehistoric sod layer C134. A field-clearance pit (C144) had cut through some of the ditch fills, including a sod layer (C134) that would have formed the ground surface of the enclosure in this area. The stone dump was subsequently sealed by a stony sediment (C138), after which a new sod layer (C132) formed. This was in turn buried during the post-medieval attempt to level this area of the site (C133).

### The enclosure banks

The outer and inner banks at Tonafortes were composed of the material removed during the digging of the ditch. Owing to the limited nature of the excavation it was not possible to determine why the ditch to the north of the entrance was twice as deep as that to the south. A large quantity of earth was required to construct the banks, and some sections of the ditch may have been dug deeper in order to provide this material. It is clear, however, that the lower part of

the ditch to the north of the entrance was soon filled by material possibly from the slumping ditch sides or the banks, and was by this stage no deeper than the southern section.

The outer bank at Tonafortes is much higher than the inner. Together they create an inward-looking appearance. It may be that these two terrace-like features were intended to accommodate people watching the proceedings in the interior. In effect, by acting as two rows, the banks may have held the 'audience' and provided excellent views of internal activities. Testing of the banks by Joubert (2003) revealed that they each averaged 8m in width and were separated by an intervening ditch with an average width of just over 7m. The outer bank, with an extant height of *c.* 500mm, currently stands nearly twice as high as the inner bank.

*Further features identified during testing*

Testing also revealed a possible cremation at the base of the ditch, not subsequently excavated. This consisted of possible pyre material—a mix of cremated bone, charcoal and dark soil—while the cremation appeared to have been associated with a spread of rounded and subrounded stones. Both features covered roughly the same surface area, 2.2m north–south by 2m east–west; as both features were left *in situ* their depths were not determined (Joubert 2003). A large number of potential archaeological features were revealed within the interior of the enclosure, including an undated cobbled surface, a pit with a diameter of 1.3m and a depth of 700mm, numerous deposits that may represent the deliberate raising of the ground level of the site interior, and a number of possible cut features (*ibid.*). Owing to the complex nature of the archaeology exposed within the trench excavated through the interior of the site, it was decided to postpone the excavation of these deposits until full resolution in 2003 (*ibid.*), but the adjustment of the design in order to preserve more of the site meant that these deposits were not investigated.

*Dating the enclosure*

Only nine lithics were retrieved from the ditch at Tonafortes; these consisted of scrapers, flakes and a chalk ball (Guinan and Nolan, see CD). Also recovered was a single sherd of plain coarseware pottery, found close to the base of cutting 3 (Gormley, see CD). This has been described as an undiagnostic body sherd and unfortunately does not help to date the site. As only a small portion of this site was to be investigated, one of the key objectives was to establish the construction date and the period of use of the enclosure. Five charcoal samples were selected for dating, two from cutting 1, two from cutting 2 and one from an external feature. Of the four radiocarbon determinations obtained from charcoal retrieved from the ditch, only two (2460–2140 cal. BC, Beta-199778, and 1760–1610 cal. BC, Beta-196296) are likely to date from the primary phase. Both came from the basal fills of cutting 1 and were originally believed to be associated with the rapid accumulation of ditch fill shortly after construction.

Each of the four ditch-fill samples selected for analysis returned a distinct date, which raises a number of concerns. Wood identification was carried out on twelve samples from this site and all produced very small amounts of charcoal, some inadequate for dating. The charcoal examined included oak, ash, hazel, alder, willow/poplar/aspen and blackthorn/cherry/plum. Originally three

of these samples (C148, C54 and C59) were chosen for dating; as they produced a very wide array of results, however, a fourth sample, C81, was selected, which interestingly produced an earlier date than the other three. C54 was the primary fill within cutting 2 and charcoal from it was identified as *Prunus* (blackthorn/cherry/plum), while the overlying C59 contained hazel roundwood of up to nineteen years of age at the time of felling. These two samples produced Iron Age (cal. AD 250–430, Beta-196293) and medieval (cal. AD 1300–1420, Beta-196294) dates respectively. While they derived from primary contexts, the shallow nature of the ditch fills within cutting 2 made them more susceptible to accidental intrusions and it is likely that they are the result of secondary activity.

As regards cutting 1, there is little to distinguish between the stratigraphic positions of the two earlier dates. Charcoal from C148 was identified as hazel and willow/poplar/aspen, while it was not possible to determine the species of charcoal from C81. Despite this a decision was taken to date this sample, as its secure position within the ditch fill offered the best opportunity to identify the construction phase of the site. Although the middle Bronze Age sample (C148) derived from a similar location, this material and the overlying sod were heavily affected by iron panning, which may have obscured any later intrusions. Nevertheless, it is also possible that the earliest date (obtained from C81) reflects residual material left over from a previous phase of activity. Charcoal from a pit outside the enclosure produced an early Neolithic date (4050–3960 cal. BC, Beta-196295), suggesting that this area may have been important to the people of the Cúil Irra peninsula long before the monument was constructed.

It is tempting, on the basis of site morphology, to suggest the interpretation of this site as a late Neolithic henge. Even at 90.4% probability (2470–2190 cal. BC), however, the date for C81 (Beta-199778) falls entirely within the early Bronze Age. It may be that this monument was a henge that appeared at the end of this tradition, or perhaps a type of ceremonial enclosure that was revived or reinvented in several periods of Irish prehistory (Gibson 2000; Grogan and Roche 2002). If the site was indeed constructed in the early Bronze Age then it is interesting to note that the next big milestone in its history may have come in the middle Bronze Age, a period that saw a re-emergence of circular ditched enclosures in Ireland. Combining the various strands of evidence available for Tonafortes and comparing it to the existing evidence for the broad span of Irish ceremonial enclosures may help to place this site within its proper context, or at least to limit the possibilities.

## The ceremonial enclosure: class and distinction

A wide variety of enclosures defined by banks, sometimes associated with internal ditches, occur in the prehistoric period. The size of the Tonafortes site suggests that it is not a barrow, a monument type primarily associated with burial. During testing, however, a possible cremation was identified within an area of the ditch not subsequently excavated (Joubert 2003). The absence of structural evidence or associated domestic debris also indicates that this was not an enclosed

occupation site. The site appears most likely to have been a ritual enclosure designed for large public gatherings to view or participate in ceremonies or festivities.

Leaving aside a variety of funerary enclosures such as barrows, ring-ditches and ring-cairns, as well as more exotic examples like radial stone enclosures, there are three chronologically very diverse expressions of this general site type in the Irish record (Gibson 2000; Grogan 2005b; Roche 2004; Roche and Eogan, forthcoming). While most emphasis will be placed on the first of these, the others will also be discussed.

### The late Neolithic (c. 2900–2500 BC)

During this period a variety of ceremonial enclosures were constructed, including embanked enclosures (sometimes referred to as henges), internally ditched enclosures and timber or post circles. The embanked enclosures of the Boyne Valley region form the core of this group and are characterised by their large size, with massive earthen banks derived from wide internal scarping, leaving a low domed interior (Stout 1991). Surprisingly, none of these sites is adequately dated: Monknewtown, Co. Meath, produced middle Neolithic evidence in the form of an unusual burial with a Carrowkeel bowl, and other, middle to late Bronze Age burials, but no evidence for the date of the enclosure itself (Sweetman 1976). A similar situation exists at Ballynahatty, Co. Down (Hartwell 1998), where the undated enclosure is centred on the small passage tomb and a number of small subterranean chambers associated with Carrowkeel pottery as well as Grooved Ware timber circles. Several other timber circles have been investigated recently at Knowth and Bettystown, Co. Meath, Whitewell, Co. Westmeath, and Balgatheran, Co. Louth (Eogan and Roche 1997; J. Eogan 1999; Phelan 2003; C. Ó Drisceoil 2003). The timber circles are well dated to the period *c.* 2800–2500 BC and most are associated with Grooved Ware pottery. Other clusters of possibly related sites in Ireland occur in the Fourknocks area of County Meath and the Boyle Valley in County Roscommon (Condit 1993), while Condit and Simpson (1998) have suggested other possible sites in counties Sligo, Clare, Cork, Kerry, Tyrone and Kilkenny.

Any discussion of what went on inside these enigmatic monuments cannot be attempted without first understanding the kind of activities and lifestyles that preceded them. The Neolithic in Ireland spanned a period of roughly 1,500 years, from 4000 BC to 2500 BC, and can be divided into three major phases: early (4000–3600 BC), middle (3600–2900) and late (2900–2500 BC). The communities of the first phase can be described as 'small and largely egalitarian . . . exploiting both domestic and wild resources' (Harding 2003). Settlement is represented by the numerous rectangular structures of the period discovered throughout the country (Grogan 2004). The collective burial deposits contained within the megalithic chambered tombs suggest local ancestor worship (Cooney and Grogan 1999). The large open earthworks of Magheraboy (see Chapter 6) and Donegore Hill, Co. Antrim, would suggest that these communities might also have been part of larger social groupings that congregated at these sites possibly on a seasonal basis. These causewayed enclosures provide the first evidence of people symbolically enclosing a space, a theme that would undergo various developments throughout subsequent periods (see Chapter 6).

The abandonment of these monuments at the beginning of the late Neolithic suggests dramatic

social change and coincided with the appearance of new types of material culture, particularly Grooved Ware, the first flat-bottomed vessels. A new range of stone and flint objects also emerged. At the same time the first henges were created, and this horizon also produced a number of related sites, including timber circles. It would appear that a new set of religious beliefs and practices replaced earlier ones (Harding 2003).

To date, three sites with similar characteristics to Tonafortes have been excavated. The enclosure at Dún Ruadh, Co. Tyrone, consists of a large circular burial cairn surrounded by a ditch and bank, and has been interpreted as a henge. The cairn is composed of a ring of stones and contains the remains of thirteen cist burials (Davies 1936; Simpson, Weir *et al.* 1994). Excavations of the hilltop enclosure at Longstone Cullen, Co. Tipperary, which has a diameter of 65m and encloses a standing stone as well as a number of barrows, revealed two cremation burials in small pits in the berm as well as a number of artefacts (P. Danaher 1973). The site produced Beaker pottery as well as a large Grooved Ware assemblage, although this was not in direct association with the enclosing features (Helen Roche, pers. comm.). At Balregan, Co. Louth, excavation in 2003 revealed a substantial quantity of Grooved Ware pottery in the ditch, which may have enclosed a stone circle (Ó Donnchadha 2003; Grogan and Roche 2005).

Many of the Irish enclosures appear to have pronounced connections with death and the past, and are often closely associated with passage tombs. There is a concentration of embanked enclosures on the east coast in the Boyne Valley area in the vicinity of the passage tombs. The Site A embanked enclosure at Newgrange encompasses a burial mound which is probably a passage tomb (Cooney 2000a). The Giant's Ring, Ballynahatty (Hartwell 1998), contained a megalithic tomb within its interior, while at Ballycarty in the Lee Valley, Co. Kerry, a possible henge is located close to a passage tomb, and nine other ritual enclosures have also been identified within this valley (Connolly and Condit 1998). In this regard it is interesting that the Tonafortes site is situated 2km east of the megalithic cemetery of Carrowmore.

A pattern whereby sites can be looked into from higher ground in their vicinity would appear to have had a bearing on location and is evident from the Boyne Valley sites. It is probable that only certain individuals would have been allowed access into the interior of these sites, suggesting that the 'construction and use of the enclosures represent an ongoing attempt to maintain the internal balance of social power but within a wider inter-regional context. In such a scenario the social elite pursue new ritual mechanisms in an attempt to preserve their dominance within the local communities by adopting more widespread trends through their existing contacts with areas such as the Orkneys, north Wales, and southern England' (Cooney and Grogan 1999).

These Irish sites have been most widely compared with British 'henges'. The word 'henge' comes from the Old English *stanhengen* or 'hanging stones', which was the ancient name for Stonehenge. Ironically, most henges do not contain stones; in fact, there are many types of henges. Henges can be defined as roughly circular earthworks with a bank surrounding an inner ditch interrupted by one or more entrances, but this definition is not all-encompassing. To aid definition, Piggott and Piggott (1939) divided these sites into two main groups, with subsequent subdivisions by Atkinson (1951). Class I henges have a single entrance and internal ditch. Class II henges have

more than one entrance and internal ditch. Class IA and IIA sites have two ditches, one on either side of the bank. Class IB and IIB henges have a single ditch located outside the bank. Classes IC and IIC are henges without any ditch, with the banks usually compiled of material scraped up from the interior. Using this model, most Irish henges are Class C henges, while Class I is the typical British henge, of which there are only a few examples in Ireland. On morphological grounds the Tonafortes enclosure appears to be a fine example of an internally ditched Class I site. While the use of the term 'henge' for a variety of middle to late Neolithic enclosures is common in Britain, however, this categorisation has not generally been applied to the Irish evidence (but see Condit and Simpson 1998), principally because monuments defined by banks, ditches, scarping or stone kerbs have a multitude of manifestations in Irish prehistory (see below).

The henge phenomenon endured for over half a millennium, gradually giving way to new developments and ideas in the Bronze Age. The dates obtained from a number of henge monuments excavated in Britain seem to indicate that none were constructed after 2600 BC. Their demise may have been brought about by a new set of beliefs and practices that were ushered in with the early Bronze Age (Harding 2003; Cooney and Grogan 1999). These new beliefs and practices are evident in the archaeological record in the form of single-grave burials, often with associated artefacts (Waddell 1990). The tradition of single burial was not a new phenomenon connected to the early Bronze Age but had originated in the fourth millennium BC. The number of people being buried in this fashion greatly increased from around 2200 BC, however. Single burials mark a shift in focus from communal monuments and rituals to those based on the individual, where grave-goods were often used to denote status (Harding 2003). With the emergence of a new society, the rituals and practices associated with henge monuments like that at Tonafortes were soon to be consigned to memory.

## *The late Neolithic enclosures: role and function*

It is apparent that there were close associations between Grooved Ware pottery and henges. 'A number of researchers have discussed the relationships between the tombs and the emerging Grooved Ware associated complex in Britain, and especially in the Orkney Islands from whence the Maesmore-type macehead deposited in the right-hand chamber of the eastern tomb at Knowth was imported (Eogan and Richardson 1982); other suggested connections include aspects of megalithic art (Eogan 1986; Eogan and Roche 1997; O'Sullivan 1986; 1993a; 1993b; 1998; Brindley 1999, 134–8), and especially the adapted use of passage tomb sites' (Grogan and Roche 2005). At Knowth, Grooved Ware was associated with a timber circle close to the eastern passage tomb at Site 1 (Eogan and Roche 1997). Cooney (2000a) suggests that the evidence from Knowth parallels a pattern that occurs 'at other centres of monumental and ceremonial activity in Ireland and Britain. The tradition of building henges and wooden circles creates a link with contemporary core areas in Britain such as Orkney, southeast Scotland, Cumbria, Yorkshire and Wessex.' These monuments and their associations may represent a profound break with the past. Fundamental to the religious ideas of this period was the circular world (Bradley 1998). The shape of these monuments and their symbolism may have originated in the concepts of renewal, reproduction and rebirth. Therefore the circle was

not just a feature of design but represented spirituality and all that it conveyed.

At least ten enclosures of so-called hengiform type have been investigated in Ireland to date. Grooved Ware was discovered in four: Ballynahatty, the Grange Stone Circle, Lough Gur, Co. Limerick, Longstone Cullen, Co. Tipperary, and the recently excavated Balregan in Co. Louth (Ó Ríordáin 1951; Roche 2004; Ó Donnchadha 2003; Grogan and Roche 2005). Beaker pottery came from three: the Grange Stone Circle, the pit circle at Newgrange (Sweetman 1985; Cooney and Grogan 1999) and the hilltop henge at Longstone Cullen, Co. Tipperary (Helen Roche, pers. comm.). It should be noted that the Grooved Ware and Beaker pottery at Grange were residual and that only very small quantities of Beaker pottery were recovered from the Newgrange circle.

As previously mentioned, the scale of these monuments varies enormously. The size of the enclosed space may reflect the number of people who gathered there. Many of the larger sites are located within areas of established Neolithic activity such as Sligo and Meath. Referring to several henges in Yorkshire, Burl (1997) states that the slightly ovoid central plateau of each of these sites, which vary from 92m to 97m in diameter, could accommodate as many as 2,000 people. At Tonafortes the overall diameter of the monument is over 80m, but the enclosed area where ceremonies/rituals were likely to have taken place is restricted to 45m in diameter. By Burl's calculations the enclosed area of Tonafortes could have contained over 400 people. As mentioned, access to these sites, as with the preceding megalithic tombs, may have been restricted and controlled by a social élite. Rather than congregating inside the enclosure, crowds may have assembled on the banks to view the proceedings conducted within. The flat-topped bank of the Giant's Ring, Ballynahatty, may be used to add credence to this proposal.

If the variation in henge design reflects a variety of functions, then what can these functions have been? The outer bank and inner ditch argue against any notion that these may have been defensive sites. In addition, they rarely occupied defensive locations, being mainly sited in low-lying areas that were often overlooked by areas of higher ground, as is evident at Tonafortes. The entrances were often quite wide, over 8m at Tonafortes, and did not contain gateways. Therefore this site was unlikely to have contained livestock. Their design might suggest that the builders were trying to keep something in—not animals or people but rather the 'dangers and feared ideas, spirits or experiences associated with untamed nature' (Harding 2003). Rather than enclosing the living, henges may have been an attempt to contain the spiritual, and may have been the setting for various sets of religious beliefs and practices. The deliberate enclosing of this space may have been intended to protect the spiritual from the corruption of the outside world. Many of these sites underwent various alterations and additions, with circular structures of wood and stone being inserted into the interior of some. These may have had spiritual or astronomical connotations.

It is as ceremonial enclosures or ritual sites that these monuments seem most compelling. The very nature of these sites dissociates them from the daily chores associated with an agricultural lifestyle or the need for defence. Instead, the unnatural way in which the area is enclosed focuses special attention on it.

The spread of these monuments throughout Britain and Ireland suggests a possible change to a new belief system, one that may no longer have been centred on localised notions of ancestry.

Based on the available radiocarbon evidence Harding (2003) suggests that the adoption of henges in widely distant regions appears to have been rapid. This does not necessarily imply that people's lives changed overnight, however, but rather that a new set of religious beliefs and practices was becoming increasingly popular. More radiocarbon dates relating to the construction phase of these sites are needed to allow for a better understanding not just of their spread but also of the possible embracing of a new world-view. Cooney (2000a) offers a different opinion on the processes responsible for the shift in monumental emphasis. Rather than being the product of a new cultural scene or the movement of people, the switch from one monument type to another may reflect a new ceremonial focus or possibly a different range of contexts. Referring to the sites within *Brú na Bóinne* (the Boyne Valley, Co. Meath), he suggests that henges had more to do with the activities of the living, as indicated by the entrances and control of movement, with a possible change in emphasis from the private interior world of the tombs to the open outdoor arenas of the enclosures. The builders of these henges appear to have been concerned with the past and paid particular attention to the passage tombs, possibly 'tapping into the power of ancestral monuments' (Cooney 2000a). The basis for authority may have been formed by the location, construction and use, as well as the control of movement, associated with these large enclosures (Cooney and Grogan 1999; Cooney 2000a).

## Tonafortes as a late Neolithic embanked enclosure

Although a late Neolithic date was not established for this site, it would not be prudent at this juncture to rule out the possibility that it was indeed an embanked enclosure/henge monument, particularly in light of the above evidence. Morphologically Tonafortes has most in common with Class I British henges, while its setting is typical of many of the Boyne Valley embanked enclosures. The close proximity to the passage tomb cemetery at Carrowmore reflects the associations between the embanked enclosures and the passage tombs in the Boyne Valley. While Grooved Ware pottery was not discovered at Tonafortes, a chalk ball, frequently associated with the Grooved Ware tradition, was discovered at the site and may hint at a late Neolithic date. The presence of this chalk ball, an artefact type that is closely associated with passage tombs, may also suggest a link with the nearby Carrowmore megalithic cemetery, where a number of these items were discovered during excavation (Burenhult 1981).

## The early Bronze Age (c. 2400–1600 BC)

While there are no manifestations of these site types in the early Bronze Age, it is interesting to note that during testing (Joubert 2003) a probable human cremation was uncovered within the ditch of this monument. This, coupled with the early Bronze Age date obtained for a basal fill from cutting 1, may imply that the site functioned as a barrow, a site type that was first introduced during this period. Given the morphology of the site, however, and bearing in mind the later intrusive burials discovered at sites like Monknewtown, this scenario is unlikely. Nevertheless, it is worth considering that this site may have come late in the sequence of embanked enclosures, but if so it would be the first such instance.

## *The middle–late Bronze Age (c. 1600–800 BC)*

There was a renewed phase of ritual enclosure construction in this period, and sites include the embanked stone circles at Grange and Circle O, Lough Gur (Ó Ríordáin 1951; Roche 2004; Grogan and Eogan 1987), and most probably other sites of this type such as Ballynamona, Co. Limerick, and Castleruddery, Co. Wicklow. At Grange there had been a long sequence of activity, possibly of a ritual nature, beginning in the Neolithic, but the enclosure itself was not constructed until the late Bronze Age. Another complex monument at Lugg, Co. Dublin, also produced evidence for activity, including burial, that pre-dates the erection of the enclosing bank and ditch (Kilbride-Jones 1950; Roche and Eogan, forthcoming). There are a growing number of middle to late Bronze Age enclosures defined by ditches (but lacking any surviving evidence for associated banks), such as Lagavooren and Kilsharvan, Co. Meath (Clarke and Murphy 2002; Russell and Corcoran 2002). A sequence of circular ditched enclosures at Rath, Co. Meath (Byrnes 2004), are dated to the middle Bronze Age. While not specifically funerary, the enclosures were used on occasion for burial, with the cremations forming a series of structured and manipulated deposits in the ditches. Burial also formed a component of the activity at Johnstown South, Co. Wicklow, which had a sequence of middle to late Bronze Age activity within an enclosure defined by an earth and stone bank (Fitzpatrick 1998). With large numbers of middle to late Bronze Age enclosures, which differ greatly in size and morphology, having been identified throughout the country, it would be quite easy to place Tonafortes within such a context, bearing in mind the middle Bronze Age date from cutting 1.

## *Iron Age*

There was a re-emergence of these features during this period, with enclosures such as Emain Macha (Navan Fort), Co. Armagh (Waterman 1997), and other related sites such as at Tara and Raffin, Co. Meath (Grogan, forthcoming; Newman 1993a; 1993b), and Dún Ailinne, Co. Kildare (Wailes 1990). Though a late Iron Age date was returned for a charcoal sample from cutting 2, this is unlikely to relate to the construction phase of this monument but may suggest that the site had an appeal for the people of this region in the Iron Age.

## *Associations with water*

There is a small seasonal pond to the south-west of the Tonafortes site. Water is associated with a number of such monuments. Many ceremonial enclosures are located close to water, and the ditches of many henges may have contained water for long periods of the year (Harding 2003). The peaty basal deposit from the ditch to the south of the entrance would suggest that this is also the case at Tonafortes, although the better-drained ditch to the north would not have held water for any length of time. Richards (1996) has suggested that the ditches of henges in Orkney were designed to be water-filled in order to create, in microcosm, the land–water relationship of the wider landscape. A number of Irish ceremonial enclosures, such as Knockadoobrusna and Ballinphuill, encircle ponds or springs. The interiors of a number of sites have been shown to retain water for short periods. The water associations of the ceremonial enclosures at Flemby and

Caherweesheen, Co. Kerry, provide additional evidence to suggest that some Irish sites are associated with a water cult (Connolly and Condit 1998). Condit (1997a) has also suggested that a number of ponds, possibly associated with embanked enclosures, in *Brú na Bóinne,* Co. Meath, were deliberately created. Cooney (2000a) proposes that there appears to be a strong link between henges and the power of water. At Tonafortes a second pond was located *c.* 120m north of the site; this was flanked by two *fulachta fiadh,* one of which was dated to 2400–2380 cal. BC and 2360–2140 cal. BC (Beta-196297).

### The ceremonial enclosure: comparative archaeology

When compared to the numerous types of ceremonial enclosure discussed above, morphologically the monument at Tonafortes is most similar to the classic British henge. In total, there are over 120 sites that are collectively referred to as henge monuments within Britain and Ireland (Harding 2003). Most of these are of the internally ditched variety, which are mainly confined to certain regions of Britain. In Ireland embanked enclosures are the most common type and are located in small clusters throughout the country. When attempting to classify field remains, one of the greatest difficulties lies in differentiating between large barrows and ritual sites that are likely to have functioned as henges (Condit and Simpson 1998).

Although only a small portion of the site was excavated, it appears that Tonafortes is a ceremonial enclosure, although the conflicting radiocarbon data and the absence of other associated material prevent a clear conclusion about its date or the duration of its use. The monument was located in a setting typical of many Irish embanked enclosures—deliberately situated in a low-lying area overlooked to the north by a small hill, possibly an attempt to control who viewed the activities within the enclosure. The location, construction and subsequent use of this site may have been an attempt by a social élite to preserve their dominance in the local community by means of adopting new trends through their various contacts with certain regions of Britain (Cooney and Grogan 1999). The excavation revealed very few traces of human activity, which suggests that the monument was largely left alone following its creation. These findings were further substantiated by the micromorphological analysis of the soil taken from the ditch, which revealed no detectable traces of prehistoric activity in the ditch fills. More often than not, even when a site presents little coherent evidence there is 'background noise' in terms of low-level traces of human activity (Lancaster, see CD). These were not present in the thin sections from Tonafortes. It would appear, therefore, that the site may have had a short life-span following its construction.

So where and how does Tonafortes fit into the overall spectrum of such sites in Ireland? While it has been indicated that late Neolithic ceremonial enclosures are associated with passage tombs in Ireland, it is surprising that only three such sites are known from Sligo, given the large quantity of passage tombs in the county. The location of Tonafortes, the only internally ditched enclosure of the three, suggests that it forms part of a wider ritual landscape, particularly in light of the N4 SIRR excavations. It is one of three Neolithic enclosures investigated within a narrow transverse that stretches from the townland of Tonafortes to the townland of Magheraboy—a distance of *c.*

3km. The earliest of these was the early Neolithic causewayed enclosure at Magheraboy (Chapter 6), while south of this was a possible stone-walled enclosure of undetermined Neolithic date at Caltragh (Chapter 5). While numerous ritual monuments are present within the landscape, many others that no longer show any surface expression may lie undiscovered. A large number of prehistoric monuments occur within a 4km radius of Tonafortes, including passage tombs, ring-barrows, bowl-barrows, megalithic structures, undated enclosures, earthworks and possible hut sites. Many of these are ritual in nature and form part of a wider ritual monumental presence within the Cúil Irra peninsula. It is probable that the ceremonial enclosure at Tonafortes was an integral part of this ritual landscape. Pryor (2003) has observed that causewayed enclosures often give rise to ritual landscapes that include a wide variety of late Neolithic and Bronze Age ceremonial sites, including henges, barrows and other 'shrine-like places'.

Tonafortes, like most ceremonial enclosures, was built as a ritual centre. What these ceremonies and rituals entailed will never be recreated and are now the forgotten customs of these once-sacred places. These monuments had other connections, as Burl (1997, 55) surmises:

> 'The axe, the sun and moon, funerary rites, timber rings and stone circles, articles buried in chosen places, enclosed spaces for seasonal ceremonies, all are aspects of henges in a tradition that endured for over a thousand years'.

## Conclusions

Enclosed by low, wide inner and outer banks (the inner being much less pronounced than the outer) and an intervening ditch, the morphology of this monument is somewhat unusual in this region. Though it has an overall diameter of 85m, the enclosed circular central area has a diameter of just 45m, with the enclosing features occupying the remaining space. The perceived role of the ditch and banks was to focus attention on the enclosed space; unfortunately none of the interior was excavated, with site investigation being limited to small areas of the ditch both to the north and south of its eastern causewayed entrance. Test excavations in 2001 revealed a number of interesting features, such as a possible cremation at the base of the ditch, but owing to a change in road design these were not revisited. Excavation in 2003 focused on an area east of the 2001 investigations and unearthed little in the way of a diagnostic assemblage, while the dating programme also proved inconclusive, with four conflicting radiocarbon dates being obtained for the site.

Having explored the various manifestations of ceremonial enclosures evident from the Irish archaeological record and the lack of evidence to tie the Tonafortes enclosure to one particular type, two are worth highlighting. Though there is no late Neolithic evidence for Tonafortes, morphologically this site has most in common with Class I British henges, while its setting is typical of many of the Boyne Valley embanked enclosures. On the other hand, given the middle Bronze Age date from this site, Tonafortes could easily be placed in such a context, particularly in

light of the large numbers and variety of middle to late Bronze Age enclosures evident throughout the country. Irrespective of date, it is worth remembering that Tonafortes was a ritual site, the construction of which was deemed fundamental to the new religious ideas of the time. Central to this was a need to create an artificially enclosed space, which facilitated a tradition of enclosure in the area.

# 5
# THE ARCHAEOLOGY OF CALTRAGH

## Introduction

The townland of Caltragh contained the largest concentration of archaeological features encountered along the N4 SIRR. These were predominantly prehistoric in date, spanning almost two and a half millennia from the middle Neolithic to the late Bronze Age. All were located within what can be described as a wide shallow valley opening to the west, which is delineated to the north by the ridge at Magheraboy and to the south by a smaller ridge. Much of the valley is poorly drained marshland, the remnants of a prehistoric lake; the eastern shoreline of this relict lake rises to good dry soil and most of the features were uncovered within this area. These features include a possible megalithic tomb, a Neolithic enclosure of drystone construction, Neolithic and Bronze Age cremations, a flint-knapping area, three *fulachta fiadh* as well as numerous spreads of burnt mound material, and three round houses of middle Bronze Age date together with associated boundaries (Pl. 5.1). A possible ring-barrow is sited just west of the roadtake at this location.

The name Caltragh comes from the Irish *ceall trach*, meaning the burial-ground or graveyard. The 1837 and 1883–4 OS maps highlight a large pagan burial that was called or referred to as the 'Calteagh'. It would appear, however, that this burial was not located within the townland of Caltragh but 400m east of the nearby Carrowmore megalithic complex.

## The possible megalithic tomb

Initial investigations carried out in the Caltragh valley between 2000 and 2001 (Joubert, see CD) revealed extensive archaeological features and deposits. Further excavations were carried out in 2003 (Linnane and McCabe, see CD). One of the sites that constituted part of the earlier investigation, known as Field G (01E0395 ext.) (Joubert, see CD), produced numerous features, among them two separate concentrations of boulders comprising three stone sockets and 28 boulders. These concentrations were interpreted as a possible unclassified megalithic tomb dating from the Neolithic. Its morphology was not established as it extended outside the eastern limits of the roadtake, while modern disturbance had damaged the area investigated (Joubert, see CD). In addition to the 28 boulders, nine undisturbed natural boulders helped form the structure, and it

*Fig. 5.1—Caltragh: boulders of the possible megalithic structure.*

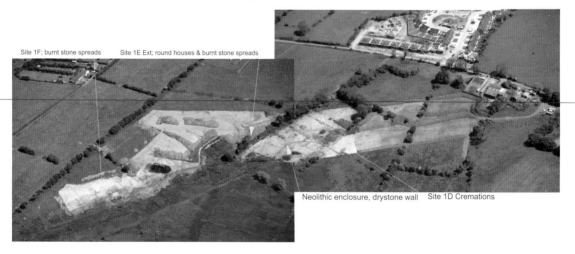

*Pl. 5.1—Overview of Caltragh.*

would appear that the builders of the tomb incorporated these stones into their design. Ó Nualláin (1989) has recorded 128 megalithic tombs in Sligo, of which 23 are unclassified. 'Unclassified megalith' is a term usually reserved for monuments that are in a poor state of preservation or completely overgrown and cannot be classified without excavation. Disturbed tombs are more difficult to classify, however, and it would appear that the Caltragh example was heavily damaged (Joubert, see CD). Figure 5.1 and Pls 5.2 and 5.3 illustrate the extent and layout of concentration 1. The construction of two boreens during the post–medieval period may have damaged this monument (Joubert, see CD).

Seventeen large boulders and two large stone sockets comprised concentration 2, which covered an area measuring approximately 150m². Some of the boulders from concentration 2 were localised on and around a low man-made mound, while a line of boulders linked this area with concentration 1 (Fig. 5.1). The flat-topped mound consisted of several deposits averaging 0.4m in height and overlay the boulder clay (Pl. 5.3). It formed an oval to subcircular shape in plan, measuring 5m east–west by 4m north–south, and was sealed by a stone spread; a Neolithic cremation pit was cut into it.

*The Neolithic cremation*

One possible and two definite human cremations were each located beside a boulder associated with the probable tomb. The earliest of these consisted of a small oval pit dug into the mound slightly west of the centre. The cremation contained two fills: the upper consisted of a possible token deposit of pyre material (charcoal, cremated bone and soil), while the lower comprised a flint hoard. Analysis of the 125 small fragments of bone showed that it was efficiently cremated and deliberately crushed, and it has been interpreted as a token deposition (Buckley, see CD). Charcoal from this deposit was dated to 3491–3039 cal. BC (UCD-0247). The underlying hoard consisted of fifteen flint flakes and one chert flake, many of which were stacked on top of one another. Analysis of this material identified the flint as knapping waste deriving from a single block of raw material imported from County Antrim (Milliken, see CD). It is possible that their association with the cremation conferred a new symbolic role on these flakes.

*Table 5.1—Details of the cremation.*

| No. | Context | Individuals | Weight | Pyre temp. | Type of bone | Date (cal. BC) | Artefacts |
|-----|---------|-------------|--------|------------|--------------|----------------|-----------|
| A | 196 | ? | G | Efficient cremation at high temp. | Bone crushed after cremation | 3491–3039 | 1 chert + 15 flint flakes |

The other definite cremation associated with the tomb contained the remains of two individuals together with sherds of late Bronze Age pottery (this cremation will be dealt with in greater detail below). As a result the excavator has suggested that the monument was in use, at least intermittently, for 1,500 years (Joubert, see CD).

*Pl. 5.2—Caltragh: concentration 2 of the megalithic structure from the north-west.*

## Discussion

The presence of the natural boulders in the immediate vicinity of the site clearly influenced the choice of location for this monument. The roughly east–west alignment of these boulders would have facilitated both the construction of the monument and its alignment in a similar direction. This would contribute to the ad hoc nature of the monument, whereby its builders manipulated the local resources and demonstrated a certain degree of opportunism in constructing this particular tomb (see Cagney 2004, 7). While the megalith at Caltragh has, to date, no obvious parallels, it may be interpreted as a form of hybrid of the known monument types dating from this period, i.e. court tombs, portal tombs and passage tombs (Cagney 2004). The presence of the nearby Carrowmore megalithic complex to the west of this townland may lend credence to this supposition.

Over 1,500 megalithic monuments are recorded in Ireland and of these 200 are unclassified (Waddell 1998). In the Neolithic these monuments were associated with multiple functions, foremost amongst which was the burial of the dead. Evidence for cremation, inhumation and a combination of both of these burial rites has been retrieved from the excavated examples. There can be no doubt about the visual impact that these imposing monuments had on the landscape. 'The erection of a monument such as a tomb creates a virtually indestructible kind of claim to the possession of the land validated by the preservation within it of the bones of the ancestors . . .' (Mitchell and Ryan 2001, 164).

As the Caltragh megalith appeared to have been heavily disturbed, there are few close parallels for it; however, tombs that utilise existing resources such as bedrock outcrops are known from, for example, Ballycarty, Co. Kerry (Connolly 1996), and Ardara, Co. Donegal (Cagney 2004). At Ardara the removal of the large capstone of an unclassified megalith exposed a roughly oval chamber composed of numerous boulders set into the subsoil, partly enclosing an internal chamber and a small stone-lined pit. A charred hazel twig complete with bark from the fill of this

pit returned a date of 3360–3090 cal. BC, but no burial or cremation deposits were recovered (Cagney 2004). Despite this, it is interesting to note that the date of the internal pit is similar to that obtained for the pit associated with the Caltragh megalith (3491–3039 cal. BC, UCD-0247). If this date is contemporary with the construction phase of Caltragh, then the monument is similar in date to many of the excavated passage tombs in Ireland, such as those of the Boyne cemetery complex. This date was linked to a cremation associated with the megalith, and cremated human remains are known from a number of Neolithic megaliths, such as the court tomb known as Dooey's Cairn at Ballymacaldrack, Co. Antrim, the tomb of Fourknocks II and the Mound of the Hostages, Tara, Co. Meath (Cooney 2005; O'Sullivan 2005).

## The knapping (flint-working) area

A potential knapping area measuring 28m north–south by 12m east–west was associated with a rough stone spread in Area 1 of Field G. Out of a total of 557 pieces of struck flint and chert (lithics) recovered from Area 1, 332 derived from the knapping area. Most of the latter were concentrated around a boulder, which may have functioned as a workstation. Other features, such as another cluster of boulders and some pits, may have been associated with the Neolithic activity.

## The Neolithic stone enclosure

Initial archaeological investigation of Field G revealed that a number of large stones protruded through the ground surface, and subsequent investigation (Joubert, see CD) revealed that these formed part of three drystone walls that formed a subcircular enclosure (Fig. 5.2; Pl. 5.4). This enclosure was later covered by peat and three spreads of burnt mound material. The three walls (segments 1 (C1103), 2 (C1068) and 3 (C1008)) had been constructed to separate the wet marshy land to the west, which was probably a lake at the time, from the drier pasture to the east. Investigation of the walls (Joubert, see CD) revealed that they pre-dated the build-up of peat in this area and that they had fallen into disrepair before the peat began to form, with the possible exception of segment 3, which the excavator concluded to have been built partly on top of the earliest peat accumulation. Segment 1, the more southerly wall, was the longest (53.5m) and was separated from segment 2 by modern disturbance. The second segment, 21m long, was of similar construction to segment 1, consisting of a row of large stones set upright at regular intervals, which would have formed the core of the wall, with small and medium-sized stones packed in between. It is likely that segments 1 and 2 would originally have formed a continuous curving wall, with segment 3 to the north-west being a later addition. This latter segment differed slightly in construction: the upright stones that formed the core of the wall were not set in a line as in segments 1 and 2 but were positioned more haphazardly, with smaller stones placed around and between them. This segment ran roughly east–west and measured just under 33m in length. While

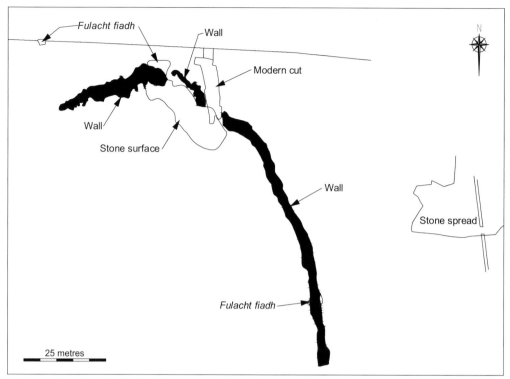

*Fig. 5.2—Caltragh: detail of the site originally named Field G (after Joubert).*

a peat layer sealed this wall, there was evidence that it overlay an earlier peat formation and a possible stone surface (Joubert, see CD). The 2001 excavation also revealed a row of eight post-holes, aligned east–west, cut into the subsoil to the north of wall segment 2. The excavator concluded that these were contemporary with the Neolithic occupation of the site and may represent part of a timber fence positioned between wall segments 2 and 3.

Other features were also encountered that either pre-dated or were contemporary with the wall. These included a linear cut and a pit, while the remains of an artificial stone surface partly sealed by a Neolithic ground surface underlay a portion of the wall. This area contained several stone tools, including a hollow scraper, arrowhead fragments, a stone adze, two flint blades and other flint tools (Joubert, see CD). Complete removal of the wall in 2003 revealed that none of the stones were set into deliberately prepared stone sockets, and no other cut features were associated with them. Two deposits of burnt animal bone were retrieved from the walls, while three stone axes were found in the fabric of the walls. Whereas the stone axes may imply a ritual practice in the course of construction, the deposits of burnt animal bone appear to have been purposely inserted at a later date, possibly when the structure was in decline (Joubert, see CD). It is tempting to suggest that these cremations are closing deposits marking the end of use of the structure, but unfortunately there is not enough evidence to support this assertion. All of this cremated material,

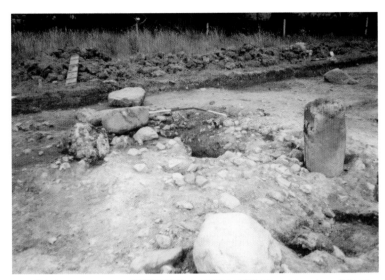

*Pl. 5.3—Caltragh: the mound from the north-west.*

*Pl. 5.4—Caltragh (Field G): aerial view of Neolithic enclosure of drystone construction, with Bronze Age houses to the right of photo (James Connolly).*

however, appeared to have been deliberately deposited as part of a ritual or rituals associated with the structure. One of the two animal cremations contained over 430 fragments of cremated bone, and one fragment was decorated prior to burning with an incised chevron pattern. Alison Sheridan (pers. comm.) has suggested that this fragment may have formed part of a bone belt hook, an early Bronze Age artefact found in Britain and Ireland. Of the twenty known examples only one comes from Ireland; this was found in a bipartite cist, which contained two Food Vessels, at Killycarney, Co. Cavan (A. Sheridan 2007). Both cremations (Buckley, see CD) appeared to be contemporary with the initial collapse of the wall and were sealed by the peat build-up. Although quite small, the fragment of decorated bone is unique in such a context; its deposition with fragments of undecorated cremated animal bone may indicate that it acquired a new significance (Pl. 5.5).

Excavation revealed that the walls comprised various rock types, including limestone,

Pl. 5.5—*Caltragh: incised animal bone (John Scarry, Department of the Environment, Heritage and Local Government).*

sandstone, shale, mudstone, granite and gneiss, varying in size from small stones to large boulders. The three walls were set contiguously and had a combined length of over 105m, while the collapsed walls varied from 2m to 3.5m in width. Many of the larger stones, averaging 0.6m in diameter, were set on end above the subsoil, and it is these that formed the core of the structure. It has been estimated that the wall would originally have stood to a height of 0.8–1m, with a similar width (Joubert, see CD). Also of note is that at the locations where spreads of burnt mound material sealed the walls, smaller stones were removed from the wall and were used in the later burnt mound activities. This type of construction, a spine with dumps of mixed stone around it, is reminiscent, at least in part, of linear field-clearance cairns.

The 2001 investigation of the walls did not involve removal of the stones as it was originally proposed to preserve the wall structure *in situ*. This proved both financially and practically unfeasible, however, and it was agreed by both the Department of the Environment, Heritage and Local Government and the National Roads Authority that full excavation of the site was preferable. The complete excavation of the wall was conducted by McCabe (see CD) during the autumn of 2003, although the southern extent of segment 1 had previously been excavated by

Linnane (see CD). These later excavations confirmed much of the earlier detail; they also revealed that the wall did not seal any trapped or buried soils or surfaces but appeared to have been placed directly on the subsoil (possibly the lakeshore), while no other features or artefacts were discovered in association with it.

*Discussion*

A number of interpretations have been put forward regarding the possible function(s) of the walls. Joubert (see CD) suggested that they may have been part of a larger Neolithic field system in the area and that further walls may be present outside the excavated area, while McCabe (see CD) has suggested that they may have formed a flood defence protecting the east of the valley from the wetter western portion. As mentioned previously, they may simply have been amalgamated linear field-clearance cairns. The positioning of the walls directly on the substrata out from the lakeshore suggests that they may have been constructed when the lake waters were receding, possibly during the summer, and that when the lake became full again, during the winter months, its waters would have lapped up over the stone structure, incorporating it into the lake. These waters would have washed over the deliberately placed stone axes, suggesting ritual connotations for the structure. The practicality of this structure as an animal enclosure or enclosed tillage field has to be questioned, as the area it enclosed was likely to have been a lake, while the three excavated walls formed a semicircular shape with no evidence of a return western wall. The directors who worked on this structure were each aware of the possible ritual nature of the walls, with Joubert suggesting that they represent a communal shaping of the landscape, similar in effect, if not purpose, to the monumental tomb-building tradition (Joubert, see CD). McCabe (see CD; Cooney 2000a) associated the structure with the other Neolithic features identified in Caltragh and suggested that all these features may have formed part of a landscape that contained 'ritual, domestic and industrial occupation, interlinked both spatially and socially'. While no definitive date has been obtained for the wall, it is probably Neolithic, but whether it originated in the early or late Neolithic is more difficult to determine. As previously mentioned, at least three Neolithic stone axes were deliberately placed within the fabric of the wall, while others were located close by. Three of the burnt mounds that sealed the wall provided *terminus ante quem* dates for the enclosure; two produced early Bronze Age dates of 2195–1861 cal. BC (UCD-0237) and 2194–1834 cal. BC (UCD-0249), while the third produced a middle Bronze Age date of 1650–1520 cal. BC. The people who occupied Caltragh during the early to middle Bronze Age were aware of the enclosing wall as they utilised it as a source of stone for use in their burnt mounds.

This pre-bog stone wall is one of many known from the north-west of Ireland, the most extensive being those at Céide Fields in north Mayo, where far-reaching field systems predominantly defined by stone walls were present underneath blanket bog. Prior to the formation of bog in this area around 2500 BC long parallel walls divided the land into strips, which were subdivided into separate fields by offset cross-walls (Mitchell and Ryan 2001). Caulfield (1988), who carried out extensive work in this area, believes that these field systems were intended for the management of cattle herds, and they appear to have been the product of

a single large-scale programme of clearance and enclosure. While some arable farming would have been practised, the economy would have been mainly a pastoral one. As temperatures in the Neolithic were at least two degrees warmer than at present, it has been suggested that the grass growing season may have been longer than the current nine to ten months currently experienced in north Mayo, thereby eliminating the need for haymaking for winter fodder. In addition to the field walls, megalithic tombs (court and portal) and settlement evidence were discovered beneath the peat. It is unlikely that the enclosure at Caltragh can be equated with the type and scale of activity that was carried out at Céide Fields, but both provide evidence of how Neolithic peoples transformed their surroundings and stand as a testimony to the relationships between these people and the land. At Céide Fields megalithic tombs and dispersed settlement enclosures were in close proximity to field walls, as was the case at Caltragh, albeit on a much smaller scale. Similar landscapes are known from elsewhere in Ireland, for example at Roughan Hill, Co. Clare (Jones 2003). Cooney (2000a) has suggested that such landscapes containing 'ritual, domestic and industrial occupation, being interconnected both spatially and socially, were a recurring element of Neolithic life'.

## The Bronze Age: *fulachta fiadh* and spreads of burnt mound material

As these sites are discussed in detail in Chapter 3, only a short overview is offered here. When looked at in the context of Caltragh they offer some interesting insights into the archaeology of this valley. Dates obtained for these sites show that they span the Bronze Age, but a number of them are related to specific events within the valley: at least three were contemporary with the middle Bronze Age houses and were located relatively close by. Unusually, most of the burnt mound spreads did not appear to be associated with troughs or any other diagnostic features; of a total of eleven burnt mound sites only three have been interpreted as *fulachta fiadh*. Although the wall had collapsed and had become sealed by peat prior to the early Bronze Age, the people who created the burnt mounds were aware of its presence and utilised it in a number of ways. Three burnt spreads were located above the wall at three separate locations along its extent, sandwiching the layer of peat between them and the wall (Pl. 5.6). At these locations the smaller packing-stones had been removed from the wall and were used in the burnt mound process, while some stones from wall segment 3 were fashioned into a circle and used as a hearth in association with the burnt spread at this location. In the site designated Caltragh 1 the wall was utilised in a different way; here it appeared to have functioned as an enclosing element, with the first two phases of burnt mound build-up being deliberately deposited to the west of the wall (Joubert, see CD).

## The Bronze Age cremations

*Table 5.2—Details of the Bronze Age cremations.*

| No. | Context | No. of individuals | Weight | Temperature of the pyre | Type of bone | Date (cal. BC) | Artefacts present |
|---|---|---|---|---|---|---|---|
| 1 | C336 | 1 adult female 1 juvenile | 436g | Efficient cremation, high temperature | Skull, tooth and long bone fragments | 1208–903 | LBA pottery |
| 2 | C136 | 1 adult female | 553g | 700–900°C | All skeletal regions but post-cranial skeleton under-represented | 1960–1540 | Stone beads |
| 3 | C138 | 1 adult | 956g | 500–800°C | Almost all the cremated remains of the body present | 1690–1510 | Stone beads |
| 4 | C620a | 1 juvenile 1 adult | 508g | Efficient cremation, high temperatures | All skeletal regions juvenile present/ cranium under-represented. A fingertip of the adult is the only bone identifiable to this individual though more may be present | | Flint scraper + sherds of BA pottery |
| 5 | C624a | 1 adult | 58g | Efficient cremation, high temperatures | 3g of cranial and 55g of post-crania present | | |

At least five cremations of Bronze Age date were recorded during the Caltragh excavations. Two of these contained the partial remains of two individuals (one adult and one juvenile), two contained the remains of an adult, while the fifth represented the partial remains of an adult. Cremation 1 was associated with the possible megalith described above. In addition to the cremated bone, charcoal flecks and several fragments of prehistoric pottery were present, which on inspection were identified as deriving from a coarse, straight-walled late Bronze Age vessel (Brindley, see CD), confirmed by a date from charred alder in the pit (Table 5.2). The cremated bone represented at least one female adult and one juvenile aged between four and ten years and indicates token deposition, whereby particular bones, representing only a small portion of the body, were selected for burial (see below; Buckley, see CD). At Area 1D Linnane (see CD) revealed two formal cremations in close proximity to each other underneath a spread of burnt mound material associated with a *fulacht fiadh*, Caltragh 6. The bones from both of these were efficiently cremated and were not further crushed after cremation. Cremation 2 represents the remains of an

*Pl. 5.6—Caltragh 1:* fulacht fiadh *overlying stone wall.*

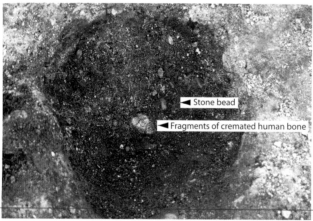

*Pl. 5.7—Cremation pit 2 before excavation.*

adult female who died probably at between 40 and 50 years of age, while cremation 3 represents the remains of an adult who was *c.* 40 to 50 years old at the time of death and whose sex cannot be determined (Table 5.2). Analysis of charcoal from each of these pits revealed the presence of hazel in cremation 3 and alder in cremation 2. Radiocarbon determination of these two samples returned dates of 1690–1510 cal. BC (Beta-197657) and 1960–1540 cal. BC (Beta-197656) respectively. A sample of charred alder from the trough associated with the spread of burnt mound material (Caltragh 6) that overlay these two cremations was dated to 1630–1400 cal. BC (Beta-197658). Both individuals represented by cremations 2 and 3 appear to have suffered from slight vertebral osteoarthritis, while three skull fragments in cremation 3 bore small green-blue stains indicative of the deposition of a bronze object or objects with the bones (Piezonka, see CD). No

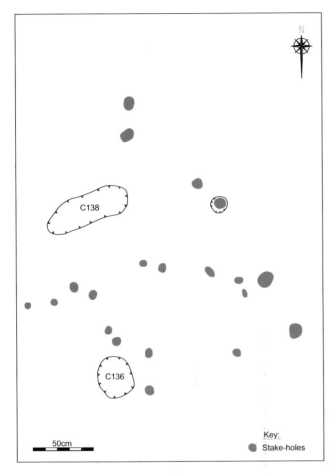

*Fig. 5.3—Caltragh: detailed plan of cremation pits 1 (C138) and 2 (C136) and stake-holes.*

metal grave-goods were found with this cremation, but four stone beads were recovered from it while a further twelve were discovered in cremation 2. Given the rarity of jewellery in Irish Bronze Age funerary contexts these beads are an important discovery and 'have a fascinating story to tell in terms of local responses to broader élite fashion trends, and their particular history suggests that the two people with whom they were buried had probably been related to each other in some significant way' (Sheridan, see CD) (Pls 5.7 and 5.8).

A number of stake-holes (twenty in all; Fig. 5.3; Pl. 5.9) were located close to the two cremation pits; although they did not form any clear pattern, it was concluded that they were associated with the cremations rather than with the overlying *fulacht fiadh*. These stakes probably formed a marker for the cremations but this could only have been of a temporary nature as both cremations were soon overlain by the spread of burnt mound material, which suggests that the significance of the cremations had been forgotten by this time (Linnane, see CD), particularly when the overlying *fulacht fiadh*, Caltragh 6, is interpreted as a site used to produce steam to manipulate timbers (Chapter 3).

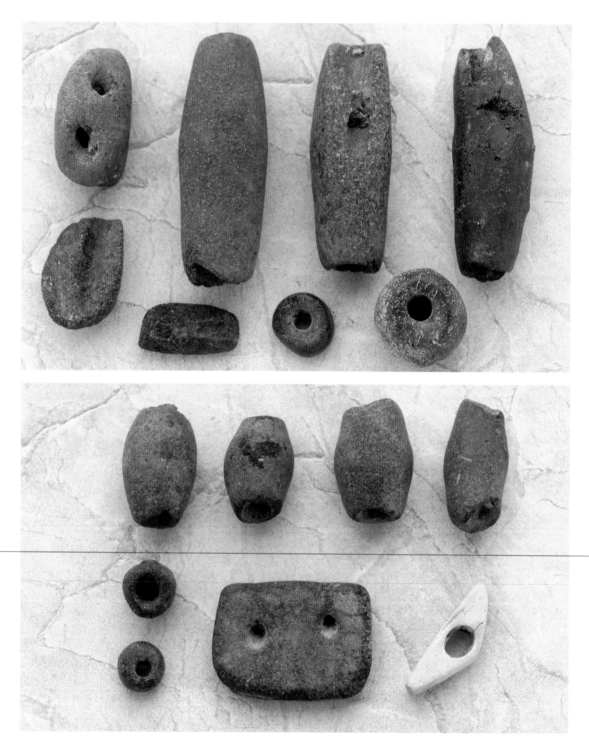

*Pl. 5.8—Stone beads from cremation pits 1 (C136) and 2 (C138).*

*Pl. 5.9—Caltragh: cremation pits 1 and 2 after excavation.*

The other cremations exposed in this area appear to have been associated with the middle Bronze Age round houses, either or both of houses 2 and 3 (Table 5.2). A subcircular pit (C636a) to the east of house 2 and to the north-east of house 3, no more than 5m away from either structure, contained two smaller pits cut into its base: the fills of these pits contained cremated bone. The slightly larger of the two, cremation 4, contained part of the remains of at least two individuals. A flint scraper and some sherds of Bronze Age pottery were also found in this fill. The bone from cremation 4 does not indicate deliberate crushing of the remains, though the high percentage of smaller pieces may suggest further post-cremation and post-depositional fragmentation (Piezonka, see CD). Most of the bone from cremation 4 represents the remains of a juvenile who was aged 13–16 at the time of death, while one definite bone fragment, a fingertip, and some possible fragments belong to a second individual who was at least 18 years old at the time of death. It was not possible to determine the sex of either person. Cremation 5 represents the remains of at least one adult. In addition to being truncated by these two small pits (cremations 4 and 5), a large pit, C618a, truncated the western edge of pit C636a and also cut the western side of cremation 4. Five fragments of a saddle quern were found in this large pit.

Six burnt bone assemblages were retrieved from different features associated with house 1 but all appear to be animal rather than human remains.

## Discussion

Our understanding of prehistoric cremations is that they were carried out on pyres; the deceased would have been placed on a pile of timber, which was subsequently set alight. Under the correct conditions it is possible that certain areas of the pyre could have reached temperatures in excess of 900°C. From the colour, consistency and degree of fragmentation of the cremated bone it is possible to establish the intensity of heat to which the bones were subjected. For instance, bone fragments that are white, chalky or sometimes slightly bluish and not very hard represent the highest degree of burning, at a temperature of at least 700–900°C. On the other hand, incompletely cremated bone fragments whose colour varies from grey-blue to jet-black and with the organic bone matter becoming carbonised indicate lower temperatures (Piezonka, see CD). Fragmentation of the cremated bone may also be influenced by other factors, such as cooling with cold water immediately after burning, which can result in smaller fragments, intentional crushing of the cremated remains before burial, which is common within the Irish archaeological record, and post-depositional factors (Piezonka, see CD).

It has been estimated that after cremation the remains of an individual weigh in the region of 1kg (Piezonka, see CD), although other estimates indicate that the remains of adult males can amount to at least 2.5kg and those of adult females to over 1.5kg. At Caltragh only cremation 3 came close to this weight; the others weighed substantially less, which is fairly typical of Bronze Age cremations. Most of the bone from cremation 4 represented a juvenile, however, and may comprise almost the complete remains of this person. It would appear that once a person was cremated it was not always deemed necessary to gather all the bone for burial, and there seems to have been a selective process whereby, for example, skull and long bones were often favoured, as is evident with cremation 1.

The deposition of cremated human remains within Irish Bronze Age settlements is not unknown; Cleary (2005a) lists 44 sites that contained either cremated and/or inhumed remains. Four of the five samples of cremated bone from Caltragh appear to be contemporary with the middle Bronze Age structures; two appear to be directly associated with houses 2 and 3, two more were located to the south of these structures within Area 1D, while the fifth and later example was found to the south-east and is associated with the possible megalith. The two adjacent cremations (cremations 2 and 3) located to the south of the settlement could easily be dismissed as isolated burials but were more than likely known to the people who lived at this site and may even have been deliberately placed at the periphery of the occupation area to establish symbolic boundaries (see K. Cleary 2002; 2005a; 2005b). This evokes the concept of liminality, or those locations that form an interface between the earthly and celestial worlds, which echoes throughout all periods of the site from the positioning of the Neolithic stone enclosure between dry and wet land to the deliberate placing of the five cremation deposits at what may have been perceived as strategic locations. At Sheephouse, Co. Meath, two cremation pits were recorded south of the settlement enclosure (Nelis 2002), while at Newtown, Co. Limerick, two cremations, containing at least four individuals, were situated 40m from a Bronze Age structure (Coyne 2002). At Kilmurry North, Co. Wicklow, three cremation pits were located to the south of a Bronze Age round house while

a fourth cremation was situated further away (O'Neill 2001a; 2001b).

As regards the deposition of human remains on Irish Bronze Age settlement sites, pits are by far the most common feature used (K. Cleary 2005a). Two deposits were directly associated with the reuse of pit C636a, which may have started life as a domestic pit but was later adapted for the deposition of cremated human remains. Token remains of at least three individuals were retrieved from cremations 4 and 5, dug into the base of pit C636a, while a third pit, which truncated C636a, containing saddle quern fragments may also have been related to the burials. Clearly this small patch of ground, covering less than 4m², was the focus of much deliberate activity that may have occurred over a prolonged period of time, possibly from the inception to the demise of the structures. Cleary (2005a, 29) suggests that this type of deliberate deposition, which is evident from numerous sites, indicates 'that thought went into these deposits and that they fulfilled an important social function'.

Cremation 4, the larger of the two pits within C636a, contained at least two individuals, a juvenile and the token remains of an adult, while cremation 5 contained the token remains of at least one adult. It is not known whether these individuals died at the same time or whether these deposits represent the remains of three former, formal cremation burials. Their association also raises a number of other questions. Are we looking at a long-drawn-out burial rite involving the mixing of the remains of the dead? Were the remains of some individuals stored until they could be buried with a second person at a later date? It is interesting to note that the adult in cremation 4 was recognised by only one skeletal fragment, a fingertip, though more fragments may have been present but unidentifiable. Such a deposit may not have been looked on as human but as an artefact or inanimate object that possibly took on a new significance in such a context and may have served a similar function to domestic items found in burial contexts. Together with the flint scraper and sherds of pottery, this fingertip may have been specifically selected for burial in cremation 4 to fulfil a particular symbolic purpose associated with the token deposition of the juvenile. Also of note is that five fragments of saddle quern were retrieved from the pit that deliberately truncated cremation 4. The reuse of these domestic items suggests that everyday activities may have involved an element of ritual, and the reburial of some fragments of bone from a formal cremation in close proximity to the site may support this. Of the numerous internal pits associated with the three structures, many contained everyday artefacts such as lithics, pottery and saddle querns. While it is easy to dismiss these artefacts as refuse, the position that many of them occupied within the various pits suggests otherwise. Each of the quernstones was either turned upside down or placed on its side facing inwards, which may symbolise the end of domestic activity within the structures. As regards cremations 4 and 5, the placing of the fragments of broken quernstone within pit C618a marked the last action associated with this cluster of pits. It is possible, therefore, that we are witnessing identical closing deposits/practices for domestic pits and structures and for pits containing cremated human remains. Thus it can be argued that a shared ritual denoted the end of the life cycle of both 'domestic' and 'ritual' features at this location, which clearly symbolises the close link between the living and the dead in middle Bronze Age Caltragh. While none of the three structures contained cremated human remains, structure 1 did contain six small samples of

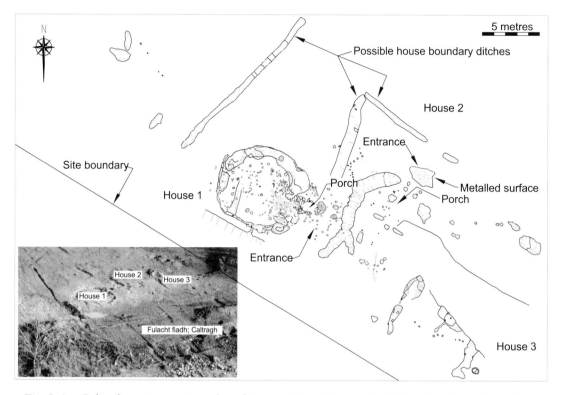

*Fig. 5.4—Caltragh: post-excavation plan of Bronze Age settlement, including three houses, boundary ditch and associated features. Inset: middle Bronze Age settlement.*

cremated animal bone, which have been interpreted as domestic waste (McCabe, see CD).

Unlike the previous four cremations, which all appear to have been associated with the middle Bronze Age, cremation 1 was dated to the late Bronze Age and was positioned close to one of the boulders that comprised the possible Neolithic megalith. Like cremation 5, it contained the token deposition of two individuals, a juvenile and an adult. Considering the previous evidence, it is improbable that this deposit was an isolated feature from a later period: contemporary sites within Caltragh have been identified, such as the *fulacht fiadh* designated Caltragh 7 to the north-west (Linnane, see CD). It has been suggested that 'evidence of previous settlements may have influenced in some way that which followed' (K. Cleary 2005a, 23).

Two cremations each contained the remains of a juvenile and an adult, which raises the question of whether the young were treated differently in death. In small, close-knit communities the death of a young person would have been a huge loss, as they would have carried on the lineage as well as undertaking many of the tasks associated with the settlement (K. Cleary 2005a; Hanley 2002; Barrett 1988; Brück 1995; 1999; Barley 1995; Doody 1987; 2000). Quite simply it may have been believed that a particular burial rite would deter future premature deaths or would prevent more misfortune from falling on the community. At Caltragh it is conceivable that this rite

ensured that token adult remains accompanied juveniles, but whether these adults died before, after or at the same time is unknown.

## The middle Bronze Age round houses and associated features

### Site location

To the east of the Neolithic stone enclosure the ground rose gently, changing from marsh to undulating pastureland. At the lower end of this slope, just above the marsh, a middle Bronze Age settlement comprising three round houses and associated features was unearthed (Fig. 5.4) (McCabe, see CD). While it has been suggested that the Neolithic wall was constructed in association with a lake, it appears that this body of water would have been greatly diminished by the time these three houses were constructed. This is indicated by the peat that had formed over the wall and which was subsequently sealed by a number of burnt mound deposits, some of which pre-dated, while others were contemporary with, the houses. The topography of Caltragh had been undergoing considerable change since the Neolithic with the development of peat and marsh, but despite these changes it continued to hold an attraction for succeeding generations. The setting of these houses on a relatively gentle south-facing slope and overlooking a body of water has numerous parallels in the Irish archaeological record; similar settings are known for many of the rectangular houses dating from the early Neolithic. South-facing slopes are often preferred as

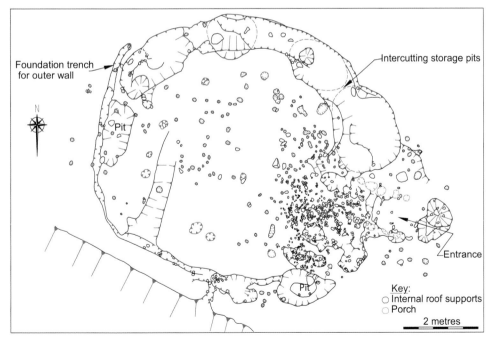

*Fig. 5.5—Caltragh: detail of house 1.*

they are the sunniest and therefore driest locations in the landscape (Cooney and Grogan 1999). Likewise, proximity to good agricultural soils was a distinct advantage, and the well-drained south-facing slopes on which these houses were set were suited to both arable and pastoral farming. The retrieval of seven grinding stones from features associated with the three houses suggests that the processing of crops was carried out in or around these houses and that these crops could have been grown nearby.

*Construction and layout*

Despite the substantial archaeological remains encountered at Caltragh, these three round houses are the only evidence for permanent settlement identified within the valley. Taking into account the range and type of archaeological features discovered in Caltragh, it is likely that this area was settled prior to the middle Bronze Age, with the remnants of structures possibly surviving outside of the roadtake, probably to the east.

Doody (2000) identified 78 individual Bronze Age houses discovered in Ireland, spread across 38 sites. Since then this number has more than doubled, with Corrstown, Co. Derry, alone accounting for 54 houses. Smaller clusters have also been identified; a group of three structures formed part of a Bronze Age settlement site at Ballybrowney Lower, Co. Cork (Cotter 2005), while at Agherton Road, Co. Derry, three circular structures of Bronze Age date were discovered (Linnane 2004). Another group of three houses, which stood side by side, was discovered at Killoran 8, Co. Tipperary (Gowen *et al.* 2005). Many isolated examples have also been revealed, such as the round houses excavated at Colp, Co. Meath (O'Hara 2003), and Tullyallen, Co. Louth (Linnane 2003), while other houses are mentioned in relation to the Bronze Age cremations discussed above. Although a blueprint for these houses was unlikely to have been used, many were similar in design and construction.

The three subcircular structures at Caltragh, which appear to be broadly contemporary, were constructed using methods typical of Bronze Age houses excavated elsewhere. The survival of linear features to the north and west gives some indication of an enclosed farmstead settlement (McCabe, see CD). This would not be unusual, as 45% of previously excavated Bronze Age dwelling sites show evidence of enclosure (Doody 2000).

*House 1*

Of the structures discovered at Caltragh, house 1 was the most substantial and best preserved of the three. Measuring 7.5m east–west by 6.8m north–south, it comprised an inner ring of eleven post-holes that formed a subcircular shape with an opening in the direction of the eastern entrance (Fig. 5.5; Pl. 5.10). A porch-like structure represented by two parallel lines of post-holes denoted the entrance. An inner ring of posts formed the main load-bearing element of the structure and would have supported a possible thatched roof that sloped over a low outer wall. This wall may have been of light/flimsy construction and was represented on the ground by a narrow, shallow slot-trench that curved around much of the structure, particularly to the south and west. This trench was composed of at least five intercutting suboval pits and possibly three isolated pits. These

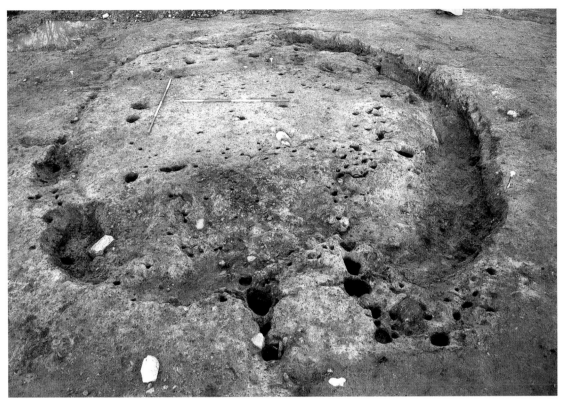

*Pl. 5.10—Caltragh: house 1 from east.*

would appear to have been internal features that were formed after the structure was built; it is unlikely that all eight would have been contemporary but would have been created over the life-span of the house, with some newer pits cutting older examples. The features differed from each other in size and depth but all were probably used for storage/refuse, while some may have been reused to contain ritual deposits marking the end of the life cycle of either the pit(s) or the house. Numerous artefacts, such as chert scrapers, sherds of coarse pottery and fragments of saddle querns, were present within many of them. To the north-east of the structure these intercutting features most resembled a bedding trench; elsewhere they appeared in isolation, but in all cases they were present just inside the outer wall. It is possible that timber planking would have acted as lids covering these pits: charred wooden planks were found in two of them and also at the entrance to the structure. Stake-holes were evident along the outer edge of some of the pits, and the excavator has suggested that a function other than that of storage may be proposed in these instances: it is possible that the pits containing stakes may have functioned as foundations for wall supports to strengthen any weak points in the roof or wall (McCabe, see CD). It was also noted that the pits along the north-eastern quadrant of the structure appeared to truncate the inner wall of the slot-trench, which would have supported the outer wall.

The interior of the house would have been accessed through the east-facing porch, where there was a small metalled area at the entrance to the main structure. Within the house dozens of stake-holes showed significant evidence of internal division or interior structures. A number of stake-holes at the entrance may represent the remains of a door-frame, while two linear arrangements may be the remains of supports for a bench or raised bed structure. O'Kelly (1954) proposed a similar interpretation for the hut structure at Ballyvourney 1, Co. Cork. It has been suggested that the concentration of stake-holes excavated within a Bronze Age hut at Cloghlucas, Co. Cork, could represent an attempt to strengthen and support a threatened collapse of the structure at that point (Gowen 1988). This indeed could explain the large cluster of stake-holes in the north-east corner of house 1 at Caltragh (McCabe, see CD). Deliberate burning of the house formally marked its end; no evidence was recovered from the site to suggest repair or reoccupation of the structure following this event. The intense *in situ* burning present along the south-west of the house would suggest that this fire was deliberate rather than accidental. Burning a timber structure down to the base of its foundations requires time, energy and determination, as the fire can only be maintained down to this level by repeatedly being reset and carefully tended. In an accidental fire, for example, a timber building will only burn down to about 0.3–0.5m above ground level before a lack of oxygen, partly resulting from the inferno itself, extinguishes the fire (Eoin Grogan, pers. comm.). Following the burning of the house it appears that a closing deposit, possibly incorporating some of the burnt remains of the house and including a sizeable quantity of artefacts such as struck chert, quernstones and hammer stones, was laid over four of the pits and the entrance to the house.

## House 2

Similar in shape to house 1 but smaller and situated less than 3m to the east of it, the archaeological remains of house 2 were less substantial but were nevertheless sufficient to offer a conjectural reconstruction. House 2 contained four internal features, probably load-bearing posts, and the wall was defined on the west side by a foundation, while an arrangement of posts and stakes may have formed the eastern and southern walls. To the north-east a porch defined by four post-holes marked the entrance, with a cobbled surface directly outside. Modern disturbance had destroyed much of the south-eastern quadrant of the structure. A number of stake-holes were found in the western bedding trench and, coupled with the other stake- and post-holes, would have supported the foundations of the outer wall of the structure. It is possible that this wall was both higher and sturdier than the outer wall of house 1 as it was probably load-bearing. An amalgamation of bedding trenches and stand-alone post- and stake-holes to form the main walls of a structure is not unique in the Irish archaeological record: a similar arrangement is found at structure D at Ballybrowney Lower, Co. Cork (Cotter 2005), and structures 10 and 15 at Chancellorsland, Co. Tipperary (Doody 2000). McCabe (see CD) suggests that it is apparent that the building methods used to construct house 2 were different from those used for house 1, the former being a more lightweight and less substantial structure, somewhat similar in design to that proposed for structure 10 at Chancellorsland, Co. Tipperary (Doody 2000). Here the frame of the structure would have

resembled an upturned basket and would have comprised a series of flexible wooden rods bent over to form both the walls and the roof; these would have been further supported by a weave of flexible rods placed horizontally across them. The frame may then have been covered with hides. The discovery of the remains of willow, the rods of which are light and flexible and ideally suited to this type of construction, within the footing trench of house 2 at Caltragh may add credence to this suggestion.

Internal features within house 2 were less clear than those seen in house 1, with the exception of several pits and some stake-holes that did not form a coherent pattern. One of these pits contained prehistoric pottery (McCabe, see CD). Interestingly, house 2 contained a pit with evidence of *in situ* burning, a feature absent from house 1. This suggestion of an internal hearth in house 2 is only one of two instances of *in situ* burning identified in association with the three structures. The second came from a small feature south of this house. The absence of a hearth feature in house 1 and possibly house 3 is not unusual: only about 30% of known Bronze Age structures show evidence of internal hearths (Doody 2000).

## House 3

The poor state of survival of house 3, owing to machine damage to the north and south, meant that little could be concluded from the excavation evidence to suggest internal layout. Remnants of probable foundation trenches to the east and south-west of the structure combined with an internal arc of stake-holes and an internal pit elucidate the type of construction methods applied in the building of this house. A single pit truncated by modern disturbance was found at what would have been the centre of the house. Given the nature of this feature and the deposits it contained, it was unlikely to have functioned either as a hearth or as a post-pit for an internal roof support. As no other internal pits are present, it is possible that the wall of the structure housed within the foundation trenches would have been the load-bearing element and would have taken the weight of the roof. A small number of stake-holes dug into the base of the foundation trenches could have formed part of the original wall, or may be seen as some evidence of repair to or additional support for the wall. Similar evidence was noted within the foundation trench of house 2. Unfortunately, owing to the modern disturbance it was not possible to determine the location of the entrance. There was not enough charcoal present to date this house, but sherds of plain coarseware pottery were retrieved from the foundation trenches; in addition, the internal pit, as well as an external one, was of a similar type to that discovered in houses 1 and 2. This all suggests that house 3 was broadly contemporary with these structures.

## Possible enclosure features

Boundaries associated with these three houses are suggested by a number of linear features to the north and north-west of the structures (Fig. 5.4). A long, narrow trench running north-east/south-west appears to delineate the western edge of house 1, while a corresponding trench outlines its eastern edge as well as serving to demarcate the western limit of house 2. At the northern terminus of this latter trench a third trench begins its course, heading south-east and enclosing the northern

area around house 2. A causeway in this trench is in alignment with the entrance to house 2, possibly allowing for a gate while also suggesting that it is contemporary with the structure. It is the view of the excavator that trench 3 may have continued further south-east to enclose the remaining northern edge of the site, but unfortunately, like many of the features associated with house 3, this was destroyed by modern disturbance. These enclosing features appear to define small plots of land associated with each of the three houses, in particular houses 2 and 3, and can be seen as further proof that these houses were indeed contemporary. The spatial organisation of the Caltragh houses is an intriguing element of this site and suggests that the domestic space was deliberately arranged by the inhabitants. This aspect of the site will be explored in more detail shortly.

*Material culture*

Small struck chert flakes, pottery and quernstone assemblages were discovered in association with the three houses, and these items shed further light on life in middle Bronze Age Caltragh. The struck chert assemblage was probably derived from locally available chert, which occurs as subrectangular debris in the soil (Guinan and Nolan, see CD). A limited range of tools were produced from this material and appear to have been manufactured on site. Guinan and Nolan (see CD) have concluded that the tools from this assemblage were not finely finished but were more ad hoc in nature, suggesting that the inhabitants were probably producing tools only for their immediate needs on site (Guinan and Nolan, see CD). The assemblage mainly consisted of scrapers (15) and flakes (19); the former were probably used for cleaning carcasses and/or wood, while some of the flakes may have been used as cutting tools (Guinan and Nolan, see CD). It is interesting to note that a number of these items were discovered in what is likely to have been a closing deposit within house 1. This deposit, which sealed a number of the internal pits, contained six scrapers, a grinding stone, three saddle quern fragments and some chert debitage. As part of this deposit these items may have acquired a new symbolic significance relating to the closing ritual of the house and may no longer have been viewed simply as domestic objects. Another explanation for the ad hoc nature of some of these struck chert tools is that they were never intended for domestic use but may have been struck to serve a specific function, i.e. deliberate deposition associated with the ritual marking the premeditated demise of house 1. Current research suggests, however, that only finely made tools were manufactured for specific ritual contexts (Eoin Grogan, pers. comm.).

As pointed out earlier, several saddle querns came from the Caltragh houses. These would have been used in the processing or grinding of cereals. A saddle quern would have consisted of two stones: an upper stone, known as a 'rubber stone', and a lower stone, known as a 'bed stone'. The shape of the bed stone resembles a saddle (hence the name) and is wide and long enough to accommodate the rubber stone across its prepared surface, thus enabling the grinding process (O'Sullivan and Downey 2006). At Caltragh seven bed stones and three rubber stones were discovered. Most derived from the pits associated with houses 2 and 3. The five more complete bed stones were either turned upside down or on their side facing inwards, possibly symbolising

the end of domestic activity within the structures. The remaining two bed stones were heavily fragmented, with one coming from the above-mentioned closing deposit of house 1 and the other from the pit truncating cremation 4. None of the rubber stones were broken.

Examination of the 34 sherds of pottery discovered within houses 1 and 3 indicates that the majority were considerably abraded prior to deposition (Gormley, see CD). This suggests that after breakage the sherds were left exposed to the elements for a considerable length of time and subsequently redeposited into various features related to these two houses (mainly pits but also some post- and stake-holes). Whether this action was accidental or formed part of an orchestrated closing ceremony is difficult to determine, but in light of other evidence the latter explanation would appear the more likely. Pottery from the site has been identified as plain coarseware—large vessels with thick walls, flat bases and round rims. Soot deposits encrusted on the interior of these vessels indicated that they were used for cooking (Gormley, see CD).

*Discussion*

As increasing numbers of Bronze Age sites emerge, largely as a consequence of development-led works, it appears that clusters of houses may form a significant part of the middle Bronze Age record and seem to point towards a farmstead-type dwelling, housing an extended family (Doody 2000; Cotter 2005; Gowen *et al.* 2005). The Caltragh evidence tends to support this. Caltragh is the first middle Bronze Age clustered settlement discovered in the north-west. Key factors such as proximity to good arable and pastoral land, water sources and building materials were clearly important in the location of this settlement; it would appear, however, that the recognition of the historical significance of the site was also a contributing factor when it came to establishing a settlement here (McCabe, see CD). Having decided on a location, the task of constructing and organising the settlement had to be undertaken and would have required a large amount of labour as well as a considerable quantity of raw materials. The substantial quantity of wood and thatch needed implies that woodland management was an integral component of landscape and farmland organisation that would ensure the availability of the necessary materials not just for house-building but other structural works, such as fence construction. While few of the tools discovered at Caltragh would appear to have been employed in the construction of the dwellings, the trough at Caltragh 6 could have been employed in the fashioning/bending of the roof timbers for these three structures.

At Caltragh spatial organisation is reflected not just by the house layout and associated boundaries but also by the placing of the burials at what may have been significant locations, as well as by the positioning of the *fulachta fiadh* and burnt mound spreads. Spatial awareness was likely to have been a key component of life within this valley. The close association between settlement, mortuary practice and *fulachta fiadh* combines the activities of the living with the dead and represents a people who had a relatively localised sense of self (McCabe, see CD). This localised sense of identity is also evident throughout parts of south Limerick (Cooney and Grogan 1999). Investigation of the beads from cremations 2 and 3 indicates that they are based on smaller, finer beads of similar shape known from a number of middle Bronze Age sites in Ireland (Tara)

and Britain (sites such as Bedd Branwen, Anglesey, Little Chesterford, Essex, and Amesbury, Wiltshire). They 'are of considerable significance in shedding light on élite fashions, networks of contacts, funerary practices and beliefs during the later part of the early Bronze Age in Ireland. In their own way, the people who owned these beads were tuned in to the latest fashions of the day, even if they could not acquire beads of precious substances such as jet, amber or faience; and their proximity in death, together with the sharing of the beads, suggests that they may have been related to each other, perhaps even as mother and daughter' (A. Sheridan, see CD).

At Caltragh the location of house entrances seems to have been an important aspect of their design. The entrance to house 1 looked onto the western side of house 2, while the entrance to house 2 looked to the north-west. Unfortunately it was not possible to locate the entrance to house 3, but if it had happened to focus on house 2 this would not be a unique occurrence (K. Cleary 2005b).

As mentioned previously, a number of sites have parallels with Caltragh, and at Killoran 8 three round houses overlooked a fourth structure (Gowen *et al.* 2005). At Ballybrowney, Co. Cork, three closely spaced round houses may have formed part of a small Bronze Age village (Cotter 2005), and at Grange, Co. Meath, on the M3 a structure similar in design to house 1 has recently been excavated (Amanda Kelly, pers. comm.). Another site of interest is Curraghatoor, Co. Tipperary: although slightly later in date, this settlement also contained a cluster of circular structures of varying size (six were circular and three were either rectangular or subrectangular in outline) (Doody 1993). A series of seven pits was uncovered inside the outer perimeter of the main Curraghatoor structures, which were defined by a ring of post-holes. As at Caltragh, the excavator believed that these pits fulfilled a storage or waste disposal function (Doody 2000). Similarly, at Knockadoon, Lough Gur, Co. Limerick, the remains of several timber structures were revealed during excavation (R. Cleary 1995; Grogan and Eogan 1987). Environmental evidence suggested that walls of wattle and daub may have been used, with vertical internal posts supporting the roof. A broadly comparable artefact assemblage was recorded. Plain, coarse, flat-bottomed pottery and simple flint scrapers and blade fragments were excavated from contexts within and around the houses themselves, though these sites did produce evidence for high-status occupation (Grogan and Eogan 1987).

## Conclusions

From the diversity of the archaeology within the Caltragh valley it is undeniable that this was an important location for the Neolithic and Bronze Age inhabitants of Sligo. Physically Caltragh would have changed considerably during this time, while the social significance of the place may have transformed with each successive generation of people who chose to settle here. In the Neolithic the lake may have been the overriding attraction or focus for the builders of the megalithic tomb and the wall, with the latter structure possibly paying homage to this body of water. The wall's construction on the lakeshore separating the dryland from the lake appears

deliberate, but whether it was intended to be ceremonial or practical (or both) in nature remains unclear. By the early Bronze Age this lake had greatly diminished, gradually being replaced by peat, which had by now sealed the walls. This changing wetland remained in use, however, as is attested by the number of burnt mound spreads dating from this period. There is evidence for a continued presence in this valley up until the late Bronze Age, at which point the focus of settlement moved away. The focus of activity also seems to have changed, from the monumental of the Neolithic to the integrated settlement pattern of the Bronze Age. The ritual aspect of Bronze Age life does not appear to have been too far removed, on both the physical and the metaphysical level, from the settlement activity, however, as indicated by the numerous cremations and the ring-barrow sited to the south-west of the site. An intriguing aspect of Caltragh is the continued theme of liminality present throughout the prehistory of this valley, from the drystone walls of the Neolithic up to the late Bronze Age cremation located close to one of the boulders of the megalithic structure. This is particularly evident in relation to the middle Bronze Age period and further emphasises the close associations between life and death in Caltragh.

A spatial strategy organising all of these elements was an important component of life within this valley. By the middle Bronze Age, as mentioned, an integrated settlement pattern had formed that incorporated past landscapes. The spatial organisation of the three houses and associated boundaries, together with the relationship between these houses and contemporary cremations and *fulachta fiadh* as well as past monuments, suggests that by the middle Bronze Age the people of Caltragh had a strong localised sense of identity grounded in an acute awareness of place with strong ties to the past. Such a pattern is apparent from other parts of the country, such as south Limerick (see Grogan 2005a; Cooney and Grogan 1999, 123–42), although in terms of scale the Caltragh evidence seems to be a microcosm of what is evident elsewhere.

# 6

# THE EARLY NEOLITHIC ARCHAEOLOGY
# OF MAGHERABOY

## Introduction

Magheraboy derives its name from *Macaire Buide*, which appears to mean 'the yellow plain'. Excavations associated with the N4 SIRR within this townland revealed evidence of human activity spanning six millennia. While at Caltragh there was a preponderance of archaeological occupation centred on the valley bottom close to the lakeshore, at Magheraboy the ridge was undoubtedly the main focus of activity (Pl. 6.1). According to Timoney (2002), the local name for this ridge is likely to be Knocknatoofil. Whereas middle Bronze Age settlement dominated the archaeology at Caltragh, the principal site at Magheraboy was an early Neolithic causewayed enclosure with ritual connotations. *Fulachta fiadh* of both late Neolithic and late Bronze Age date, pits of possible late Neolithic origin, a small Iron Age penannular structure and a ringfort of the early medieval period accounted for the majority of the other archaeological sites. In this chapter the findings from the causewayed enclosure will be discussed, while the remaining archaeological sites discovered in Magheraboy will be dealt with in Chapter 7.

The excavation focused on the eastern portion of this monument, with slightly over 2.5 acres of it being investigated. The remainder lay outside the roadtake. No trace of the site was visible before excavation. At the outset of the excavation the site was divided into five separate zones (Fig. 6.1).

### Causewayed enclosures

In its simplest form a causewayed enclosure may be described as a large enclosed area defined by one or more roughly concentric rings of ditches, frequently interrupted by causeways of undug soil, usually with the excavated material piled inside to form a bank. The enclosing element of a number of these sites is often enhanced by the presence of an inner timber palisade, such as those identified at Freston in Suffolk, Whitehawk Camp in East Sussex, Donegore Hill in Antrim, Calden in Germany and Sarup in Denmark, to name but a few. These monuments vary considerably both in size and in duration of use.

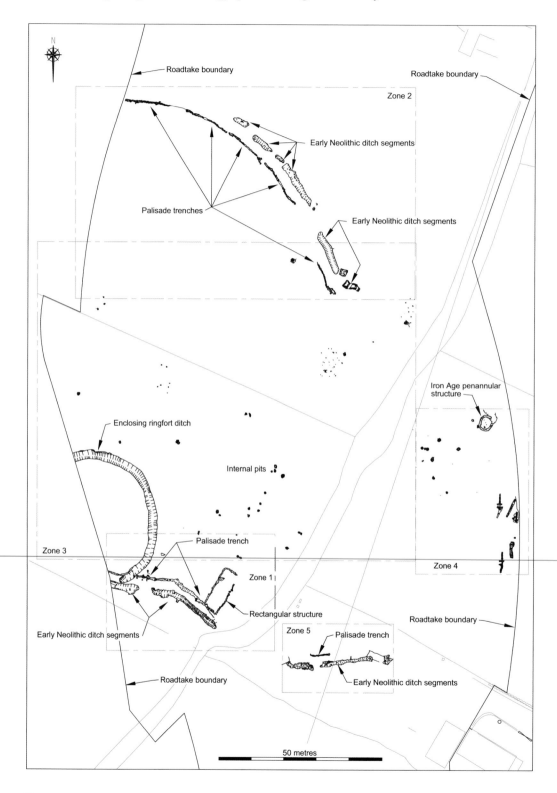

N

Roadtake boundary

Roadtake boundary

Zone 2

Early Neolithic ditch segments

Early Neolithic ditch segments

Palisade trenches

Iron Age penannular structure

Enclosing ringfort ditch

Internal pits

Zone 3

Palisade trench

Zone 1

Zone 4

Rectangular structure

Early Neolithic ditch segments

Roadtake boundary

Zone 5

Palisade trench

Early Neolithic ditch segments

Roadtake boundary

50 metres

*Pl. 6.1 (right)—Magheraboy: aerial view of the ridge (Marcus Casey).*

*Fig. 6.1 (opposite)—Magheraboy 2B and 2C: plan of the early Neolithic causewayed enclosure, the Iron Age penannular structure and the early medieval ringfort.*

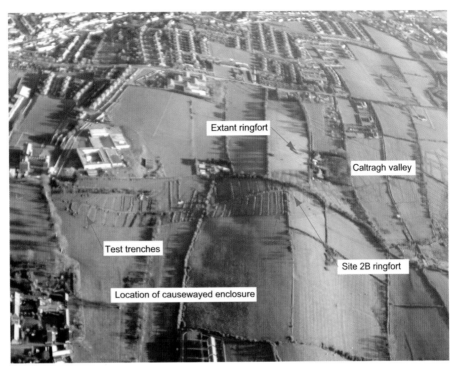

## Area 2C: The early Neolithic causewayed enclosure

The Magheraboy enclosure lies to the south-west of Sligo town in the eastern quadrant of a large ridge running south-west/north-east. It commands panoramic views of Sligo town and the surrounding countryside. Situated east of centre, the site did not crown the top of the ridge, although it is unlikely that there were any practical reasons why it could not have been located there. Relinquishing the crown or most prominent point of a hill, ridge or field is a characteristic of many causewayed enclosures. At a height of approximately 50m OD, the ridge at Magheraboy is the highest and most prominent point in the region between Knocknarea to the west and Cairn's Hill to the east.

It is possible that this ridge, which slopes to the north and south, was specifically chosen not just for the view from the site but also because the site itself was visible from some of the surrounding uplands in the region, such as Knocknarea and Cairn's Hill. These latter hills are located some distance away from Magheraboy and, although the site is visible from both, it is unlikely that the activities that were carried out within would have been discernible. In comparison, a contributing factor in the siting of the later embanked enclosures was that the interiors were often overlooked by higher ground in the vicinity; for example, at Tonafortes a small hill to the north of the henge overlooked the interior (Danaher, see CD). Cooney and Grogan (1999, 90) suggest that the concern with making the activities within henges 'visible but only from a distance is compatible with the use of the sites being controlled'. Although the enclosure at

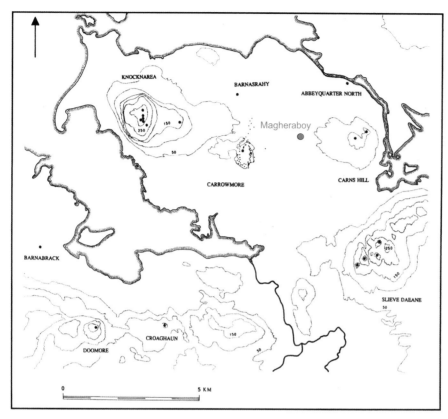

*Fig. 6.2—
Magheraboy within
the Cúil Irra region,
Co. Sligo (after
Bergh 1995).*

Magheraboy is likely to pre-date the cairns (passage tombs) on Knocknarea and Cairn's Hill, it is clearly visible from the summit of each. In antiquity, it was probably detected as a gap in the tree line from both of these sites, as well as from the surrounding countryside. At elevations of 328m (1,083ft) and 100m (330ft) respectively, Knocknarea and Cairn's Hill, together with the Magheraboy ridge (although diminutive by comparison), form the highest points in the topography of this area (Fig. 6.2).

The natural topography at Magheraboy does, however, restrict visibility from certain areas of the site. From the south, none of the lowlands to the north of the site are visible, with only the upper slopes of Ben Bulben and the Ballygawley Hills in view, while from the north the area to the south of the site cannot be seen. Landmarks to the east and west are visible from both the north and south of the site, however, while the summit provides the only vantage point with unrestricted views. As the topography of this area of Sligo has altered little over the 6,000 years since the construction of this enclosure, visibility from this site would have remained largely unaffected, with the exception of a major change in vegetation. Environmental analysis of various molluscs retrieved from a number of the British causewayed enclosures suggests that most sites of this type located on high ground were probably initially located in small clearings in woodland. At Magheraboy this woodland appears to have consisted largely of oak and hazel. After the clearing

was created, the felled wood was probably utilised in the construction of the timber palisade, with oak providing the main structural timbers and hazel rods the wattling. These two species together with willow, ash and other wood types were all used as firewood, while some fragments were deposited in the various pits and ditch segments.

## The site

The deliberate positioning of the site below the summit of a prominent ridge implies conscious manipulation of the local environment to suit the needs and beliefs of these early farmers. With the excavated area of the site measuring roughly 150m north–south by 130m east–west and covering in excess of 1.1ha (2.5 acres), it is possible to suggest that the Magheraboy monument was elliptical in shape and enclosed an area in the region of 2.02ha (5 acres). What has been determined is that the enclosing elements comprised an incomplete circuit of ten ditch segments and the foundation trench of an inner timber palisade. It would appear, however, that the eastern edge of the site may not have been artificially enclosed. Not all of the ditch segments were contemporary with the palisade; some appeared later in the history of the site. Fifty-two small shallow pits and three possible timber structures were contained within the interior, although two of these structures were associated with the timber palisade delineating the southern part of the site. By and large the interior was devoid of features and was basically a large empty space. While there were many causeways between the various ditch segments and numerous gaps within the timber palisade, it appears that there was only a single formal entrance. This is best described as a funnelled entrance created by two inward-deflecting ditches to the north of the site.

## The enclosing elements: construction and layout

Having chosen their location and begun clearing the site of vegetation, the Neolithic builders would probably have set about the task of establishing the site perimeter, or at least part of it. This would have been defined by most of the constructional elements known to these people: ditches, banks and timber structures (Oswald *et al.* 2001). It is the segmented nature of the ditches and their intervening causeways that has given rise to the name of this class of monument.

Work on the constructional elements of the site at Magheraboy may have begun while other areas were still being cleared of vegetation. The incomplete plan of the site and the nature of the ditch segments and palisade suggest that the construction of the enclosing elements was an ongoing process that may never have been completed. Further vegetation may have been cleared after the initial phase(s) of site preparation. The construction of the timber palisade, ditches and banks, and the other enclosing elements, may have been extended as or when needed or planned. Alternatively, a possibly more rational option was to completely clear the site of vegetation prior to construction; this method has been suggested for the construction of numerous causewayed sites in Britain (Oswald *et al.* 2001).

## The palisade

Assuming that the ridge would have had tree cover prior to the creation of the causewayed enclosure, these trees would have provided the raw materials for the timber palisade. After being

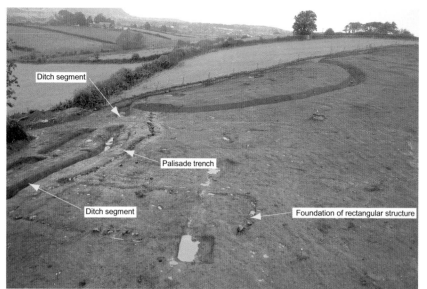

*Pl. 6.2 (left)—Magheraboy 2B and 2C: the south of the site during excavation.*

*Pl. 6.3 (below)—Magheraboy 2C: palisade trench, showing stone packing. Note the relationship between the palisade trench and the outer ditch segment; both follow the same alignment.*

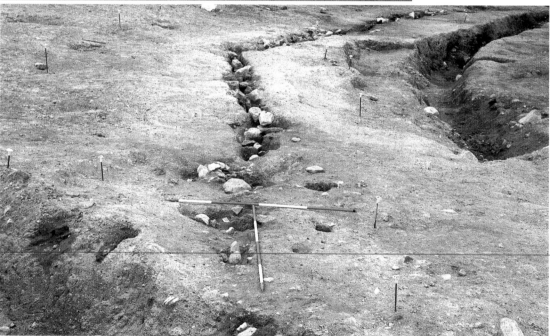

cut down, they may have been processed and stored until the palisade trench was dug. Wood identification of the many charcoal samples from various features excavated throughout the site showed that oak and hazel were by far the most common species.

In contrast to the ditches (below), the method employed in the construction of the timber palisade/fence was fairly uniform throughout the site, with the exception of the slight modification of building style identified within the short stretch of palisade trench excavated to

*Pl. 6.4—Magheraboy 2B: excavated features to the south of the site.*

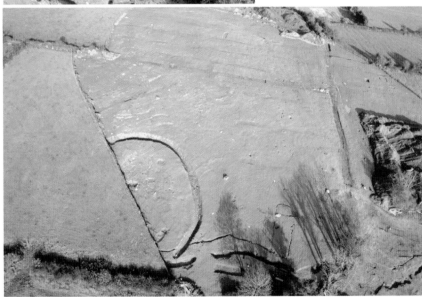

*Pl. 6.5—Detail of early Neolithic features delineating the south-east of the causewayed enclosure visible in the bottom right of the photo.*

the south-east of the site (zone 5). When compared to other Neolithic palisades in both Ireland and Britain, the form of the Magheraboy palisade is best described as a timber fence type (Gibson 1998) and it would have stood to an average height of 1.5m. The combined total length of the palisade trenches within the site was *c.* 108m. This does not include any gaps between palisade trenches, however, such as the numerous examples along the northern perimeter (zone 2).

The construction of the *c.* 37m-long palisade on the southern side was the most elaborate identified. On the western side it was aligned east–west, but just beyond the halfway point it turned at a roughly 35° angle, altering its route to the south-east. The corresponding outer ditch segment followed a similar path (Fig. 6.3; Pls 6.2–6.4). The western section of this palisade trench was truncated by the later ringfort (see Chapter 7).

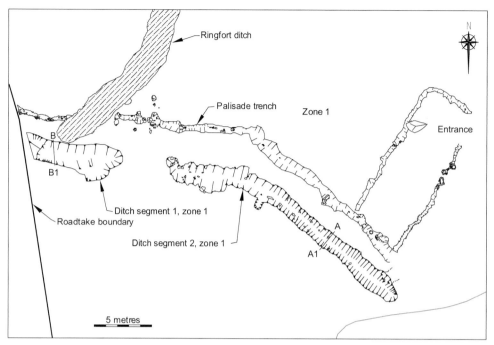

*Fig. 6.3—Magheraboy 2B: post-excavation plan of early Neolithic features to the south of the site, with part of the later ringfort ditch evident in the top left-hand corner.*

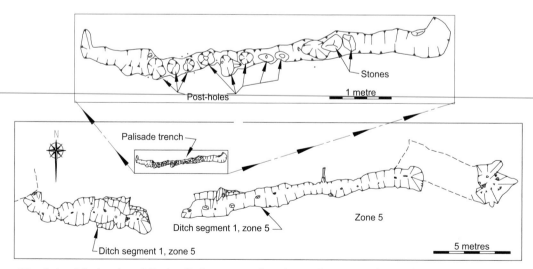

*Fig. 6.4—Magheraboy 2C: detail of causewayed enclosure features to the south-east of the site (zone 5). Inset: Magheraboy 2C, close-up of palisade trench.*

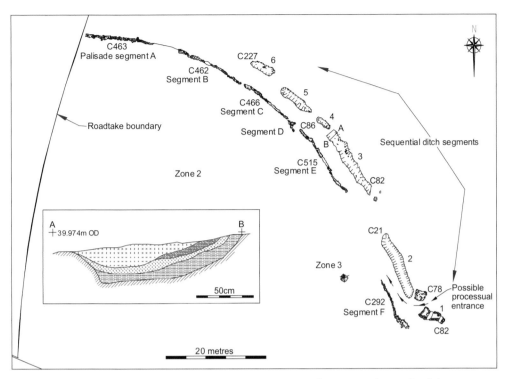

*Fig. 6.5—Magheraboy 2C: detail of causewayed enclosure features to the north of the site.*

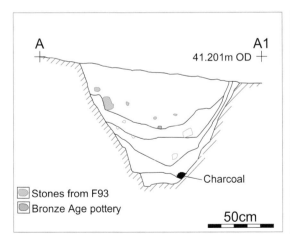

*Fig. 6.6—Magheraboy 2B: section through ditch segment 2, zone 2.*

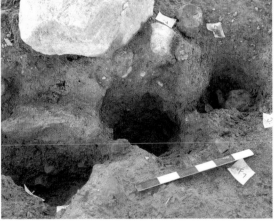

*Pl. 6.6—Magheraboy 2C: detail of contiguous post-holes within the palisade trench.*

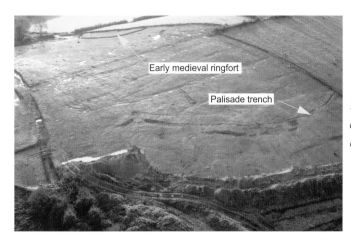

*Pl. 6.7—Magheraboy 2C: aerial view of causewayed enclosure features to the north of the site.*

*Pl. 6.8—Magheraboy 2C: site crew marking the course of the northern palisade trench of the causewayed enclosure.*

To the east of this area further traces of a palisade trench, 6.5m long, 0.28m wide and 0.25m deep, were identified (zone 5). Rather than being constructed of post-pits and split timber planks, the foundation trench here contained a succession of post-holes, suggesting that the timber palisade would have comprised a contiguous line of posts set within the bedding trench (Fig. 6.4; Pls 6.5 and 6.6). On the northern side of the site the palisade was not continuous but was divided into six separate bedding trenches, varying from 9m to 16m in length, with a cumulative length of nearly 90m, including the gaps between the segments (Fig. 6.5; Pls 6.7 and 6.8). The morphology of these five bedding trenches was similar to the palisade trench to the south of the site (zone 1).

*The ditch segments*

In total, ten ditch segments were revealed: four to the south of the site and six to the north. The combined length of the ditch segments excavated to the south was very similar to the combined length of those exposed to the north, slightly in excess of 50m. Much variety was identified across the ditch segments.

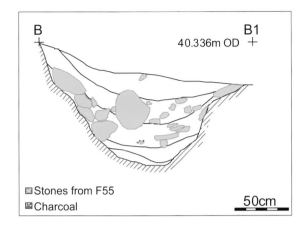

*Fig. 6.7—Magheraboy 2B: section through ditch segment 1, zone 1.*

## Form

Of the two ditch segments (Figs 6.1 and 6.3; Pls 6.2 and 6.4) delineating the south of the site (zone 1), only the full extent of one was exposed, with the remainder of the other lying outside the roadtake. A 5m 'causeway' separated these two ditch segments. The larger segment (no. 2, zone 1), which appeared to have been recut at least twice (Fig. 6.6), was 23m long with an average width of 1.6m and depth of 0.7m; it had a U-shaped profile, and the remnants of a burnt wooden plank were identified directly above its base. Like most of the other segments, it ran parallel to the inner palisade and followed parallel changes in direction. Over 300 sherds of early Neolithic (Carinated Bowl) pottery, a small number of lithics and a large quantity of boulders were retrieved from the

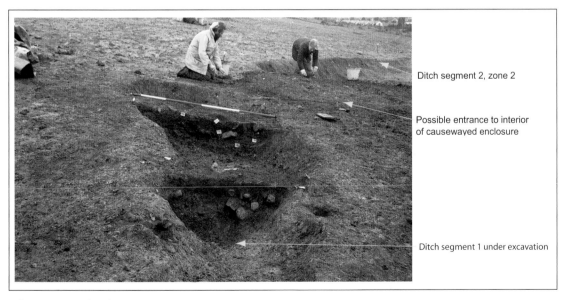

*Pl. 6.9—Magheraboy 2C.*

99

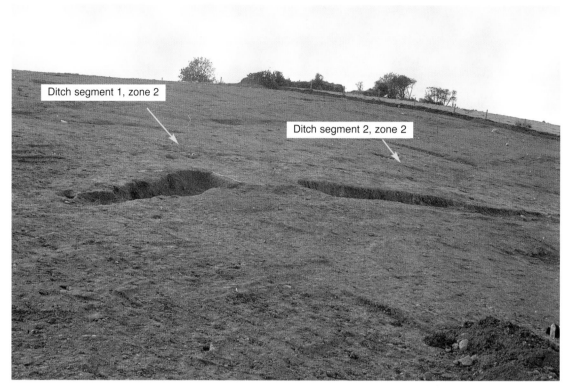

*Pl. 6.10—Magheraboy 2C: detail of funnelled entrance to causewayed enclosure.*

fills. The second southern ditch segment (no. 1, zone 1) was aligned roughly north-west/south-east. The exposed portion was also U-shaped in section; it measured 8m in length by 2.1m in width and was over 1m deep (Fig. 6.7). No recuts were evident, and the five deposits contained within the fill appeared to be the product of a combination of silting and soil collapse. Surprisingly, only a single artefact, a sherd of Carinated Bowl, was retrieved from this ditch but, as in the other ditch segment in this area, a large number of boulders were present.

East of these two ditch segments a further two occurred in zone 5 and both had similar morphology (Fig. 6.4; Pl. 6.5). Segment 1, the smaller of the two, ran east–west and measured 7.2m in length, 1.2m in width and had an average depth of 0.4m. It contained a single fill with the remnants of *in situ* burning and a pit dug into it at a later date. Segment 2 was 15m long, 1.5m wide and extended to an average depth of 0.45m. Aligned in the same direction as segment 1, it contained numerous deposits reflecting a more prolonged history of infilling, with at least one recut evident. Both ditches were U-shaped in profile and were separated by a 2.4m-wide causeway of undug soil. Over 260 artefacts were retrieved from the two ditches, and boulders were plentiful in both.

More variety in terms of form was evident amongst the six ditch segments to the north of the site, which varied from little more than shallow elongated pits to larger segments over 12m long

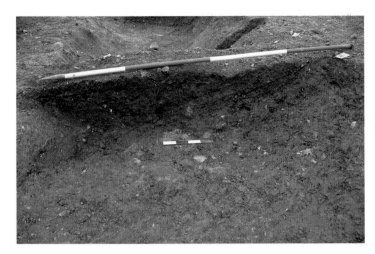

*Pl. 6.11—Magheraboy 2C: north-west-facing section through segment 3, zone 2, showing recut.*

*Pl. 6.12—Magheraboy 2C: ditch segment 3, zone 2, after excavation.*

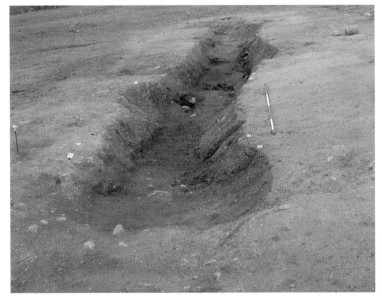

and 1m deep (Fig. 6.5; Pl. 6.7). As will be suggested in greater detail below, it is quite possible that these segments were sequential in nature, and it appears that they were perceived as unfinished entities in a constant state of renewal, with the smaller, shallower segments eventually evolving to the status of their larger counterparts.

*The entrance*
The only formal entrance is indicated by the inward deflection of ditch segments 1 and 2 (Fig. 6.5; Pls 6.9 and 6.10): similar features are known from causewayed enclosures in Britain such as Haddenham in East Cambridgeshire, Windmill Hill (Inner Circuit) in Wiltshire, Burford in West Oxfordshire, Staines in Surrey and Eastleach in Gloucestershire (Oswald *et al.* 2001).

*Function of the ditch segments*

While the timber fence formed much of the physical expression of the site, the ditches and the interior were the main focus of ritual activity. The ten ditch segments, and particularly the six northern examples, offer a glimpse of the type of activities that were conducted in association with the enclosure. The six northern segments can be generally treated as two distinct groups of three. The first group comprised three larger ditch segments (nos 1–3, zone 2) containing a relatively large quantity of artefacts, while ditches 4–6 were much smaller and yielded less cultural material.

Segment 3 was the largest of the ditches in zone 2 and had the typical U-shaped profile associated with causewayed enclosure ditches (Fig. 6.5; Pls 6.11 and 6.12). Like the other segments, it had a flat base above which lay an intentionally deposited cultural layer, C169; the incomplete charred remains of split oak planks were deposited *c.* 3m further to the south-east. These planks may have acted as a platform or altar for perishable offerings of which no trace remains. Joints of meat from both cattle and sheep are common inclusions in British causewayed enclosure ditches. At Magheraboy, however, acidic soil conditions did not favour bone preservation and no bone survived, with the exception of small quantities of cremated bone fragments from a number of ditch segments and internal pits. These fragments were mainly of sheep/goat but larger, though unidentifiable, mammals were also represented.

A large number of finds were intentionally deposited in layer C169: these included broken sherds of pottery, a waste chert flake and fragments of two stone axeheads, one a deliberately broken porcellanite axe. Before deposition in the ditch, this axe was broken by a series of controlled blows at different angles (Mandal, see CD). This action would have rendered the axe functionally useless. The axe, other items and dark 'occupation-like' material that may have derived from a midden were ritually placed in the ditch and, together with the charred oak planks, were subsequently covered with a layer of redeposited natural. In essence, the 'ritualisation' of this material appears to have involved the processes and ceremonies otherwise associated with death and burial. It is possible that these events recorded within the ditch reflected the life of a dead relative and that the deposited items were a selection of treasured possessions as well as goods that may have been used and subsequently discarded by them. Alternatively, each ditch segment may represent the beliefs and customs of a particular community of early Neolithic farmers who converged, together with other groups, at this location on special occasions. A midden used by the individual and/or their family may have been the source of the darker cultural layer. Following the burial of these deposits, the ditch was later recut, with the cultural deposits left largely intact, and the process of deposition and infilling was repeated. A large quantity of artefacts, 141 items in all, were retrieved from segment 3. Although cultural layers were present within both segments 1 and 2 in zone 2, a much smaller number of artefacts were contained within these deposits. No recuts were identified in either segment, although both appeared to have been deliberately backfilled.

Less than 2m north-west of segment 3 was the first of the second group of ditches. These three (nos 4–6) are smaller variations of segments 1–3, although segment 1 was similar in depth to no. 6. Of segments 4–6 only the deepest of the three, no. 6, contained Neolithic artefacts, although all three produced various quantities of deliberately buried stone. It is difficult to explain why these

segments differed from nos 1–3. It is possible that they served different functions or that the disparity is a reflection of their development, with the smaller ditch segments being at an earlier stage in their formation process compared with the more mature stage of the other three segments. Based on the dates obtained for segments 3 and 6 (see Table 6.1), it would appear that the ditches to the north of the site were not necessarily all dug at the same time. New segments were being created while the older ones may have been lengthened or amalgamated, producing a range of plan forms (Oswald *et al.* 2001). Some of the Magheraboy ditches are similar in form to those at the causewayed enclosure at Bryn Celli Wen, Anglesey, particularly as regards their depth. Following excavation there, Edmonds, Thomas and Johnson have argued that many of the more elaborate English sites, 'like Hambledon Hill, Crickley Hill, Abingdon and Whitesheet Hill, are the product of lengthy sequences of rebuilding, which may have had quite modest beginnings (Thomas 1991, 32–8). At Crickley Hill, for instance, the phase 1bi ditches were very similar in size to those at Bryn Celli Wen, and had been backfilled soon after digging (Dixon 1988). One is prompted to consider what Crickley Hill might look like as a monument had its development been arrested after phase 1bi, and whether such sites exist to be located' (Edmonds and Thomas 1991).

The ideas discussed above in relation to the northern segments also apply to those on the south of the site. As in zones 1 and 2, the segments in zone 5 contained evidence of what may have been the last rite of passage of an individual (or individuals). The two segments in zone 5 showed evidence for the structured deposition of artefacts in the ditch (Fig. 6.4; Pl. 6.5). Both also revealed evidence for recutting. Within the smaller segment, no. 1, this recut was represented by a small pit cut into the cultural deposit. The pit contained sherds of Carinated Bowl, fragments of unidentifiable cremated bone and a flint leaf-shaped arrowhead. The primary deposit contained a number of carefully placed offerings, including a mudstone axe that had been partially encircled by 30 pieces of quartz. Unlike the axe in ditch segment 3, zone 2, which had been ritually decommissioned, the axe in this segment was in almost perfect condition apart from slight damage to the butt. It is possible that it had never been used as the blade is in pristine condition. Together with the quartz pieces, it is probable that this deposit represents something distinctively different from the rituals associated with the axe burial in zone 2. Rather than commemorating the death of an individual by ritually destroying one of their prized possessions, it may represent the celebration of a new life by placing a newly created object in the ground, surrounded by mysterious objects/forces that will protect that person in their journey through life. An arrowhead located above the axehead in zone 5 was broken, but it is not known whether this was the result of a deliberate action. Alternatively, as mentioned earlier, the deposition of these items may reflect a separate set of rituals or beliefs practised by one group of people in comparison to another. The smaller of the ditch segments in zone 5 contained more lithic artefacts than any other feature on site. Nolan and Guinan (see CD) observed that all types of artefacts found on site were represented here.

The recut associated with the second and longer segment 2 in zone 5 did not extend the full length of the ditch but did mirror it in form. This too was deliberately backfilled with a large quantity of cultural material. Like segment 1, it contained a large number of small boulders along its base; many of these were associated with fragments of Carinated Bowl pottery and some lithics.

The type of activity identified in both of these segments was also observed in no. 2 in zone 1, where boulders were associated with the deposition of pottery sherds, convex scrapers and waste flakes.

The last remaining southern ditch was segment 1, zone 1. This was much deeper and broader than the others in this area and contained only a single artefact, a sherd of Carinated Bowl. Although it contained boulders, these did not directly overlie the base but appeared higher up in the stratigraphical sequence of the ditch. In all, five deposits filled this segment. Generally, as mentioned earlier, the individual length of a ditch segment in the south of the site was longer than those to the north. Additionally, the change in direction noted in segment 2, zone 1, may highlight a change in the function or focus of the ditch segments in this area compared to those in the north. Having excavated the causewayed enclosure at Etton, Cambridgeshire, Pryor (2003) interpreted that site as having two halves, public (to the west) and private (to the east). The site consisted of an oval circuit of segmented ditches and was divided in two by a north/south-aligned palisade. The individual segments to the east were smaller and more numerous than those to the west. Pryor also postulated that the public gatherings to the west of the site would have involved feasting as well as the exchange of seeds, animals and gifts. Marriages may also have been arranged and conducted in this area. On the other, more private side of the site, families may have gathered to mark the passing of relatives and to send them on their last journey (Pryor 2003). The ground-plan of ditch segments at Magheraboy compares well with this site, but with a north–south rather than an east–west focus. Although no formal boundary was identified that divided the site, activities conducted to the south may have differed from those carried out to the north. This is highlighted by the presence of the timber structures as well as the change in ditch direction in zone 1.

## Dating the ditch segments (Table 6.1)

The radiocarbon determinations for four of the ten ditch segments would suggest that some were initially constructed between 4150 and 3935 cal. BC (probably 4100–3950 BC). It is evident that the ten ditch segments were not constructed simultaneously, with sequential construction of ditches probably occurring in zone 2. It is possible that they were perceived as unfinished entities in a constant state of renewal, whereby the smaller, shallower ditch segments would eventually evolve to the status of their larger and therefore earlier counterparts: this is supported by the dates ascertained for ditch segments 3 and 6 (zone 2). This latter segment may have been the most recent, with a construction date that may be as late as *c.* 3700 cal. BC. Dates for the Magheraboy monument show that there was Neolithic activity on this site for at least seven centuries, which was likely to have been sporadic rather than prolonged. A more comprehensive dating report, entitled 'Magheraboy radiocarbon dating' (Bayliss *et al.*), is presented on the CD at the back of this volume.

## The site interior: the rectangular structure

The archaeological remains of a rectangular structure abutted the palisade to the south of the site in zone 1 (Fig. 6.3; Pls 6.2 and 6.4). It was defined by three slot-trenches excavated into the sandy subsoil, with stone packing along their extents; the timber palisade would have formed its southern

*Table 6.1—List of radiocarbon dates from four ditch segments.*

| Ditch segment | Dated material | Submitter's no. | Lab. no. | 2 Sigma cal. BC |
|---|---|---|---|---|
| C290 **3**, zone 2 | Oak plank from base of ditch | 03E538F203S119 | Beta-186488 | 3980–3680 |
| C290 **3**, zone 2 | Oak sapwood from plank at base of ditch | Context 290/A | GrA-319161 | 3980–3780 |
| ★C290 **3**, zone 2 | Oak sapwood from plank at base of ditch | Context 290/A | OxA-X-2173-16 | 4240–3970 |
| C169 **3**, zone 2 | Hazel charcoal from northern extent | 03E538C169S159 | Beta-199989 | 3970–3780 |
| C226 **6**, zone 2 | Pomoideae charcoal from basal fill of ditch | 03E538F226S135/A | GrA-31959 | 3780–3630 |
| C226 **6**, zone 2 | Hazel charcoal from basal fill of ditch | 03E538F226S135/C | OxA-16037 | 3950–3700 |
| C371 **1**, zone 5 | Hazel charcoal from localised deposit (fire?) | 03E538C371S195 | Beta-199986 | 3950–3710 |
| C321 **1**, zone 5 | Hazel charcoal from main fill of ditch | 03E538C321S176 | Beta-199988 | 4040–3660 |
| C425 **2**, zone 5 | Hazel charcoal from fill of possible recut C459 | 03E538C425S236 | Beta-199984 | 4050–3900/ 3890–3800 |
| C382 **2**, zone 5 | Hazel charcoal from middle fill of ditch | 03E538C382S231 | Beta-199985 | 4230–3950 |
| C323 **2**, zone 5 | Hazel charcoal from fill of ditch | 03E538C323S203 | Beta-199987 | 4030–4020/ 3860–3810 |
| C376 **2**, zone 5 | Hazel charcoal from a middle fill | 03E538F376S226/C | GrA-31960 | 3710–3530 |
| C376 **2**, zone 5 | Hazel charcoal from a middle fill | 03E538F376S226/D | OxA-16021 | 3710–3540 |

★The majority of this sample appears to be derived from sediment carbon; therefore the age should be treated with caution.

gable. The slot-trenches had an average width of 0.32m, while their depths ranged from 0.08m to 0.2m. Consequently, it would appear that this structure would have been of a light or flimsy construction: it is unlikely that degradation by ploughing could account for the shallow nature of these slot-trenches. A break in the east wall towards its northern limit suggests a possible entrance to the structure. The foundations of this structure measured about 14m by 4.5m; its long axis was aligned north-east/south-west, and it had an internal area of under 63m² (678 square feet) and a length to width ratio of 3.11:1.

The structure has a number of similarities to early Neolithic rectangular houses in terms of location, size, shape and form (Grogan 2004). The setting, on a relatively gentle south-west-facing slope and possibly overlooking a lake, is very similar to that of many Neolithic houses, many of which are situated on gentle south- to west-facing slopes, which are the sunniest and therefore driest locations in the landscape (Cooney and Grogan 1999). Examples include Tankardstown South, Co. Limerick, and the partly exposed house at Pepperhill, Co. Cork (Gowen 1988), which are both located on south-west-facing slopes overlooking rivers. Many Neolithic houses also have a north-eastern entrance. While it appears to have been built in the style of an early Neolithic rectangular house, the Magheraboy structure may have been unroofed, however, and the shallow foundations would suggest that the timber walls were not as high as the uprights of the palisade

fence. No post-pits or load-bearing elements were present either within the slot-trenches or the interior of the structure. Likewise, there were no traces of either a hearth or floor surfaces. It seems unlikely, therefore, that this structure functioned as a dwelling.

Only a single sherd of Neolithic pottery was retrieved from this structure, while no other material was found in association with it that could shed light on its function. A number of possible roles for Neolithic houses are suggested here. The excavation of several causewayed enclosures in Denmark and Germany has revealed evidence for unroofed timber structures abutting the enclosing palisade. At Sarup in Denmark and Calden in Germany palisades formed a maze-like series of outworks and a number of small annexes (Andersen 2002; Oswald *et al.* 2001). The Magheraboy structure may parallel these annexes. Although no such elaborate timber structures have been identified from British causewayed enclosures, a timber screen was located behind one of the enclosure entrances at Orsett, Essex, while a possible palisade annexe, although interpreted by the excavator as a barbican, flanked the entrance of the Stepleton enclosure on Hambledon Hill in Dorset (Oswald *et al.* 2001). At Etton a large gatehouse was positioned at the northern entrance, while a small structure, interpreted as a guardhouse, marked the western entrance to the site. At the Windmill Hill causewayed enclosure a mortuary structure (a building or small enclosure associated with part of the burial ritual, such as the exposure or treatment of human remains before final burial) was located outside a possible entrance causeway. Pryor (2002) has indicated that the guardhouse at Etton resembled one of the mortuary structures excavated at Fengate in Peterborough. Another of these Fengate structures was originally believed to have been a Neolithic house but was later interpreted as a mortuary structure (Pryor 2002). Therefore one possible interpretation of the rectangular structure at Magheraboy is that it served as a mortuary structure. Timber mortuary structures are also reported from Tustrup in Denmark (Becker 1973), while O'Kelly (1984) suggested that a hut foundation unearthed during the course of the Newgrange excavations may have been a mortuary house.

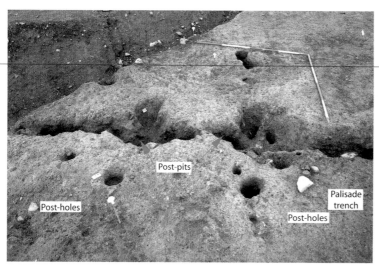

*Pl. 6.13—Foundation of possible excarnation platform/lookout tower.*

Other functions are possible. As feasting appeared to be part of the role of these enclosures (see below), it is possible that this structure was employed as a food store or animal pen. Its size and construction would have been sufficient to house animals for slaughter during feasting, particularly sheep/goat, as implied by the cremated bones of these species retrieved from the various features excavated. Alternatively, it may have had a ritual function associated with the change in direction of the palisade and ditch segment in this area. Together with the possible lookout tower or excarnation platform (structure 4 below), it may have formed part of a larger focus of ceremonial activity in this area.

*Lookout or excarnation platform and the possible circular structure*
Structure 4 is situated along the line of the palisade and is associated with the causeway between ditch segments 1 and 2 in zone 1 (Fig. 6.3; Pls 6.4 and 6.13). It is defined by a bedding trench averaging 0.4m in depth and 0.32m in width that contained post-pits dug into its base, a large quantity of packing-stones, charcoal-flecked soil and some pottery sherds. It may have functioned as a tower, lookout or podium. The focus of this structure, and possibly this part of the site, may

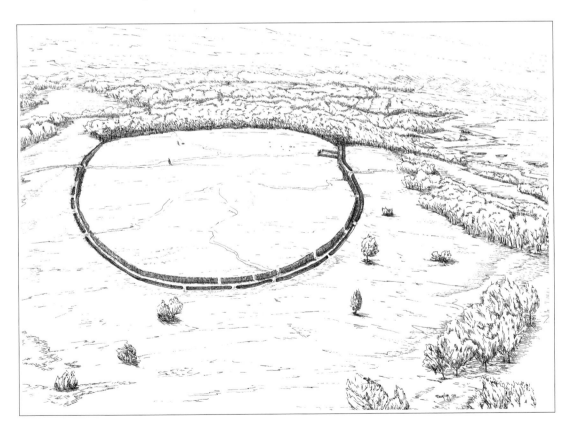

*Fig. 6.8—Magheraboy 2B and 2C: conjectural reconstruction drawing of the causewayed enclosure (John Murphy).*

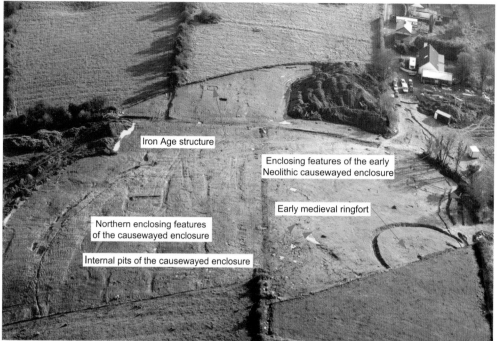

Iron Age structure

Enclosing features of the early
Neolithic causewayed enclosure

Early medieval ringfort

Northern enclosing features
of the causewayed enclosure

Internal pits of the causewayed enclosure

*Pl. 6.14 (above)—Magheraboy 2B and 2C: detail of archaeological features on the ridge at Magheraboy.*

*Pl. 6.15 (left)—Magheraboy 2C: three of the segment 2 internal pits after excavation. These three are among the only ones that displayed any discernible pattern.*

have been the now relict lake at Caltragh and/or perhaps Knocknarea to the west. It is also possible that it functioned as an excarnation platform, and similar structures are known from various Neolithic sites in Europe. These platforms appear to have been used to expose the dead in the open for a lengthy period before the remains, often by this time picked clean of flesh by carrion or vermin, underwent further rituals that in some cases at least involved formal burial.

A second internal structure may be located just below the summit of the ridge on the southern side. This may have comprised an array of posts and stakes. No clear pattern could be identified, however, and no associated artefacts or datable material were retrieved. During her excavation of the Magheraboy ringfort O'Neill (see CD) revealed a number of post-holes forming an arc. Radiocarbon analysis from charred hazelnut shells from one of these features returned a date of 3650–3510 cal. BC (Beta-197653). The ground to the west of this arc was heavily disturbed and it is possible that these features may originally have formed part of a circular structure, the other post-holes having been destroyed as a result of ground disturbance.

## Pits

In essence, the interior of the site was a predominantly vacant enclosed space (Figs 6.1 and 6.8; Pl. 6.14). The only other internal features were 55 pits, most of which appeared to have been deliberately backfilled. In most cases the fills consisted of dark deposits that may have derived from occupation layers or middens. Like the ditch fills, this material may have been specially brought to the site for the purpose of deposition. Most pits contained some Neolithic artefacts. Apart from diagnostic artefacts, many of these fills produced charcoal, seeds, cremated bone, large stones, burnt clay and dark soils. No clear patterns were identified in terms of the grouping of these pits, with the exception of three in zone 4 that formed a linear arrangement (Pl. 6.15). The majority, however, were located within a small area of the south-east quadrant.

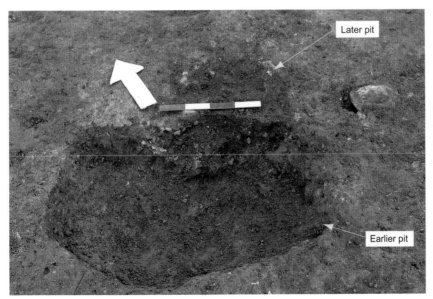

*Pl. 6.16—Magheraboy 2C: detail of a smaller, later pit truncating a larger, earlier one; only two such events were recorded on site.*

Two types of pit were discernible. The first group consisted of just two examples. These were large features (at least 1m in diameter) that had been deliberately backfilled shortly after being dug, firstly with a layer containing Carinated Bowl pottery and secondly with redeposited subsoil. Subsequently a second, smaller pit was cut into the redeposited fill, which was again deliberately filled with cultural material (Pl. 6.16). The process of creation, burial and recreation of these two pits parallels events encountered in ditch segment 3 in zone 2 as well as ditch segment 1 in zone 5. The size and form of the second pit group were similar to the recut features in the large pits. The majority of these were roughly circular in form and did not exceed 0.4m in depth, with most averaging *c.* 0.22m in depth and 0.5m in diameter.

The material placed in both pit types may represent certain aspects of domestic life that had been removed from their everyday role. Through this process of burial and removal, simple domestic refuse acquired a new ritual meaning. Similar examples are known from a number of excavated sites in Ireland. At Ballinaspig More 4 and 5, Co. Cork, a number of pits contained occupational debris consisting of Carinated Bowl sherds, stone tools, cremated bone, cereal grains and charred hazelnut shells; many also contained dark occupation debris that appeared to have been deliberately deposited (Danaher 2004c; 2004d). At Ballyconneely, Co. Clare, excavation of a prehistoric site revealed a large number of pits, some of which contained early Neolithic pottery and highly processed cremated animal bone (Chris Read, pers. comm.). At Goodland, Co. Antrim, over 170 pits of a similar nature were excavated (Case 1973). Many of the pits from the above-mentioned sites had similar dimensions to the Magheraboy examples.

It is possible that the ritualisation of objects from domestic life was carried out at each of these sites on different scales and over different periods of time. Thomas (1991) states that ritual deposition was a widespread phenomenon during the Neolithic. At the Etton causewayed enclosure a number of small filled pits were located close to the eastern ditch segments that Pryor has interpreted as the 'private' side: he suggested that the pits in this area 'commemorated departed individuals of the family whose history is recorded in the placed deposits within the nearby ditches' (Pryor 2003). He further suggested that these pits could be viewed as the Neolithic counterparts of Christian gravestones. While no pits were located near any of the Magheraboy segments, the sentiments expressed in relation to the pits at Etton resonate across the Sligo site.

## Dating the internal pits

The radiocarbon determinations for eight of the 55 Magheraboy pits suggest that not all of these features were contemporary. Three of the pits (nos C28, C125 and C92) appear to date from an early phase of activity *c.* 4200–3700 cal. BC. The other five (nos C40, C147, C221, C248 and one to the north-east of the ringfort), while showing some overlap with the earlier pits, suggest ongoing activity that continued to *c.* 3600, or possibly even after 3500 BC. This dating indicates that the pits reflect activity contemporary with the construction of the earliest enclosing ditch segments, as well as with later deposits within these features. Like the ditches, the internal pits appear to have been formed episodically over a long period of time.

*Table 6.2—List of radiocarbon dates from internal pits and a post-hole.*

| Dated material | Submitter's no. | Laboratory no. | 2 Sigma cal. BC |
| --- | --- | --- | --- |
| Alder charcoal from pit C28 | 03E538F29S23 | Beta-186483 | 4220–3700 |
| Hazel charcoal from pit C40 | 03E538F41S17 | Beta-186484 | 3650–3500 3450–3380 |
| Oak charcoal from pit C125 | 03E538F126S90 | Beta-186486 | 4240–3700 |
| Oak charcoal from secondary fill of pit C147 | 03E538F148S92 | Beta-186487 | 3790–3620/ 3600–3520 |
| Hazel charcoal from primary fill of pit C92 | 03E538C93S38 | Beta-199990 | 3990–3700 |
| Oak charcoal from primary fill of pit C221 | 03E538C230S123 | Beta-196298 | 3620–3600/ 3520–3360 |
| Oak charcoal from fill of pit C248 | 03E538C249S138 | Beta-196299 | 3620–3590/ 3530–3360 |
| ★Hazelnut shell from pit to NE of the ringfort | 03E0536F3S5 | Beta-197649 | 3770–3640 |
| ★Hazel charcoal from post-hole within ringfort | 03E0536F69S36 | Beta-197653 | 3650–3510 |

★Both of these samples derived from the excavation of the ringfort (Area 2B) by Tara O'Neill.

## The cultural material: structured deposition

It is a feature of many causewayed enclosures that the Neolithic deposits associated with them are often of a complex nature. Internal features within these monuments are quite rare and those that do exist are usually poorly preserved, therefore presenting a greater problem of interpretation (Oswald *et al.* 2001). Much of the cultural material derives mainly from the ditch segments, many of which were subjected to various recuts, deliberate backfilling and highly organised artefact deposition. Much of the understanding of these sites relies on the interpretation of these layers of 'symbolic complexity' and how particular items are placed in particular contexts, for instance whether an item was placed into the ground upside down or right side up (Pryor 2003). These small details are fundamental to our understanding not only of the sites themselves but also of the people who created them. Many items were ritually decommissioned on these sites; for instance, whole axes were often smashed prior to deposition, rendering them functionally useless. The importance of the structured deposition of cultural material was first realised by Isobel Smith in 1965 on examination of the evidence from Windmill Hill; she interpreted this as the remains of 'communal feasting buried ceremonially in the course of episodic visits' (Oswald *et al.* 2001).

Unfortunately, owing to acidic conditions no bone other than tiny fragments of cremated material survived at Magheraboy. It is quite conceivable, however, that unburnt bone originally nestled within the dark midden-like material together with the sherds of pottery, lithics and other

*Table 6.3*—*'Probability distributions of dates from the enclosure ditch and Neolithic pits. Each distribution represents the relative probability that an event occurred at a particular time. For each of the dates two distributions have been plotted, one in outline, which is the result produced by the scientific evidence alone, and a solid one, which is based on the chronological model used. The other distributions correspond to aspects of the model. For example, the distribution* First build Magheraboy enclosure *is the estimated date when the enclosure's ditch was dug. Dates followed by a question mark have been calibrated (Stuiver and Reimer 1993) but not included in the chronological model for reasons explained' (after Whittle et al., forthcoming) in the dating report on the CD at the back of this volume. 'The large square brackets down the left-hand side of the graph, along with the OxCal keywords, define the overall model exactly' (after Whittle et al., forthcoming).*

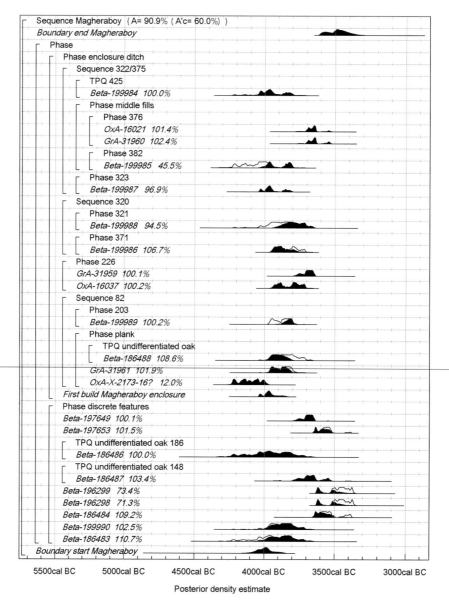

*Table 6.4—Probability distribution of the number of years during which the enclosure was in use, derived from the model shown in Table 6.3 (after Whittle* et al., *forthcoming).*

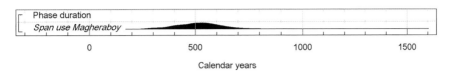

material. Of the identifiable cremated bone fragments, the majority appear to have been from sheep or goats (caprovid), while larger mammals were also represented within the assemblage. The bone would appear to be the waste from the preparation and cooking of food. Although the assemblage is of little interpretative value, the higher percentage of caprovid over cattle bone is slightly at odds with British causewayed enclosures, where feasting on cattle was the norm. The pottery within these deposits may have been used in the consumption, storage or preparation of food, and a small number of pits in the Magheraboy interior contained charred cereal grains and hazelnut shells. Could this be construed as evidence for feasting?

Much of the cultural material encountered within the midden-like deposits of the ditch segments was also found in many of the internal pits, which may suggest that the actions behind the structured deposition in the ditches were expressed on a more personal level in the digging of these small pits. Interestingly, five of the eight dated pits appear to have been formed centuries after the final backfilling of at least three of the ten ditch segments. It must be remembered, however, that some of the ditch segments in zone 2 may have been formed at different times. This suggests that structural deposition was a long-term feature of the internal pits, some of which are contemporary with the dated ditch segments. Healy (2004), in discussing the British causewayed enclosures, suggested that 'no two segments in a single ditch can be assumed to have been built at the same time'.

*Axes and related artefacts*
Taking a closer look at the various artefacts discovered at Magheraboy, we can suggest that structured deposition was a key characteristic of this site. The remains of three stone axes were recovered, two from the same primary deposit in segment 3 in zone 2 and the third from segment 1 in zone 5. Only the butt portions of the first two were retrieved: one appeared to be limestone while the other was porcellanite (a type of pyroclastic rock found only in restricted areas of County Antrim). Prior to insertion in the ditch the porcellanite axe appears to have been deliberately broken by a serious of controlled blows (Mandal, see CD), suggesting that it may have been symbolically decommissioned or, put in other terms, ritually killed. Both of these axe fragments were placed in a dark, midden-type material that was deliberately covered with clean redeposited subsoil.

The third axe did not suffer the same fate. This was a complete mudstone example that was ritually deposited in an alternative manner, lying face down and partly surrounded by 30 fragments of quartz crystals, while the point of a broken arrowhead lay above it. Like the other two axes,

these items were buried within a dark, midden-like deposit. This mudstone axe was extremely light in weight and had altered geologically. Like the limestone example, it was probably sourced locally.

Most of the quartz crystals were conical (Pl. 6.17). These items occur naturally but would have been specifically selected for burial with the axe. Quartz is found in a number of Neolithic contexts, including burials such as Drumrath court tomb in County Donegal, where sixteen similar pieces were recovered from the central burial chamber during excavation in 1996 (Joanna Nolan, pers. comm.). They have also been found in caves associated with Neolithic burials. The association of quartz with burials appears to have withstood the test of time: the recent excavation of a medieval graveyard in Ballyshannon, Co. Donegal, revealed that quartz was placed in the hands of many of the dead prior to burial, while up until the 1950s in Scotland it was a common tradition to place quartz in the mouth of a deceased person (Michael MacDonagh, pers. comm.). Quartz is highly symbolic, representing transparency and cleanliness, and also has a number of mystical properties. Banging two pieces of quartz together produces a bright, lightning-like flash of light known as triboluminescence (Lewis-Williams and Pearce 2005), and in sunlight it can act as a prism, filtering light through it. In their book *Inside the Neolithic mind* David Lewis-Williams and David Pearce (2005, 256–60) explore the ritual associations of quartz in the Neolithic, principally the notion that quartz may have been viewed as a 'gateway to other dimensions'. Various ethnographic studies from around the world clearly indicate the close correlations between quartz crystals and spiritual beliefs (*ibid.*).

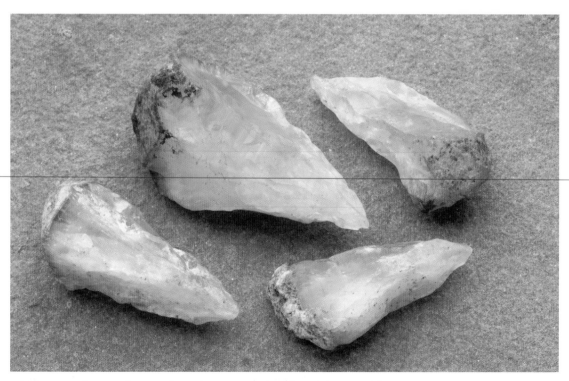

Pl. 6.17—*Selection of quartz from the causewayed enclosure (J. Hession).*

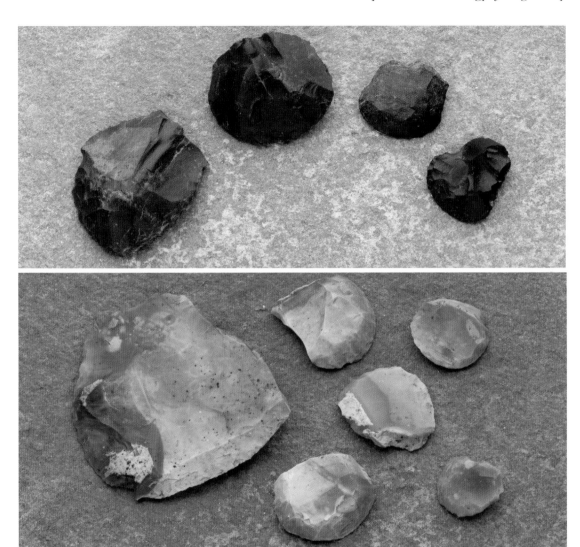

*Pl. 6.18—Selection of chert and flint scrapers from the causewayed enclosure (J. Hession).*

*Lithics*

The lithics (stone tool) assemblage indicates manufacture on site, but the low number of cores and primary flakes compared with the relatively high quantity of debitage suggests tool finishing rather than tool production from nodules (Pls 6.18 and 6.19) (Guinan and Nolan, see CD). The range of artefacts in the assemblage as well as the deposition pattern are similar to many of the excavated causewayed enclosures of southern Britain. All the lithics in the assemblage were recovered from the fills of the enclosing ditches and the internal pits, with contexts C321 of ditch segment 1 in zone 5 and C81 of ditch segment 3 in zone 2 containing 93 and 23 items respectively. Combined,

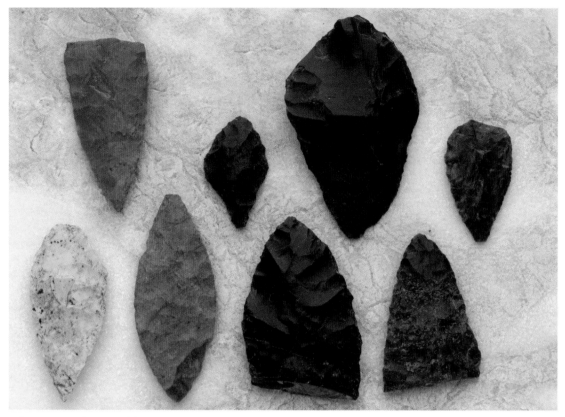

*Pl. 6.19—Selection of flint and chert arrowheads from the causewayed enclosure (J. Hession).*

the lithics from these ditch fills accounted for 34.2% of the total assemblage. This may indicate preferential treatment of these two ditch segments. In this context C321 produced quartz crystals—the only 'exotics', other than the porcellanite axe, retrieved from the site. Also recovered from segment 1, zone 5, was a flint arrowhead (one of twelve arrowheads from the site); this appeared to be unused and was associated with Carinated Bowl pottery and cremated bone. These items were retrieved from a small pit that had been cut into deposit C321.

*Pottery*
The excavation at Magheraboy produced a total of 1,229 sherds of Carinated Bowl pottery (860 sherds from 2C and 369 sherds from 2B), representing a minimum of 36 vessels. The assemblage is a homogeneous group in terms of both fabric and form. Although four different clay fabrics were present, there was no variation in the form constructed from the different fabrics, and, in the absence of later modified types, it is clear that the material dates from before 3600 cal. BC (Gormley, see CD).

Some differences were noted between the pottery from the ditch segments and that from the

pits, with the former being more fragmented and abraded than the latter. It would seem that the pottery in the ditch has been exposed to the elements to a greater extent than the pottery in the pits prior to being sealed in its context (Gormley, see CD). Two pits contained fewer than 28% of the total number of sherds recovered from the site, while contexts, both in the pits and ditches, often contained the remains of more than one pot, perhaps only one or two small sherds from each vessel. Some contexts were notable in that they appeared to hold only the remains of one vessel, for example ditch fills C325 and C388/418 and also pit fills C29, C233, C275, C041 and C055 (Gormley, see CD).

Unfired clay containing various tempers was deposited in a number of ditch segments and pits. Much of this material resembled Carinated Bowl pottery. It is possible that this clay had been moulded into the shape of vessels but, rather than being fired, was deliberately dismantled and deposited in various features. If this pottery was intended to be ritually deposited, firing may not have been deemed necessary. In comparison, a poorly fired pottery vessel containing charred cereal grains was found in the ditch of a recently excavated causewayed enclosure in Peterborough, close to the causewayed enclosure at Etton. It has been suggested that this pottery was probably constructed specifically for structured deposition (www.channel4.com/history/timeteam/).

The pottery assemblage from Donegore Hill amounted to over 45,000 sherds from the excavated 3% of the site. In comparison, the Magheraboy assemblage is small. Prior to the excavation at Magheraboy no Carinated Bowl pottery was known from this area of County Sligo, with the nearest example coming from the Creevykeel court tomb some 30km to the north (Hencken 1939).

*Domestic material*

The deposits within the various ditches and pits contained what can be described as domestic material, much of it possibly refuse. Although it is similar to the material from refuse or collection pits identified from settlement sites of the same period, it is unlikely that the Magheraboy pits served the same function. At this location, the domestic material was probably expected to take on a new role following deposition.

# General comments

If the Magheraboy enclosure and the activities carried out within it were seasonal, the site may have evolved in a number of ways, physically, spiritually and conceptually, with the passing of each year. With its reputation continually expanding, the monument would have become an important feature of the landscape and would also have been established in the minds of the local and neighbouring Neolithic communities. The site itself may have been viewed as an active entity that was never complete, requiring continual care and effort. This is reflected by the activities associated with a number of the ditches, such as structured deposition and recutting. Ditches of many of the British causewayed enclosures as well as their European counterparts provide evidence of

numerous recuts, which are frequently associated with ritual deposits. This process of continual deposition in the ditches of these monuments again suggests that they were never regarded as finished entities but rather as ongoing projects (Oswald *et al.* 2001). It must be noted, however, that not all contained recuts while many were short-lived, surviving less than two generations (about 50 years).

The excavation at Magheraboy revealed evidence for the constructional elements in the form of ditch segments and bedding trenches of timber palisades. No surviving banks were evident. Having established the site boundary, it is difficult to determine whether the ditch segments or the timber palisade came first or whether they were established simultaneously. The plan of both along the south of the site (zone 1) suggests that they were contemporary with each other, with any change in direction being shared by both features. In general, they remained parallel to each other at a distance of about 3m throughout the site. Creation of the ditch segments prior to the palisade would have been advantageous, as they may have acted as quarries providing stone for use as packing in the palisade trenches. To the south of the site (zone 1) the combined distance of the palisade trench was roughly equal to the combined length of the ditch segments. A similar comparison cannot be made of these features in the south–east of the site (zone 5) owing to the possible destruction of much of the palisade there, perhaps as a result of modern activity. Along the north (zone 2), the combined length of palisade trench was much greater than the combined length of ditch segments in this area. At this location, the palisade curved from roughly east to west around the ridge and continued beyond the western limits of excavation. The probable sequential ditch segments of zone 2 were confined to the eastern and mid-section of this area, but whether the intention had been to form more segments beyond this point that ran parallel to the palisade must remain a matter for conjecture. Geophysical survey west of the site limits may reveal further ditch segments, however.

If it had been the intention of the Neolithic builders of this site to provide substantial views of the surrounding landscape from the summit of the ridge, a large area would have had to be cleared. Using the gradient of the hill set against the height of oak trees, it is possible to establish the extent of the area that had to be cleared of trees to provide these views. These figures would also ascertain whether the ditches delineated this cut-off point or whether trees still needed to be cleared beyond these points. On average, an oak tree will reach heights of 110ft (33m). The summit of the hill is *c.* 50m OD (above Ordnance Datum). To the north of ditch segment 3, zone 2, the height is *c.* 23m OD, a difference of 27m; to the south of ditch segment 2, zone 2, the height is *c.* 40m OD, a difference of 10m. If the ditches delineated the actual area of the ridge that was stripped of trees, then views of the surrounding landscape would have been restricted, particularly to the south towards the Caltragh valley and the possible lake at this location, which was at a height of 33m OD. Therefore, in order to provide unrestricted views of the lake within the Caltragh valley much of the area between this and the causewayed enclosure would have needed to be cleared of large trees. This is particularly relevant if the timber structure located along the line of the palisade directly north of the causeway between ditch segments 1 and 2 of zone 1 was indeed a lookout tower intended to overlook the Caltragh valley. In effect, this would suggest an association between

the two places; the location of causewayed enclosures on high ground close to wetland areas has been mentioned above, with the Sarup-type enclosure sites in Denmark being prime examples. On the other hand, the slope to the northern side of the ridge was much steeper and a much smaller area would have needed to be cleared of large trees here. The area of wetland to the north of the ridge had a height of *c.* 23m OD.

## The site in context: some Irish parallels

Only a small number of close parallels for Magheraboy occur in the Irish archaeological record. A larger number of mainly British comparisons are discussed below. Of the Irish sites only Donegore, Co. Antrim, contained segmented ditches, but the palisaded fences and finds assemblages of the other sites, in particular Carinated Bowl pottery, are characteristics that are shared by all.

*Donegore*
Before the discovery of Magheraboy, the only similar enclosure known from Ireland was, as previously mentioned, at Donegore Hill, Co. Antrim (Mallory and Hartwell 1984). This roughly oval site, located near the summit of a hill at 234m and overlooking the Six Mile Water Valley, was defined by two concentric interrupted ditches and the bedding trenches of two timber palisades. No more than 5% of the site was excavated. The outer ditch enclosed an area measuring 219m by 175m (2.6ha or 6.4 acres), while the inner enclosed an area of 2ha (4.8 acres); the ditches were 3m wide and 1m deep.

There are a number of similarities between the ditches at Donegore and Magheraboy. Neither appears to be defensive in nature, while the ditches do not consistently follow the hill contours, a feature evident in many causewayed enclosures of southern Britain. The outer ditch at Donegore has been dated to 4000–3700 BC, while the inner ditch dates from between 3800 and 3400 BC. A date range of 3900–3200 BC has been established for activity within the interior, and although the site has been badly damaged by repeated ploughing, traces of some structures have been recovered.

Finds from the site include approximately 49,000 sherds of Carinated Bowl pottery, representing at least 1,500 vessels (A. Sheridan 2001), a large quantity of both flint waste and artefacts, numerous fragments of porcellanite axes and about half a dozen polished beads and pendants (Mallory and Hartwell 1984). The stone axes appeared to have been deliberately broken, while the large quantity of pottery and lithics suggests either prolonged small-scale deposition or more episodic activity. Occupation of the site may have been as short as 300 years or as long as 900 years (Cooney 2002).

*Timber palisades in Ireland*
Gibson (1998) has described the timber palisades at Donegore, as well as at a number of other sites that are similar in size and construction, as fencing and has distinguished them from the much

larger free-standing posts of later Neolithic palisaded enclosures. These fences would have stood to an average height of 1.5m.

A similar example of this fence-type palisade was identified 6km to the south-east of Donegore Hill across the Six Mile Water Valley. Here, on the prominent landmark of Lyles Hill, Co. Antrim, following limited investigation by Evans (1953), excavations during the 1980s revealed two roughly parallel lines of palisade trench (Gibson and Simpson 1987). A late prehistoric hillfort encloses the top of this hill; the palisade trenches were located within the south-east of this enclosure at a distance of 40m from the hillfort's bank. The trenches were 3–6m apart, while both bedding trenches contained packing-stones and a large quantity of modified Carinated Bowl pottery. The inner palisade has been dated to 3330–2920 cal. BC, while a date of 2600–2350 cal. BC was obtained for the outer palisade. Evidence of Neolithic activity was retrieved both inside and outside the palisade trenches, with a date of 3650–3250 cal. BC being established for a hearth. Like the trenches, this hearth contained Carinated Bowl pottery and provides the only date that is comparable to the Magheraboy and Donegore dates for similar pottery. Although both trenches could relate to an enclosure, additional work is required to establish this.

Two definite timber palisaded enclosures have been unearthed at Knowth, Co. Meath, and Thornhill, Co. Derry (Eogan 1984; Logue 2002). Both sites are associated with a domestic or farming role but Thornhill may also have had trade links. At Knowth two curved palisade trenches were recorded. These post-dated the earliest Neolithic phase of occupation but pre-dated the construction of the passage tomb dating from the middle Neolithic (Eogan 1984; Eogan and Roche 1997). The trenches had a length of almost 60m and would have contained upright posts set closely together, each with an average diameter of 0.25m; this is very similar to the diameter of the posts within zone 5 (which averaged *c.* 0.23m in diameter). The palisade trenches were located 8–11m apart at the western end of the ridge overlooking the Bend of the Boyne. Estimations of the overall diameters of the enclosed areas have been calculated as *c.* 70m for the inner palisade and *c.* 100m for the outer palisade. As with the northern portion of the palisade at Magheraboy, gaps were evident along the trenches, with the most noticeable being located along the inner trench where a 3m-wide gap was pebbled, possibly denoting a formal entrance. This gap was not mirrored in the outer palisade, which tentatively implies that they were not contemporaneous. The excavators (Eogan and Roche 1997) have interpreted these trenches as forming part of a palisaded enclosure that has been subjected to differential preservation. Pottery associated with the palisade is of modified Carinated Bowl type and later than that found at both Magheraboy and Donegore Hill. Although no dates are associated with the palisades, a date of between 3800 BC and 3500 BC has been proposed for the structure (A. Sheridan 2001). Grogan and Roche (2002) suggest that the palisade would have formed a stockade for cattle beside a settlement area and that it may have been up to 2.5m high. They also propose that this activity dates from the end of the early Neolithic period, *c.* 3500–3300 BC.

The Thornhill site was located on a low ridge on the banks of the Foyle at approximately 36m OD. Several phases of palisade construction appeared to have been present and it is possible that burning destroyed elements of them, while arrowheads found in the vicinity of these structures

might indicate an attack. The enclosure measured almost 100m in diameter. At least five timber buildings, both round and rectangular examples, were contained within, while hundreds of stake-holes, post-holes, pits and spreads of occupation debris indicated a variety of activities undertaken on the site. A wide range of artefacts were recovered: these included flint projectile points, stone and flint axes, various flint and stone tool types, stone beads, saddle querns and sherds of Carinated Bowl pottery, as well as evidence for the working of quartz (Logue 2002). An early fourth-millennium date is expected for the site.

*Other possible causewayed enclosures in Ireland*

Examination of aerial photographs of the Lough Gur area, Co. Limerick, has revealed what could possibly be the outline of a causewayed enclosure west of the Knockadoon peninsula, but investigation of the site needs to be carried out to substantiate this (Eoin Grogan, pers. comm.). Recent excavations of a kidney-shaped enclosure at Kilshane, Co. Meath, measuring 38m north–south and 27m east–west, revealed a considerable quantity of cattle bone in the ditch fills. Overlying these bones was a silty deposit that contained some Neolithic pottery, while Bronze Age artefacts appeared to have been deposited in the upper fills. In addition to this ditch, a curvilinear feature was located nearby; this comprised two ditch segments separated by a causeway of undug soil. Though this site has a number of similarities to causewayed enclosures in Britain (Dermot Moore, pers. comm.), it has recently been interpreted as a late Neolithic henge (see FitzGerald 2006).

*Other Neolithic monuments in Ireland*

Cooney (2002) has identified five other hilltop enclosures that may be Neolithic in date in addition to the hilltop enclosures at Donegore Hill, Magheraboy, Thornhill, Knowth and the possible enclosure at Lyles Hill. Of these, Turlough Hill, Co. Clare, has a number of features similar to the causewayed enclosures at Magheraboy and Donegore. Situated on the northern end of Turlough Hill at 240m OD, a conspicuous feature of this site is the segmented nature of the enclosing stone wall, which 'may be an expression in stone of a form of interrupted enclosure normally represented as an earthwork' (Cooney 2002). Internally, the site measures 200m north–south by 220m east–west, while the wall is 1–1.75m high and 1–4m wide, with up to twelve deliberate breaks in the stone wall. The only traces of structures within the interior were a number of semicircular hut sites adjoining the wall. There are additional hut sites on higher ground to the south-west of the site. It is possible that this site may equate with certain 'tor enclosures' in south-west England—granite-built enclosures, some with narrow entrances set at relatively frequent intervals, and potentially of early Neolithic date. 'Cliff castles' in Cornwall and certain stone-built enclosures in south Wales may also be comparable in form (Oswald *et al.* 2001). Further information on the hilltop enclosure at Turlough Hill will only be gleaned through excavation, however, as the site is undated.

*Ritual deposition in Ireland*

At both Magheraboy and Donegore it was evident that the ditches reflected various episodes of

deposition, much of it the focus of ritual activity. While these two sites may be grouped together under the site type of causewayed and palisaded enclosure, other Neolithic sites of later date also revealed deliberate deposition in their ditches. These include Goodland, Co. Antrim, Scotch Street, Armagh (Cooney 2002), and possibly Tullahedy, Co. Tipperary (McConway 2000).

Goodland is worthy of further mention. Dating from 3650–2900 BC, this site consisted of a roughly square ditch arranged in eight peculiarly shaped segments. A large number of deposits consisting of boulders with sherds of pottery and flints were placed within these segments. As at Magheraboy, the ditches appear to have been deliberately backfilled. Apart from the segments, over 170 pits were present within a small area measuring 13m by 15m. These were very similar in form to the pits excavated at Magheraboy and contained similar items, such as pottery sherds, flints and boulders (Case 1973). The ritualisation of these domestic artefacts within deliberately backfilled pits and ditch segments suggests a series of votive deposits associated with the sealing of flint extraction pits (Cooney and Grogan 1999, 51).

This type of structured or ritual deposition of items of domestic life, which is shrouded in symbolism, has been encountered during the excavation of some rectangular Neolithic houses in Ireland. At Ballygalley, Co. Antrim (Simpson 1996; Simpson, Conway *et al.* 1994), thousands of artefacts were associated with the early Neolithic house (3776–3386 BC), while recent evidence suggests that it was contained within an encircling ditch. Simpson (1996; Simpson, Conway *et al.* 1994) believed that the house was more than just a habitation site and felt that the finds and the way they were deposited paralleled the type of activities that went on at causewayed enclosures.

## The British evidence

The number of known sites increased dramatically throughout Britain during the 1970s as a result of aerial prospection, with 69 examples now identified. This has helped to define the geographical distribution of this class of monument. Prior to the 1970s, sites were mainly known from the uplands of southern England and were recognisable on the ground. The newly discovered sites were located on the river gravels of the south and east midlands (Mercer 1990). Although most causewayed enclosures in Britain are confined to southern and central England, outliers are known on the Isle of Anglesey, the Isle of Man and Aughertree Fell, Cumbria (Horne *et al.* 2002), for example. With reference to the causewayed enclosures of Britain, however, Oswald *et al.* (2001) point out that 'despite their importance, the activities that went on within the enclosed areas remain only dimly understood'. There is no single explanation for the function of these sites, nor has it been ascertained why they were built. Further possibilities emerge with each new discovery and site excavation. Most, if not all, appear to have been built in densely wooded landscapes; this newly created space could have been utilised in a wide variety of ways. In Britain research since the 1920s indicates that these sites were used as periodic meeting places for several communities and that the activities conducted during these meetings may have involved the 'holding of initiation ceremonies, matchmaking and weddings, the exchange of stock and seed-corn and

perhaps of more durable goods. Rites and ceremonies are performed to ensure the fertility of the flock and herds and the growing of the corn, and finally to celebrate the harvest' (Smith 1965). The closest modern parallels to these sites are the community halls that are present in most towns. Both in effect are communal monuments where space is provided to cater for a wide variety of events and purposes but with all activities occurring under the auspices of the community. With causewayed enclosures, however, these activities were likely to have had more profound ceremonial/ritual connotations, as ritual and everyday life in the Neolithic would almost certainly have gone hand in hand and should not be viewed as existing separately from each other in the way they do today.

As previously mentioned, the ditch segments of most of these sites were never intended to act as physical obstructions but rather as boundaries separating sacred places from the outside world. At Magheraboy the ditches appeared to have been deliberately backfilled, so the role of defining the enclosed space would have been fulfilled by the timber palisade. The creation of an open space that was formally bounded in a landscape where fields or other land divisions were few and far between would in itself have afforded the site a special significance. In his interpretation of Etton, Pryor (2003) felt that the enclosure could have provided a liminal place, between one world and another. If the ritual deposition of objects in the ditch segments and pits was associated with the dead, then the enclosures may also have represented an entry point to the afterlife.

Examination of the current archaeological literature on this class of monument offers a wide range of interpretations, including political, topographic, social, ritual, economic and defensive functions (see Malone 2001; Oswald *et al.* 2001; Varndell and Topping 2002; Mercer 1990; Darvill and Thomas 2001). The quantity and quality of goods evident from these sites suggest high status and demonstrate the ability of the occupants to engage in a wide network of social interaction and exchange (Malone 2001).

In the case of Magheraboy, it is likely that the site was multifunctional. Apart from the ceremonies associated with both the private and communal offerings, the enclosure would have played host to gatherings of the local community and possibly visiting communities, when a wide range of activities would have taken place. These would have varied from rites of passage to exchange of goods and feasting. The numerous artefacts, cremated animal bones and charred seeds provide the only tangible surviving evidence for these events.

## European parallels

Together with ideas, lifestyles and material culture, the origins of these monuments can be found in the earlier Continental Neolithic, in particular the *Bandkeramik* cultures of west central Europe. The earliest enclosures date from between 5000 and 4200 BC. These early sites were succeeded by examples in northern Germany, western France, Denmark, Britain and Ireland, most between 500 and 1,000 years later (Pollard 1997; Oswald *et al.* 2001). Surprisingly, Irish sites appear to have followed relatively quickly, with construction dates for both Magheraboy and Donegore Hill

possibly starting around 4000–3800 BC.

Based on an enclosure at Darion in Belgium, which, although classed as a causewayed enclosure, contained evidence for settlement in the form of longhouses, Bradley (1993) suggested that this and similar types of enclosures of early date came to be idealised. This consequently gave rise to the belief that constructing monuments with causewayed earthworks was the correct way to build communal enclosures and the idea spread across north-west Europe, perhaps aided by folk memory.

Throughout this chapter, reference has been made to numerous British and some European causewayed enclosures, in particular Etton, Bryn Celli Wen and Sarup. Sarup is located on the island of Fyn in Denmark and, like the 30 other similar enclosures known from Denmark, dates from between 3400 and 3200 BC. This site has the same structural elements as Magheraboy, as well as containing evidence of a square-fenced enclosure and an oblong-fenced enclosure, both of which abutted the palisade. Cultural layers were evident from the ditch segments as well as from the internal pits (Andersen 2002).

## Conclusions

### Numbers using the site

As regards the number of people who would have used these sites, it is a commonly held view that their construction would have required a communal pooling of labour, with the larger sites such as Hambledon Hill in Dorset involving several hundred thousand man-hours. With large numbers likely to have been involved in the construction of these sites, it is reasonable to suggest that the same people were privy to whatever went on in the enclosures (Pollard 1997). Compared to these larger enclosures, Magheraboy is quite small and would have required fewer people and less time to construct. In fact, the creation of the open space (felling of trees etc.) was probably more time-consuming and labour-intensive than the actual formation of the enclosing elements. The construction, however, would have involved the efforts of the local community and possibly of people further afield.

### Period of use and abandonment

Construction of the Magheraboy monument occurred probably two centuries before the formation of the enclosing ditches at Donegore Hill, the next in the sequence of causewayed enclosures within Ireland and Britain (3845–3670 BC but probably 3765–3690 BC). By sometime between 3590 and 3440 BC the causewayed enclosure at Donegore Hill was no longer in use. In contrast, the British causewayed enclosures do not date from the earliest stages of the fourth millennium but from a few centuries later, generally starting at 3700 BC and continuing on until 3300 BC but peaking at around 3600–3500 BC. While a number of these sites were used over a long period, probably centuries, such as Hambledon Hill, Dorset, Crickley Hill, Gloucestershire, and Etton, Cambridgeshire, many had much shorter life-spans of 50 years or less, such as Whitesheet Hill, Wiltshire, Maiden Castle, Dorset, and Whitehawk, Sussex.

Taking into account the early dates for this site and its location within a ritual landscape spanning millennia and including a large number of sites such as megalithic tombs, henges, barrows and stone circles, Magheraboy can be placed at the forefront of this sacred landscape as it is the oldest of these monuments. By 3000 BC in Britain new site types had become the focus of ritual activity and no new causewayed enclosures were being constructed. Henges and, in Ireland, embanked enclosures had now become the monuments of choice. Two hengiform enclosures are located only a few kilometres from Magheraboy, the nearest less than 2km to the south in the townland of Tonafortes while the second is *c.* 3.5km to the north in the townland of Lisnalurg. The former site is dealt with in Chapter 4.

The abandonment of causewayed enclosures at the end of the middle Neolithic suggests dramatic social change. The move away from these monuments coincided with the appearance of new types of material culture, particularly Grooved Ware, the first flat-bottomed vessels. A new range of stone and flint objects also emerged.

### The Neolithic community at Magheraboy

The advent of the Neolithic brought about a shift from the hunting and gathering of the preceding Mesolithic to a more sedentary lifestyle, one based on animal husbandry and the cultivation of cereal crops. New material technologies such as pottery and ground stone tools became part of everyday life. As a consequence of farming, food stores were created and would have been used to level out the seasonal peaks and troughs of food availability that had probably been experienced by previous populations. With these surpluses, a society could generate the resources to support the substantial seasonal workforce needed for monument construction. A hierarchical system within a community may have mobilised, organised and controlled the workforce used in the construction of monuments. Monument construction and therefore the associated social stratification that generated these sites were features of the Neolithic from the construction of the causewayed enclosures of the early Neolithic (Donegore Hill, Antrim; Magheraboy, Sligo) to the various megalithic tombs and the subsequent creation of henge-type monuments.

The large open earthworks of Magheraboy and Donegore Hill suggest that these communities might also have been part of larger social groupings that congregated at these sites, possibly on a seasonal basis. These causewayed enclosures provide the first evidence of people symbolically enclosing a space, a theme that would undergo various developments throughout subsequent periods. The archaeological record of the middle and late Neolithic suggests a preoccupation with enclosing space. In the middle Neolithic burial mounds and cairns were often associated with ditches, while in the late Neolithic embanked enclosures/henges became the monuments of choice. The enclosure at Magheraboy demonstrates that in Ireland people were constructing monuments at the cusp of the Neolithic, during the period traditionally regarded as the transition between the Mesolithic and the Neolithic. To date the evidence in Britain is in stark contrast with this, with a pre-monument Neolithic spanning at least two centuries before the first monuments, long barrows, were constructed around 3800 BC, followed by causewayed enclosures a century later.

It is likely that the construction of the enclosure at Magheraboy would have had a unifying

influence on the local community and would have brought them together in a common purpose and sense of place, while the activities carried out there would undoubtedly have had a bonding effect on all the participants. Compared with Donegore, the activities at Magheraboy were carried out on a much smaller scale; this may reflect differences in community size. The enclosing elements of Donegore, in particular the ditches, are greater in both size and quantity than those excavated at Magheraboy. While a large portion of Magheraboy was excavated (possibly up to 50%), the artefact assemblage is minuscule when compared with that from Donegore, of which only 3% has been excavated. The larger assemblage may be explained either by greater numbers of people visiting the Donegore site or else by more prolonged occupation. Despite the difference in the size of the assemblages, however, there are distinct similarities in the artefact types, and in particular the early Carinated Bowl pottery.

## Site development

Looking at the form of Magheraboy, particularly the enclosing elements, it appears that these features were transient. At the outset, the construction of the timber fence would have afforded the site a more permanent character—otherwise it would only have appeared as a clearance within the forest cover. The palisade did not show signs of having been repaired or replaced, however, and would have had a lifespan of less than 30 years. Many if not all of the ditch segments would have been backfilled soon after being formed and therefore may not have been easy to detect. The majority of the ditch segments excavated did not show signs of recutting and it is possible that the formation of each ditch occurred in stages, becoming progressively wider and deeper with the passing of each subsequent stage. This would leave little or no trace in the archaeological record. Work on each of the ditch segments could have occurred on separate occasions, and therefore a complete circuit could take much time to complete. In other words, no two segments were necessarily constructed simultaneously. At Magheraboy a complete circuit of ditch segments was never formed; this could indicate that the site was never fully completed, even though there is evidence that people visited this location for centuries.

## Site history

Overall, the radiocarbon determinations for three of the ten ditch segments suggest a date of construction possibly at the very beginning of the Neolithic in Ireland. Later dates, ranging from 3700 to 3400 BC, were returned for a number of the internal features. The late fifth/early fourth-millennium dates for the construction of this monument do not have any parallels in either Ireland or Britain, and we have to look towards western and central Europe for contemporary monuments.

It is likely that the first stages of the site at Magheraboy were constructed over a brief period, with many of the excavated features possibly having been formed in less than a generation. Subsequent construction and activity were piecemeal and were spread out over a period as long as seven centuries, though there seems to have been a spike between 3700 and 3500 BC. Interestingly, but possibly not coincidentally, this occurs at the same period when these monuments were being created in Britain.

Many of the ditches appear to have been backfilled and their depositional sequences completed before many of the internal pits were dug, suggesting that the site was likely to have been unenclosed at this point. The palisade had long since decayed and the ditches had filled up, possibly now existing only as very shallow depressions. Therefore the site itself, or the sacred space which it may have come to represent, was no longer bounded by timber fences and earthworks. Consequently, the site may have been transformed from a physically into a metaphysically enclosed space, where the memory of ancestors and past enclosures now marked off this sacred space from the outside world. If this was the case, the history of the enclosure can be separated into at least two separate phases. The first phase related to the site when it was physically enclosed and when it was characterised by structured deposition within the ditches and some internal pits. No enclosing elements marked the second phase while structured deposition was confined to pits, although at least one new ditch segment was added to the north of the site.

## The site in the prehistoric landscape

Whatever its origin, Magheraboy is likely to have been an integral part of the prehistoric landscape of this region. Within a radius of a few kilometres of the enclosure there are numerous later prehistoric sites; many of these are ritual in nature and form part of a wider ritual monumental presence within the Cúil Irra peninsula. Most of these sites are to the west of Magheraboy, which may have been the point of origin for the ritual landscape in this region. Pryor (2003) has observed that causewayed enclosures often give rise to ritual landscapes that include a wide variety of late Neolithic and early Bronze Age ceremonial sites, such as dozens of henges, barrows and other 'shrine-like places'.

# 7

# THE LATER ARCHAEOLOGICAL SITES
# AT MAGHERABOY

## Introduction

While the early Neolithic causewayed enclosure was the most significant site at Magheraboy, numerous other traces of life were evident in this townland, ranging in date from the late Neolithic to the post-medieval: these sites are reviewed in this chapter. Two of the sites, the ringfort and the penannular structure, were situated on the ridge and occurred within the earlier Neolithic monument; another site (prehistoric pits) was present to the south of the ridge, while the remaining sites (*fulachta fiadh*) were in the marshland to the north. These sites will be dealt with chronologically.

## Area 2D: *fulachta fiadh* Magheraboy 1, 2 and 3

North of the causewayed enclosure the ridge gave way to an area of low-lying marshland where much burnt mound activity was discovered. Excavations revealed at least three, if not four, distinct *fulachta fiadh* in a relatively small area; dates for these sites range from the late Neolithic/early Bronze Age to the late Bronze Age and provide further proof of a continued prehistoric presence in the area. These sites are discussed in greater detail in Chapter 3.

## Area 2A: prehistoric pits

*Location*
Although technically within the townland of Caltragh, Area 2A will be discussed in association with the archaeology of the ridge at Magheraboy. The site was located in grassland along the lower southern contours of the Magheraboy ridge, which at this point sloped gently in a southern direction down into the Caltragh valley. As with most of Sligo, Knocknarea dominates the view to the west; to the east trees and hedgerows restricted the view, while only the southern summit of the ridge was visible to the north. The archaeology of Area 2A comprised two discrete concentrations of pits, group A and group B; the first group consisted of five pits and two deposits

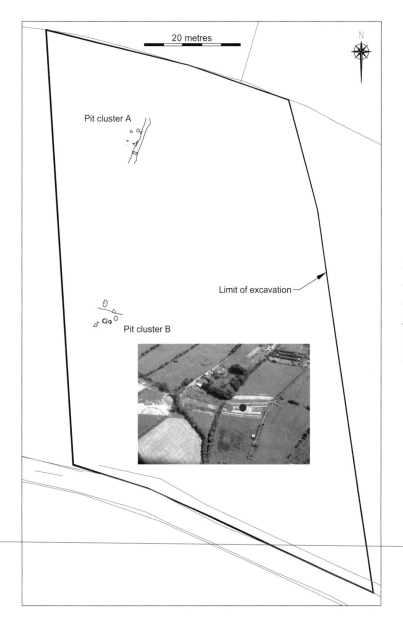

*Fig. 7.1—Caltragh 2A: location of pit clusters 1 and 2. Inset: aerial view of Caltragh 2A, showing location of pit clusters A (marked in red) and B (marked in blue).*

of burnt material, while the second contained seven pits, two of which were truncated by a post-medieval field drain. Two pits from the latter group had originally been detected during the testing phase (Henry 2003) and were situated just over 25m south-south-west of group A (Fig. 7.1).

*Group A*
Confined to an area of less than 6m², the pits formed a roughly semicircular shape, with the widest opening present to the south-west. A post-medieval field drain truncated the eastern edge of two

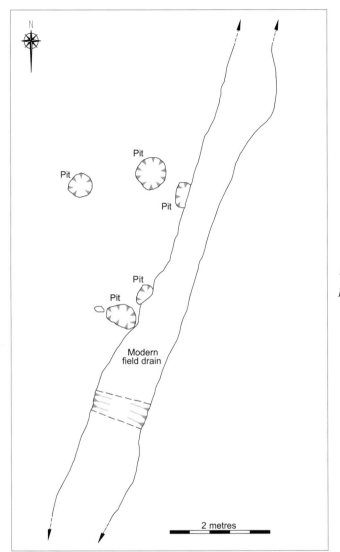

*Fig. 7.2—Caltragh 2A: post-excavation plan of pit cluster A.*

of the pits and may possibly have destroyed a third that could have been sited between the truncated examples. The pits were generally oval to circular, with an average diameter of 0.4m and a depth of 0.2m (Fig. 7.2). All the pits contained a similar charcoal-enriched primary fill, while at least four contained one or more of the following: coarse undecorated pottery, cremated bone, chert and flint debitage (Table 7.1). Pottery was retrieved from two of these features and comprised body sherds only, with no diagnostic rim or base sherds present. Cremated bone was found in two pits but was also undiagnostic. Surprisingly, given its scarcity in County Sligo, flint accounted for the majority of the lithics in this group of pits and appears to represent tool-manufacturing debris. Although no primary flakes were recovered, some of the debris was shatter, a by-product of core knapping (Guinan and Nolan, see CD).

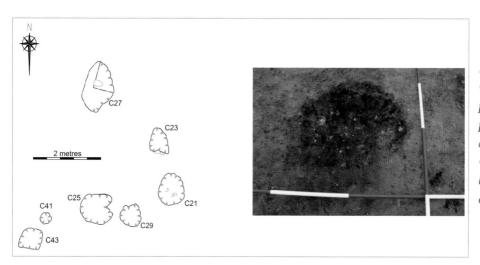

*Fig. 7.3—Caltragh 2A: post-excavation plan of pit cluster B. Inset: C21 from east before excavation.*

## Group B

The pits in this second group were generally larger than those in group A, measuring on average 0.65m in diameter, and were cut in a more regular subcircular shape with an average depth of 0.2m (McCabe, see CD). All seven were contained within an area measuring roughly 7m². They did not form a regular pattern but were situated relatively close together (Fig. 7.3). Some of the pits contained several fills but there was no evidence for recutting and all contained charcoal. Other inclusions present in some of the pits comprised cremated bone, burnt stone, water-rolled stones and struck chert, while five chert scrapers were retrieved from three of the pits and sherds of coarse undecorated pottery from another (see Table 7.2). Chert was the predominant material used in tool manufacture in this group and it is likely that the material from group B represents the product of tool-making, hence the chert scrapers.

## Dating and discussion

While a number of similarities exist between both groups of pits in Area 2A they are not necessarily contemporary, nor is it correct to assume that they fulfilled the same function. The most compelling evidence to support this is provided by the analysis of the lithics, which indicates that different processes were carried out within each group, while the techniques used in each are characteristic of different periods of tool manufacture (Guinan and Nolan, see CD). The group A pits appear to be associated with the primary reduction of flint, as indicated by the presence of a flint core and flint-knapping waste; no finished tools were present in this group. The high-quality chert associated with group B may be the product of tool-making or finishing, while platform technology applied within each group would tentatively suggest a Neolithic date for group A and a late Neolithic/early Bronze Age date for group B (Guinan and Nolan, see CD). Of the four charcoal samples sent for wood identification, three were of oak while the fourth was the remains of hazel rods, which were nine years old when burnt (O'Carroll, see CD). Radiocarbon analysis

of this latter charcoal sample obtained from one of the group A pits returned a date of 2890–2500 cal. BC (Beta-194431); no other dates were obtained for this site. A similar late Neolithic date was obtained for one of the *fulachta fiadh* (Magheraboy 1) on the other side of the ridge at Magheraboy (see Chapter 3). Interestingly, no other contemporary dates were obtained for features recorded in the area between these two sites.

The excavator has cautiously suggested that Area 2A represents the remains of a local burial-ground (McCabe, see CD) of the late Neolithic and bases her findings on the combination of cremated bone and artefacts in the form of lithics and pottery recovered from a number of the pits. Of the five cremated bone samples sent for analysis, two were unidentifiable while the other three contained animal remains; none of the other pits contained bone, and it has been suggested that the pits may represent token burials—the ritual recognition of a person's life without the presence of any actual remains. As seen in Chapters 5 and 6, this 'ritualisation' of everyday objects was a fundamental element both of the early Neolithic causewayed enclosure discovered at the summit of the Magheraboy ridge and of middle Bronze Age life in Caltragh. The material placed in many of the pits associated with these latter sites was likely to have been a representation of certain aspects of domestic life that had been removed from their everyday role. Through this process of burial and removal, they had acquired a new ritual meaning. Whether the activities carried out at Area 2A may have been a continuation or an extension of the type carried out at the causewayed enclosure is uncertain. While similarities do exist, a line has to be drawn between a pit that clearly represents domestic waste and one that represents the ritualisation of objects from domestic life. Much of our understanding of these sites relies on our interpretation of these layers of 'symbolic complexity' and how particular items are placed within particular contexts, for instance whether an item was placed into the ground upside down or right side up (Pryor 2003). These small details are fundamental to our understanding not only of the sites themselves but also of the people who created them.

Initial examination of the group A pits suggests that much of the material is everyday waste, burnt stone, charcoal, flint-knapping material, broken pottery and cremated animal bone, seemingly deposited haphazardly in the pits. There were no finished tools. Closer consideration of the material together with the date obtained for the site implies, however, that the site is probably ritual in origin. The late Neolithic date returned for pit C4 in group A suggests that the pottery from this site is most likely to be Grooved Ware; taking into account the other material within these pits, this type of deposit is certainly reminiscent of those from pit circles (E. Grogan, pers. comm.), which at Newgrange produced cremated animal bone (Eogan and Roche 1997; 1999). While neither cluster is likely to represent a pit circle by itself, they may well represent a similar type of ritual deposit. Recently, similar late Neolithic material has been identified in the north-west. Excavations associated with the Bord Gáis pipeline at Cloonbaul/Kilbride in County Mayo revealed the remains of a timber circle (Cotter, forthcoming). Ninety-seven sherds of Grooved Ware were retrieved from this site, while a pit containing 1,500 sherds of Grooved Ware was discovered at Lowpark on the Charlestown bypass (Roche and Grogan 2006). If indeed these pits are associated with ritual activities of the late Neolithic, then they demonstrate the sustained

*Table 7.1—Group A pits.*

| Pit no. | Pit fills | Lithics | Cremated bone | Pottery | Other inclusions | Wood | R/carbon dating (cal. BC) |
|---|---|---|---|---|---|---|---|
| C4 | C7 | Chert & flint debitage | Small fragments, unidentifiable | | Burnt stone | Hazel rods | 2890–2560 2520–2500 (Beta-194431) |
| C5 | C6, C14 | Flint debitage | | Coarse undecorated | Burnt stone | | |
| C8 | C9 | Flint debitage | 11 fragments, unidentifiable | Coarse undecorated | Burnt stone | Oak | |
| C11 | C12 | | | | Burnt stone | | |
| C19 | C20, C35, C36 | | | | Burnt stone | | |
| C15 (deposit) | | | | | | | |
| C17 (deposit) | | | Flint debitage | | | | |

*Table 7.2—Group B pits.*

| Pit no. | Pit fills | Lithics | Cremated bone | Pottery | Wood identification | Other inclusions |
|---|---|---|---|---|---|---|
| C21 | C22, C33, C39 | Chert flakes | | | | Burnt stone + water-rolled stone |
| C23 | C24 | | | | | 2 water-rolled stones |
| C25 | C26, C30, C31, C32, C40 | 2 chert scrapers + flakes | Animal (cattle) + unidentifiable fragments | | | |
| C27 | C28 | | Fragments, animal (cattle) tooth enamel | | | |
| C29 | C37, C38 | 2 chert scrapers | | | Oak | Burnt stone |
| C41 C43 | C42 C44 | Chert scraper | One fragment, animal longbone | Coarse undecorated | Oak + hazel fragment | Burnt stone |

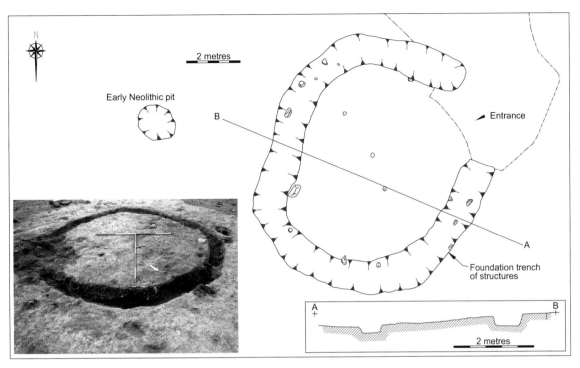

*Fig. 7.4—Magheraboy 2C: detail of Iron Age structures. Left inset: Iron Age structure during excavation. Right inset: profile through structure.*

importance of the Magheraboy ridge during the Neolithic period and testify to a continuation of ritual activity in this area, spanning a period of around 1,500 years.

Interestingly, the pits within this site appear as two distinct groups; similar groupings were not evident amongst the pits associated with the causewayed enclosure. Apart from representing the remains of a late Neolithic ritual site, it is also conceivable that these two sets of pits are the remnants of two separate and unrelated short-stay sites where various activities took place, such as the burning of wood, the cooking of food and the reduction or finishing of lithics, and that the pits contain the sweepings or leftovers from these events. Of these two possibilities the ritual interpretation is the more convincing, however.

## Area 2C: the Iron Age structure

Structure 1 was a small circular building, *c.* 4m in diameter, defined by a penannular foundation trench with a possible north-eastern entrance. The base of the trench was lined with charred split oak planks; radiocarbon analysis of charcoal from one of these returned a date of 370–30 cal. BC (Beta-186485) but there were no associated finds. While its function is uncertain, it is likely that

it would have comprised a light timber frame covered either by hides or thatch. This building would have been adequate as a store, shelter or hut (Fig. 7.4).

Although a large number of Iron Age domestic structures are known from Britain, only a few Irish examples have been identified. At Ballinaspig More 5, Ballincollig, Co. Cork, structure 3 was roughly circular with a diameter of less than 3.5m. The foundations were defined by a small slot-trench that held split oak planks and four, possibly associated, post-holes. Radiocarbon analysis of a sample of the oak plank returned a date of 790–390 cal. BC (Danaher 2004d).

Structures similar to that discovered at Magheraboy have been revealed in recent excavations but are currently awaiting radiocarbon dating. For example, a structure of similar shape and dimensions was unearthed at Morett 4, Co. Laois. This measured *c.* 4.5m in diameter and was defined by a gully: the north-western section was U-shaped in profile (0.6m wide by 0.26m deep) while the western and south-western sections had a V-shaped profile (average width 0.74m, average depth 0.34m) (Dempsey 2005).

The Magheraboy structure contained charred planking along its base, which may indicate an attempt to waterproof what were likely to have been the load-bearing elements of this structure. Mortice joints were probably present along these horizontally laid planks, housing the main structural posts that would have formed the hut.

In terms of morphology, comparisons can be made with hut structures of the late Bronze Age, many of which contained footing trenches and were of similar dimensions (Doody 2000). The Ballincollig and Magheraboy structures dated from the early and later Iron Age respectively, suggesting a continuity in building styles from the late Bronze Age through to the Iron Age, in particular small hut structures with a footing trench. When excavated, many of these structures reveal no trace of an associated/diagnostic finds assemblage. A search through the archaeological literature for parallel examples yields various late Bronze Age structures. During the excavation phase, consequently, these structures are often assumed to derive from this period. It is only through radiocarbon analysis that their true dates emerge. Therefore, the dearth of Iron Age structures in the Irish archaeological record may be partly due to the automatic designation of similar structures to the late Bronze Age without the consideration of a later date for them. Owing to the lack of publication, this may be a trend that is set to continue.

## Area 2B: the ringfort

*Site location*

Excavation of the early medieval features (O'Neill, see CD) within the site suggested that they would have formed part of a ringfort, for which there are many comparisons. The archaeological remains consisted of an enclosing ditch and a small number of internal features, representing about 50% of the ringfort. The excavated dimensions of the site were 37m north–south by 30m east–west (Pl. 7.1).

Ringforts are usually sited on gentle slopes with good views of the surrounding countryside

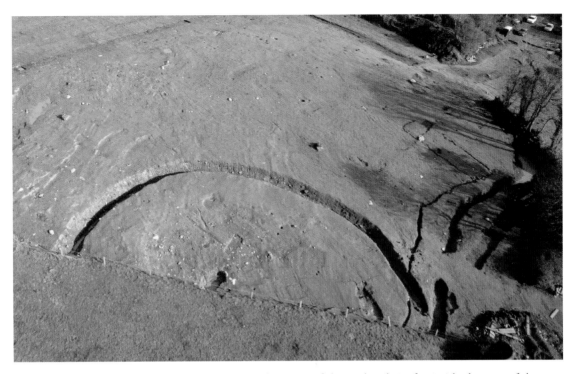

*Pl. 7.1—Magheraboy 2B and 2C: the excavated portion of the medieval ringfort, with elements of the earlier Neolithic causewayed enclosure to the right of the photograph (James Connolly).*

and, although they tend to have a dispersed distribution in the landscape, they are occasionally found in pairs or even small clusters. As most ringforts were the homesteads of farmers, proximity to good agricultural land was a major factor in their siting, with poor-quality soils such as peatland being avoided. Altitude may also have played a part: land near sea-level and valley bottoms was not favoured (M. Stout 1997). The Magheraboy ringfort had a typical location on the side of a south-facing slope sheltered from the prevailing north-westerly winds, although the gradient at this location was uncharacteristically steep. This siting would have ensured water run-off and prevented flooding in times of heavy rainfall (O'Neill, see CD). There is an extant ringfort (SL 014:125) less than 200m to the east on the southern slope of the same ridge, albeit on a much gentler gradient. This monument appears largely untouched and is smaller than the Area 2B example. While ringforts are often found in pairs, it is not known whether these two are contemporary.

An idea of what the surrounding landscape may have looked like in antiquity can be glimpsed from some of the other excavations that were carried out in Magheraboy as well as Caltragh to the south. *Fulachta fiadh*, which are usually located close to water, often a stream, lake, river or marsh, were plentiful both to the north and south of 2B. Three *fulachta fiadh* (Magheraboy 1, 2 and 3) were situated in marshy land to the north of the site, while to the south at Caltragh at least three examples were excavated, together with six spreads of heat-shattered stone and charcoal. The

presence of these features suggests that this localised marshy environment both to the north and south of the ridge at Magheraboy may not have changed much over the past few millennia.

There may have been fresh water in the form of a receding lake at Caltragh. Close proximity to a water supply, coupled with factors such as topographic considerations, local resource availability and proximity to good agricultural land, would have been of prime importance to the early medieval inhabitants in determining the choice of settlement location.

*The enclosing features*

The most substantial feature was the enclosing ditch, although, as stated earlier, only half of the site lay within the roadtake. Radiocarbon dating revealed that the ditch was constructed during the early medieval period. Other enclosures of similar date have been excavated at a number of locations around the country, such at Ballyconneely/Ballygireen, Co. Clare (Breen 2002a; 2002b), Ballycasey More, Co. Clare (T. O'Neill 2003), Curraheen 1, Co. Cork (Danaher 2005), and Rosepark, Balrothery, Co. Dublin (Carroll 2002).

The archaeological material unearthed provides evidence for a more definitive interpretation than simply that of 'enclosure'. The site would appear to have been a settlement of possibly high status but with much of the occupation evidence extending to the west, outside the excavated area. The Magheraboy evidence conforms to Ó Ríordáin's (1995, 29) definition of a ringfort:

'In its simplest form the ringfort may be described as a space most frequently circular, surrounded by a bank and fosse or simply by a rampart of stone. The bank is generally built by piling up inside the fosse the material obtained by digging the latter. Ringforts vary very considerably in size. In the more elaborately defended examples, the defences take up a much greater area than that of the enclosure.'

Although no evidence of a bank was visible prior to excavation, work on the ditch revealed that it contained large amounts of stone representing the collapse of an internal stone wall that may have been supported by a low earthen bank. The geology of this area would have greatly influenced the construction of the bank. As the subsoil was extremely stony, fashioning an all-earthen bank would have been difficult. A bank comprised of both materials would therefore have been the most practical. The excavation of a ringfort at Carrowgobbadagh, Co. Sligo, revealed that 'an earthen bank, on top of which a stone bank had been constructed', defined the enclosure (Opie 1996). Banks of similar construction to the one proposed for the Magheraboy site, a low earthen bank capped by a stone wall, are evident from a number of ringforts in the Sligo area.

The majority of ringforts—*c.* 80%—are enclosed and defended by a single bank (M. Stout 1997, 17). The banks would usually have been constructed of upcast material from the ditch, increasing the level of protection offered to the site. The ditches, or fosses as they are sometimes called, vary greatly in size and shape. They rarely exceed 3m in width and 2m in depth, while V-shaped, U-shaped and flat-bottomed profiles are all represented. As the bank was often located close to the ditch, the latter frequently filled up with slip. Early medieval texts suggest that the size

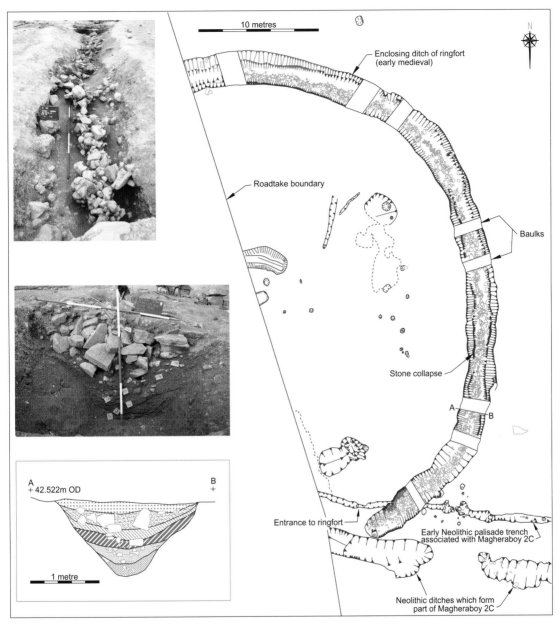

*Fig. 7.5—Magheraboy 2B: early medieval ringfort with the enclosing ditch truncating some features of the early Neolithic causewayed enclosure. Top inset: ringfort ditch during excavation. Middle inset: section through ditch, highlighting the quantity of stone present. Bottom inset: section through early medieval ringfort ditch.*

and number of ditches and banks associated with a ringfort signified status: the more elaborate the ringfort, the higher the social rank of the occupants. Defence was unlikely to have been the principal reason for ringfort construction. This is often reflected by the neglect of many ringfort ditches, which were allowed to silt up naturally. The Magheraboy ditch had no evidence for maintenance and appears to confirm this pattern.

The profile of the enclosing ditch was relatively consistent throughout: it was broadly U-shaped, with an average width of 2.4m across the top and 0.6m across the relatively flat base. The average depth was 0.94m and it was notably deeper at its southern and south-eastern edges, where it appeared to be less truncated. The total length of the excavated portion of the ditch was 56.9m (Fig. 7.5).

Numerous sections excavated across this ditch at various locations yielded evidence not only of the formation and destruction of the ditch and associated bank but also of the types of activities that went on within the enclosure itself. Apart from the stone derived from the inner stone wall, the ditch also contained a number of silt deposits that demonstrated that it had gradually silted up over a long period of time and showed no evidence of being recut. A moderate quantity of animal bone, charcoal fragments, a ninth–tenth-century ringed pin and some displaced early Neolithic artefacts were also recovered. There were numerous silt layers throughout the course of the ditch, with some bone and charcoal deposits representing events attributable to human activity. The silt and stone fills reflect gradual silting over a period of time and a gradual collapse of the internal stone wall and bank, while the bone and charcoal are probably the result of people deliberately discarding items into the ditch. A dense concentration of stone was evident at the south-eastern edge of the ditch. Otherwise, the silt deposits and stone collapses are mirrored throughout the north-west, north, north-east and east of the enclosure (O'Neill, see CD).

It is likely that the bank survived *in situ* following the collapse of the stone wall, as there was little or no trace of redeposited subsoil within the ditch, and may subsequently have been removed owing to agricultural activity (O'Neill, see CD). It is evident that considerable silting had taken place before the collapse of the internal wall. These silt deposits represent the initial period of site occupation. Smaller stones occurred in the lower deposits, while larger stones occupied a position above these. Silt deposits separated these two layers of stones and demonstrate the longevity of the process. It appears that the wall was of drystone construction, with the smaller stones being ideal as packing to secure the larger stones and boulders (O'Neill, see CD). It is also feasible that the larger stones were used for the base and lower part of the wall, which would have supported the smaller stones on top: when the wall eventually collapsed, the upper (smaller) stones toppled into the ditch first—hence their position within the lower fills. The stone used was limestone, which was quarried during the digging of the ditch; the stones ranged in size from 0.08m by 0.1m by 0.12m to 0.4m by 0.3m by 0.2m. Ploughsoil up to 0.28m thick sealed the majority of these stone and silt deposits. Finds from this context included a flint arrowhead, a chert arrowhead, chert debitage, a burnt flint fragment, corroded iron fragments and animal bone (03E0536:4:1–9). The chert and flint finds were of early Neolithic origin and were displaced either during the construction of the ringfort or by later agricultural activity.

At Seacash, Co. Antrim (Edwards 1990, 22), the ditch quickly silted up but occupation of the site continued, while at Ballyconneely, Co. Clare, the excavator has suggested that the upper sections of the enclosing ditch were backfilled in more recent times, possibly as landscaping in connection with a deer-park (Breen 2002a). Excavation of a circular enclosure at Killulla, Co. Clare, indicated that the ditch was deliberately backfilled (Murphy 2003). Evidence also exists for the recutting of ditches after they had been backfilled, as at Ballypalady, Co. Antrim (Edwards 1990, 21).

The ditch dimensions at Magheraboy suggest that if the bank was composed of upcast material then it may not have been more than 1.5m in height. While the depth of the ditch was generally 0.8–0.9m, the removal of the soil during its construction would have loosened it, creating a larger column of material, while the drystone wall erected on the earthen bank would have afforded it greater height. If this stone and earthen bank coupled with the relatively shallow ditch were the only defence afforded to the site, then it stood little chance of repelling a concerted or prolonged attack: as with most ringforts, these defences were probably built to deter cattle-raiders or thieves and to keep out wild animals. Recently Chris Lynn (2005) has proposed an interesting alternative explanation for the origins and development of ringforts. He believes that the ringfort phenomenon, whereby huge numbers of these monuments appeared throughout the countryside in a relatively short period of time, may have been a response to the spread of plague and other pestilences. As these diseases were mainly spread by interpersonal contact, the isolated locations of ringforts may have been regarded as providing some measure of protection against contact with infected people.

The entrance was on the south side of the enclosure, although the full extent of this feature was unresolved as it continued west outside the limits of excavation, as did the corresponding western terminal. The entrance, like that of most ringforts, consisted of an undug causeway across the ditch, leading to a gap in the bank that may have been protected by a gate, although no corresponding post-holes were discovered. The entrance to the majority of ringforts was located in the east or south-east quadrant, whatever the lie of the land. This position would have provided protection from the prevailing south-westerly winds as well as affording maximum use of the prevailing sunlight (M. Stout 1997, 19). The largest concentration of stone within the ditch was located in the terminal. This may represent increased fortification of the entranceway. The construction of a large reinforced wall would have afforded added protection to the entranceway, which is always the most vulnerable part of the structure. Similar evidence was noted at Killulla, Co. Clare (Murphy 2003), where large quantities of stone were present within each of the terminals. The western terminal of the Magheraboy ditch was not exposed and therefore cannot be analysed for comparative purposes.

*Internal features*

Very few archaeological features were revealed within the interior of this site. Activity was mainly concentrated in two areas—along the western baulk and in an area to the east of this—and consisted of linear features, pits, post-holes, stake-holes, spreads, a metalled surface, furrows and hearths. Not all of these were contemporary with the ringfort: some related to the early Neolithic

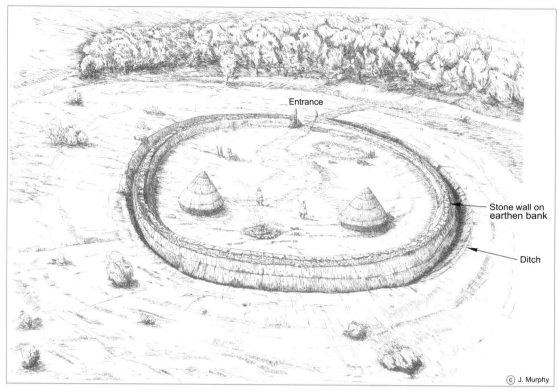

*Fig. 7.6—Magheraboy: conjectural reconstruction drawing of early medieval enclosure.*

causewayed enclosure, while at least one was of modern origin. Many of the features present along the western baulk were only partly exposed as they extended beyond the western limits of excavation, and it is this activity, with some exceptions, that appears to be contemporary with the ringfort. The excavator has suggested that most of the settlement evidence was located in the western portion of the enclosure and that the partially exposed remains in this area represented the outskirts of the main occupation area and/or area of activity within the enclosure (O'Neill, see CD). An arc of post-holes in the eastern portion of the enclosure produced a Neolithic date. At least two of the pits within the interior of the site contained early Neolithic pottery; one of these pits produced an early medieval date, however, indicating the level of contamination between early medieval and early Neolithic activity. The number of residual Neolithic artefacts in the ringfort ditch is further proof of this, as is the dating of one of the two linear features at the western edge of the site. The secondary fill of this curvilinear east–west feature (1.37m by 0.91m by 0.75–0.98m deep) contained part of a rotary quernstone (03E0536:12:1) with charred barley grains that were dated to cal. AD 680–890 (Beta-197651), although the primary fill sealed beneath it contained early Neolithic pottery. Neolithic deposits appear to have been displaced while the ringfort was being constructed, ending up in early medieval contexts. Bearing this in mind, the arc

of post-holes that represent the only tangible remains of a structure on site may not necessarily be Neolithic in origin, particularly when no other such structure was associated with the causewayed enclosure. Within earthen ringforts dwellings and other structures were built of timber posts, with walls constructed of wattle, mud or sods. This arc of posts, which may originally have formed a house with a circular or oval ground-plan, may indeed be associated with the ringfort. Studies of houses within ringforts have revealed a sequence of house types at a number of sites, with rectangular houses usually replacing circular ones (Fig. 7.6) (M. Stout 1997).

Analysis of charcoal from two external hearths in the eastern area of the site revealed an early medieval (cal. AD 720–1020, Beta-197652) and a medieval (cal. AD 1040–1290, Beta-197655) date. Neither hearth was enclosed, a relatively common feature of ringfort sites. Hearths were often located outside the house structure owing to the considerable risk of fire. The absence of finds from any of these features makes it difficult to establish their precise function (O'Neill, see CD).

Part of a metalled surface was exposed: the remainder extended beyond the western limits of the excavation. This consisted of small angular and subangular stones (less than 60mm in diameter), which were tightly compacted together directly above the substrata. Overlying this feature was dark silty clay that contained charcoal flecks, fragments of animal bones and a brooch/bronze clasp (03E0536:32:1–2), which appeared to have been broken in antiquity. The exposed metalled surface measured 0.7m east–west by 6.6m north–south and may represent an outdoor yard or working area. The second and most southerly of the two linear features was abutted by this surface. It was aligned north-east/south-west (4.3m by 2.1m by 0.24m) and contained a corroded iron fragment and perforated stone (03E0536:31:1–2). As the full extent of these two features was not revealed, the relationship between the two was not established; it is possible, however, that the latter feature may have acted as a drain for the stone surface or may have formed some sort of enclosure around it.

O'Neill (see CD) concluded that much of the interior and elements of the ditch were heavily degraded owing to later agricultural activity, and this may help to explain the lack of occupation levels within the internal area. Ringforts have undergone centuries of erosion, reuse and at times deliberate destruction. Monuments are coming under increasing pressure from development and intensive agriculture. Many have been partially or completely destroyed since the 1960s, and often the only indication of the former presence of a ringfort is preserved in place-name elements such as *Dún*, *Rath*, *Cashel* or *Lios*—some of the most common place-name elements in the country.

*The floral, faunal and artefactual assemblage*
Apart from the small number of early Neolithic artefacts recovered from the ditch, the remainder related to the use of the ringfort and included a ringed pin, both cremated and unburnt faunal remains, and charcoal from various wood species. A cattle-based economy appears to have been the main prehistoric subsistence strategy, and this continued into the early medieval period. It appears that the occupants of ringforts were principally cattle-farmers and that dairying was their chief subsistence activity (M. Stout 1997). The tillage of land and the manufacture of goods such as textiles and metal implements would have played a smaller role.

*The animal bones*

Many excavated ringforts produce large quantities of animal bones, particularly within the enclosing ditches. The animals best represented are cattle, pigs and sheep. The faunal remains retrieved from the early medieval phase at Magheraboy represented cattle, sheep/goat, pig, horse and deer. The minimum number of individuals (MNI) within the faunal assemblage was analysed, with cattle remains accounting for approximately 29% of the total number of animals of all species identified, sheep/goat for 36%, pig for 14%, deer for 14% and horse for 7%. Although the MNI for cattle was low at 29%, cattle nevertheless provided the main source of meat consumed on site, which conforms to the standard expected from ringfort sites (Beglane, see CD). Documentary texts show that while cattle were seen as the everyday food source, pork was the food of choice for feasting, with each person receiving the cut of meat appropriate to their rank (Kelly 1998, 336, 357–8). The remains of at least two deer were identified, suggesting that some hunting took place, which is a common feature of many sites of this period (Beglane, see CD). Kelly (1998) suggests that deer-hunting was mainly for sport and military training of the nobility. The partial remains of a horse were present on the site: Mytum (1992) has suggested that horses were used for riding during this period, so the presence of a horse may be evidence for a relatively high-status settlement (Beglane, see CD). The faunal analysis suggests that the inhabitants of the ringfort practised dairy farming and raised sheep primarily for meat, although wool would have been a useful secondary product. Pigs, on the other hand, would have been bred exclusively for consumption. The working of cattle horn was also carried out on site (Beglane, see CD). Horn was used to produce items such as handles for knives, drinking-horns and decorative items (Schmid 1972).

Cremated bone was retrieved from thirteen features on this site. Analysis proved that all identifiable bone was animal, and no human bone was positively identified within the assemblage.

*Environmental analysis*

Specialist analysis of various environmental samples revealed that cereals such as barley, oats and bread/club wheat were present during the early medieval occupation of this site (Hall and Carrott, see CD). In addition, trees such as oak, alder, hazel and willow/poplar/aspen were burned as fuel and were retrieved in the form of charcoal from various features.

Wood identification of eighteen of the more than 30 charcoal samples retrieved from both the ditch and internal features revealed large (oak, ash) and smaller (alder, hazel, willow/poplar/aspen) trees as well as some scrub (hawthorn/apple/rowan). All of these species would have been present in the area. Alder occurs in wet habitats, particularly along streams and riverbanks. Hazel was very common in early medieval Ireland, while the process of coppicing, which is the production of long straight rods of hazel, was extremely important, particularly in the construction of houses, as was evident at Deer Park Farms, Co. Antrim (Lynn 1987; 1994), where the well-preserved remains of houses within a ringfort were almost entirely constructed from hazel, with the exception of some timber uprights of ash and oak. A preserved door-frame from this site was also of oak. Oak has been used as a structural timber from Neolithic times and also makes very good firewood. Ash is easily worked and was often fashioned into items such as wooden bowls. It may have thrived at

Magheraboy, preferring the lime-rich, freely draining soils that this location had to offer. Willow can appear either in a tree or scrub form and, like ash, is a native species. In tree form it is a durable wood and is commonly used for wooden posts; it would have been in its natural habitat in the wet conditions of Caltragh or north of the ridge at Magheraboy. Pomoideae (apple/hawthorn/rowan) would also have been quite frequent during this period and are often found in hedgerows (O'Carroll, see CD; Hall and Carrott, see CD).

*Discussion*

The ringfort is the most abundant field monument in the country; over 40,000 have been recorded by the Archaeological Survey of Ireland. This number is continually increasing, however, with aerial photography providing new evidence for previously unrecorded examples. Many of these appear as cropmarks, having been levelled as a result of agricultural activity or deliberate dismantling.

Most ringforts were enclosed farmsteads, between 25m and 50m in diameter. Univallate ringforts, with a single bank and ditch, are the most common type, while the bivallate (double-ringed) and trivallate (triple-ringed) examples are rarer. It is widely accepted that ringforts did not serve a military function but were primarily enclosed farmsteads, the fortifications of which were designed to keep out cattle thieves and wild animals such as wolves. The landscape around such settlements would have contained managed and enclosed field systems, which generally appear to radiate out from the location of a ringfort. An excellent example of the associated enclosures and field systems can be seen at Caherballykinvarga, Co. Clare, where boundaries form a clear field pattern radiating out from the ringfort itself.

In investigating the national distribution patterns, Matthew Stout (1997) categorised the ringforts of County Sligo as being in a zone of very high density, with the highest density of ringforts in Ireland occurring in north-east Connacht ($1.52/km^2$). The Magheraboy site fits into what Stout has identified as the 'most significant coastal concentration' of ringforts in the country, which occurs in a 5km band stretching from Killala Bay, around Sligo Bay to Mullaghmore Head. He has calculated that the density of ringforts at this location is four times the national average ($2.17/km^2$).

*Dating these monuments*

Dendrochronological and radiocarbon dating of samples taken from ringforts 'have fairly consistently provided a date range during the second half of the first millennium AD' (Edwards 1990, 11). After examination of the scientific dating evidence from 47 sites, M. Stout (1997, 24) concluded that the majority of Ireland's ringforts 'were occupied and probably constructed during a three hundred year period from the beginning of the seventh century to the end of the ninth century AD'. Not all of the dates obtained for the Magheraboy site fall within this range. A charcoal sample of ash taken from the secondary fill of the enclosing ditch suggests that the site was probably constructed during the eighth century AD, while activity within the site appears to have covered a period possibly spanning four centuries. Of the seven samples sent for radiocarbon analysis, four returned early medieval dates and one a medieval date, while the remaining two were Neolithic. The medieval date of cal. AD 1040–1290 (Beta-197655) may suggest continued

*Table 7.3—List of radiocarbon dates obtained for the enclosing ditch and some internal features.*

| Licence No. | Dated material | Submitter's no. | Lab. No. | 2 Sigma (cal. BC/ AD) | (cal. BP) |
|---|---|---|---|---|---|
| 03E0536 | Hazelnut shell from pit to north-east of enclosure | 03E0536F3S5 | Beta-197649 | 3770–3640 BC | 5720–5590 |
| 03E0536 | Barley grains from pit within ringfort interior | 03E0536F10S1 | Beta-197650 | AD 770–980 | 1180–970 |
| 03E0536 | Barley grains from linear feature with rotary quern | 03E0536F12S3 | Beta-197651 | AD 680–890 | 1270–1060 |
| 03E0536 | Hazel charcoal from hearth within ringfort interior | 03E0536F57S32 | Beta-197652 | AD 720–740/ 760–1020 | 1230–1210/ 1190–930 |
| | Hazel charcoal from post-hole within ringfort interior | 03E0536F69S36 | Beta-197653 | 3650–3510 BC | 5600–5460 |
| 03E0536 | Ash charcoal from enclosing ditch | 03E0536F75S29 | Beta-197654 | AD 570–880 | 1380–1070 |
| 03E0536 | Hazel/alder charcoal from small hearth within site interior | 03E0536F121S34 | Beta-197655 | AD 1040–1290 | 910–660 |

occupation of the site; since only a single date pertained to this period, however, it could be argued that this related to a sporadic event.

So how do the Magheraboy ringfort dates add to the debate on the chronology of these monuments? This debate is based around three general theories: the first is that ringforts originated in the Iron Age (see Limbert 1996), the second is that ringforts continued into the later medieval and early modern periods (see Barrett and Graham 1975; Proudfoot 1970), while the third and generally accepted theory is that ringforts were constructed and used during the second half of the first millennium (see M. Stout 1997; 2000; Edwards 1990; Lynn 1975). Even the most widely accepted theory, which is supported by the bulk of the excavated evidence, has limitations. To date, most of the excavated ringforts on which this theory is based are situated in the east and north-east of the country, and therefore the dates obtained for the occupation of these sites do not necessarily reflect those of the country as a whole. Many of these areas in the east of the country were under Anglo-Norman rather than Irish control, while very few excavations have taken place in the west of the country, where many parts remained under strong Irish control until the seventeenth century. O'Conor (1998, 90) has commented that although many ringforts had been deserted by the end of the first millennium, this does not mean that the monument type went out of use.

Beal Boru, Co. Clare, was constructed in the early eleventh century and continued in use until the early part of the twelfth century, while the excavations of four sites (Lismahon, Castleskreen, Duneight and Rathmullan) in County Down indicate that they were all occupied as raised raths

until their takeover by the Anglo-Normans sometime after 1177 (O'Conor 1998). These and other excavations provide evidence of sites in the east of the country being abandoned as a result of the political situation caused by the arrival of the Anglo-Normans, who often took control of these ringforts for their own use, transforming them into motte castles. On the other hand, in the areas that remained under Irish control, in particular in the west of the country, some sites appear to have continued in use. Throughout these regions the occupants of ringforts were not subject to the same political pressures as their counterparts in the east of the country and therefore it was not necessary for them to abandon these sites.

O'Conor (1998) outlines strategies for tackling various questions raised by this topic, including the excavation of a ringfort that would help to address the question of whether ringforts continued in use beyond the eleventh century and through to the seventeenth century. After careful consideration, a site that was thought to have the potential to answer questions about the medieval use of this monument type was selected. This is situated in Tulsk, Co. Roscommon (RO022:114), south-east of the remains of a tower-house (RO022:114) and across the road from a Dominican priory (RO022:114). The tower-house was built in 1405 and the priory in either 1446 or 1448. O'Conor (1998) states that this was a very important medieval Irish centre and that the ringfort may represent the site of a pre-tower-house O'Connor residence. The upper levels appear to be of seventeenth-century date, and below them are the remains of a substantial stone structure possibly of fifteenth/sixteenth-century date. Although no early medieval or medieval occupation layers have yet been exposed, a ringed pin of similar date to the one retrieved from the ditch at Magheraboy (*c.* AD 1000; Niall Brady, pers. comm.) had been discovered. This ongoing work, as well as a number of recent excavations, is producing evidence for post-eleventh-century activity; it will undoubtedly enhance our knowledge of this type of monument and may go a long way towards changing accepted ideas.

The construction of Shannon airport led to the partial excavation of two ringforts (Rynne 1964) that revealed evidence of what the excavator believed were sites constructed in more recent times. The first of these, Garrynamona, comprised a raised area surrounded by a low bank and discontinuous ditch, while excavation of the interior revealed seventeenth-century habitation evidence (*ibid.*, 258–67). The second site, 'Thaddy's Fort', a bivallate ringfort, was more substantial in size. The foundation of a rectangular house was uncovered, which Rynne (1964, 255–66) believed to have been first occupied very early in the seventeenth century and built soon after the construction of the ringfort. Both of these sites have been largely discounted as it is felt that the rectangular structure and other seventeenth-century material were not associated with the bank construction (Edwards 1990, 19). There is a slowly increasing volume of information for post-eleventh-century ringfort use, however. Apart from these latter two sites and the ringfort at Beal Boru, structural and documentary evidence suggests that ringfort occupation in County Clare continued well into medieval times (thirteenth–fifteenth centuries), particularly in places like the Burren, where the ringfort defences were mainly of stone wall construction. A number of the few historical references to the medieval occupation of ringforts refer to sites in County Clare (O'Conor 1998).

To return to how Magheraboy adds to the corpus of western excavated ringforts and to the debate on the origin and use of this monument type, the radiocarbon evidence from the site indicates that activity may have commenced in the late eighth or early ninth century AD (*c.* AD 800); the duration of this activity is uncertain, but Beta-197650, 197652 and 197655 suggest that it may have continued into the late tenth or early eleventh century. But despite the possibility that more intense activity is represented beyond the roadtake restrictions, the limited evidence for occupation, derived mainly from the ditch fills, may indicate a shorter period of occupation within this time-span, or perhaps a history of intermittent occupation. What is extremely interesting, however, is that there is no evidence of the site's survival beyond the arrival of the Anglo-Normans and the establishment of Sligo town to the north. It is possible, though conjectural, that Magheraboy was abandoned by its occupants as a result of the political situation caused by the arrival of the Anglo-Normans in the area around 1188, but unlike the four County Down sites mentioned above there was no evidence that the Anglo-Normans took control of the site.

*Conclusions*

Although increasing numbers of sites are revealing evidence of continued settlement beyond the date ranges proposed by Edwards and Stout, it is likely that the majority were first constructed during the early medieval period. The construction of this large number of similar sites within such a short period may reflect a certain wealth and homogeneity in society; this is substantiated by pollen analysis as well as by the presence of high-status items at a number of sites. As outlined in Chapter 2, pollen analysis shows a rapid growth of agriculture at the start of this period. This is reflected at this site, with charred seeds of oats, barley and wheat being recovered from a number of features of early medieval date. Apart from farming activities, a broad range of craft activities were carried out within ringforts, including weaving, metalworking and glass-working.

It would appear that most activity on this site took place during the early medieval period and it is interpreted as a ringfort. The arc of post-holes to the east of the site may be contemporary with the enclosing ditch (even though an early Neolithic date was obtained for material from one of the post-holes) and as a result may represent one of a number of structures within the enclosure that would have housed the occupants of the site or their retainers. The metalled surface, pits and linear features provide further evidence of settlement. As with most ringforts, the occupants of the site would have been farmers, principally cattle-farmers. Dairy farming was practised, while sheep and pigs were also reared at Magheraboy. Hunting of deer also seems to have taken place, while the presence of a horse may denote high status. Analysis of the environmental samples indicated that cereals such as oats, barley and wheat would have been cultivated close by, and local resources such as various wood species were exploited. At least two crafts were carried out on site, the working of cattle horn and possibly weaving, as suggested by the perforated stone/spindle-whorl. Examination of the radiocarbon results suggests that the site may have been occupied from the eighth century until the arrival of the Anglo-Normans, when the site appears to have been abandoned by its occupants. It has not been determined whether this occupation was continual or periodic, however. If continual, then the site may have been occupied by many generations of the same family.

# 8

# CONCLUSIONS

## Introduction

Having presented an assessment of the N4 SIRR in chapters dealing with the clusters of new sites in each townland and the specific archaeology of *fulachta fiadh* and the Magheraboy enclosure, the aim here is to provide a chronological overview of the scheme as a whole.

## Early prehistory

Though the first phase of the causewayed enclosure was constructed in the late fifth millennium BC, no Mesolithic remains were discovered along the route, nor were any Mesolithic artefacts discovered during topsoil-stripping.

## The early Neolithic

New insights into early Neolithic life in Ireland are provided by the segmented ditched and palisaded enclosure at Magheraboy. This causewayed enclosure is not just the earliest site of its type but is also the earliest known Neolithic monument in both Ireland and Britain, and its significance is far-reaching. Its presence implies that from the outset of the Neolithic communal monuments were components of life in this region, if not the island as a whole. Taking other early Neolithic sites such as Donegore Hill, Thornhill, Co. Derry (Logue 2002), and Knowth into consideration, it is clear that 'enclosure' is a vital feature of this period; what sets sites like Magheraboy and Donegore apart is their integrated and prolonged ritual nature. While Thornhill and the earlier phases of activity at Knowth represent settlement activity, it can be inferred from the construction of Magheraboy that the associated domestic sites were somewhere in the vicinity. With regard to Knowth and early Neolithic settlement in the Boyne Valley, it has been established that at least five centuries of a pre-monumental Neolithic preceded the construction of the megalithic cemeteries (Eogan 1991). It is generally agreed that during these centuries this society generated the resources needed to support the substantial seasonal workforce required for monumental tomb-building. It

is probable that a hierarchical system within the community mobilised, organised and controlled this workforce. The scale and level of work involved in the considerable monuments of the Boyne Valley and at Magheraboy are not comparable, and it is unlikely that the same complexity of social organisation was either achieved or required for the construction of the Magheraboy enclosure. It is more likely that this site quickly succeeded the establishment of settlement in the region and may have been a primary component of what was a conscious effort to organise the landscape and to provide an element of social cohesion.

Taking this evidence into consideration, the origins of the Neolithic in this region may best be explained by the rapid and widespread appearance of a 'Neolithic package(s)' (see A. Sheridan 2001). The artefactual assemblage at Magheraboy and other early sites was distinctly Irish and, with the exception of the porcellanite axe and flint from Antrim, was locally sourced. This suggests rapid local, or perhaps more properly regional, development, represented by the distinct character of separate communities. Nevertheless, these reflect common elements in the expression of identity over a wide area of north-west Europe: it is in this context that the construction of Magheraboy and Donegore should be viewed, and the very early dates at these sites may be explained within a system of communications not just with Britain but within a network of north Atlantic sea routes. These two important sites indicate that the new inhabitants of the Cúil Irra peninsula had established a network of contacts with similar groups in Ireland as well as abroad.

Magheraboy demonstrates the early Neolithic settlement of this area of Sligo, while the longevity of the activity on the site indicates a stable and successful population during the final centuries of the fifth millennium and the first centuries of the fourth millennium BC. It is only a matter of time, therefore, before the domestic sites of these early farmers are discovered. Analysis of the pottery from Magheraboy indicates that it was similar to the material recovered from the Creevykeel court tomb, 30km to the north. It is certainly possible that some visitors to Magheraboy were interred at Creevykeel or other court tombs in the area during this phase of the Neolithic. Megalithic tombs have long been the traditional indicators of Neolithic settlement, and the numerous tombs in this area suggest a fairly widespread regional settlement pattern. While no early Neolithic human remains were discovered during the course of the excavation, one of three bones of an adult male found in Sramore Cave, Meencam, in the neighbouring county of Leitrim produced a date of 4217–3697 cal. BC (Dowd, forthcoming). This late fifth-millennium BC date is contemporary with the beginnings of the causewayed enclosure, so it is possible that this individual may have frequented Magheraboy on a number of occasions or may even have helped to build it—or, at the least, have been aware of it. At a wider level, early Neolithic activity is known from sites such as Ballyglass, Co. Mayo, where a large rectangular house with an annex at one end was discovered beneath part of a court tomb. This structure was dated to the second half of the fourth millennium BC, while investigation of a second megalithic tomb in the same townland also revealed the remains of wooden structures underneath it, but these were interpreted as workshops rather than domestic structures (Ó Nualláin 1972a; 1972b). The rectangular structure at Ballyglass was the first of its kind discovered in the north-west; a second Neolithic house was revealed more recently at Gortaroe, Westport, Co. Mayo (Gillespie 2002).

Although enclosures appear to have been a feature of the early Neolithic in Ireland, activity within this site was still continuing centuries later; it is interesting to note that there appears to have been a resurgence of activity at Magheraboy at *c.* 3650 BC, the period when causewayed enclosures were peaking in Britain. The last date obtained for Neolithic activity within the enclosure was *c.* 3300 BC, when these monuments were well in decline, while the building of passage tombs was in full swing.

## The middle Neolithic

During this period the main phase of tomb-building in the region was undertaken, with the passage tombs at Carrowkeel, Knocknarea, Cairn's Hill, Knocknashee and further afield beginning to appear across the landscape (J. Sheridan 1985/6). A review of the Carrowmore dating sequence has been undertaken with the sampling of bone pins from one of the tombs in the cemetery (S. Bergh, pers. comm.). Circular hut sites are located close to the tombs at Mullaghfarna, Carrowkeel and Knocknarea (Bergh 1995). Interestingly, possible enclosures comprising lengths of segmented banks, reminiscent of the type of activities associated with causewayed enclosures, are known from both areas. At Kesh, near Carrowkeel, a circular enclosure defined by interrupted segments of bank may form part of the wider Neolithic landscape in this area. At Knocknarea a system of banks traverse the eastern side of the mountain, three quarters of the way up the summit. These consist largely of drystone walling and are generally univallate, except at the northern end, where there are several parallel banks, some of which are segmented (Bergh 2000). A series of radiocarbon dates, from different material such as cattle bone, charcoal and hazelnut shells deriving from a variety of contexts and locations, have helped to establish an accurate sequence of events for this feature, which has been firmly dated to *c.* 3300 BC (S. Bergh, pers. comm.).

At Caltragh the first signs of land use can be traced back to the Neolithic, though it has not been possible to determine exactly when this activity originated. The only securely dated feature is a cremation from a low mound, which may have been associated with a possible tomb. Dated to 3491–3039 cal. BC, this cremation comprised a mix of charcoal, cremated bone and soil over a small lithics hoard and is unparalleled in the area.

## The late–final Neolithic

The fact that the Magheraboy ridge was of prime ritual significance does not appear to have been lost on successive Neolithic generations, with a number of late Neolithic pits, some containing Grooved Ware, being located on the slope of the ridge on the way to Caltragh. These pits may reflect the activity of timber circles and continue the established tradition of ritual at this location. A picture of late Neolithic ritual in the north-west is slowly emerging with the discovery in recent years of sites such as this one, the timber circle at Cloonbaul/Kilbride (Cotter, forthcoming) and

the pit containing Grooved Ware pottery from Lowpark (Grogan and Roche 2005).

Though Neolithic activity was recorded in the Caltragh valley, it is quite possible that the late Neolithic pits indicate the beginning of a shift in focus from the upper levels of the ridge to the marginal areas of the valley bottom, which appears to have been the preferred location for much of the Bronze Age. It is also around this period that we see the use of hot stone technology for the first time within the study area, both to the north of the ridge at Magheraboy and at Tonafortes.

Prior to the excavation of a small portion of the ceremonial enclosure at Tonafortes, this site was believed to have been the remains of a 'henge'; from the limited and conflicting results of the excavation, however, it was not possible to either confirm or deny this interpretation. With four variant dates obtained for ditch deposits, it is feasible that this monument appeared at the end of the henge tradition, although it is more likely to be a version of a site type that began in the late Neolithic but was revived or reinvented in several periods of Irish prehistory under various manifestations. Origin aside, however, what it does represent is a set of changing religious beliefs that were now replacing megalithic tombs; but even though these new beliefs were coming to the fore, artificially enclosed spaces were still the main focus of activity.

Archaeological research into the Neolithic of this region, in particular Cúil Irra, is currently well served, with ongoing studies of the hut sites at Mullaghfarna and the completion of work at Knocknarea (S. Bergh, pers. comm.). The findings from Magheraboy, Tonafortes and Caltragh will contribute greatly to this research.

## The Bronze Age

With the exception of activity at *fulachta fiadh* at Tonafortes and Magheraboy and possibly the ceremonial enclosure at Tonafortes, most of the Bronze Age activity was concentrated in Caltragh. Burnt mounds within this valley span the Bronze Age, and the continuity of life in Caltragh is reflected by the ongoing use of these sites. *Fulachta fiadh* and related burnt mound activity would appear to represent various functions, most notably cooking, as attested by animal bone from a number of sites. Interestingly, at least one may have been employed in fashioning timbers possibly for the production of roofs for nearby round houses. While the exact role of these sites is still uncertain, they are becoming increasingly important in comprehending settlement patterns and landscape use in the Bronze Age. The three houses were the first of their kind discovered in the region, and while these are the remains of domestic units, various deposits within them highlight the fact that the ritual and the secular were clearly interwoven in the middle Bronze Age. This is emphasised by the deliberately placed items within many of the internal pits as well as in the houses themselves, in particular house 1, which may be construed as closing deposits. Boundaries were associated with each of the three houses; considering the location of the cremations and burnt mounds in the valley, it appears that spatial awareness and organisation were key components of life in Caltragh. The relationship between the houses and the cremations is an intriguing one,

with complex interactions occurring between the two. Many of the burials were placed in what may have been key locations, and possibly served as a reminder that the dead were never far from the living, physically as well as metaphysically. At Caltragh there appears to have been a strong localised sense of identity, which is also evident throughout other parts of the country (see Cooney and Grogan 1999). We are probably looking at a self-sufficient community but one that was still influenced by the outside world, as indicated by the style of the beads from cremations 1 and 2. These would appear to be a locally made copy of a smooth and fine-textured style of bead that appears in other parts of Ireland and Britain: the Caltragh examples are composed of rougher stone and are more robust in form.

At Caltragh an integrated settlement pattern developed and spanned the entire period, continuing in use until the late Bronze Age, when there was a shift in focus away from these locations. As indicated earlier, all of the Bronze Age activity within this valley was located along the margins of wetland.

## The Iron Age

Very little Iron Age activity was discovered during the N4 SIRR excavations, possibly owing to the low-lying nature of much of the route topography. The most substantial feature was a small penannular hut discovered on the ridge at Magheraboy near the eastern roadtake boundary. No other features or material were found in association with the remains of this wooden structure, but it is possible that they lay east of the roadtake; its presence on the ridge, however, may indicate the move away from the preferred wetland locations of the preceding Bronze Age.

## The early medieval period

Given the large number of ringforts and early medieval activity in the region, it is surprising that only a single site of this date was discovered. This may, however, reflect the excellent preservation of standing monuments such as ringforts and the avoidance of these in the proposed route of the N4 SIRR. The Magheraboy ringfort adds greatly to the corpus of western excavated ringforts. As with many ringforts, the occupants of the site would have been farmers, principally cattle-farmers. Analysis of the animal bone indicates that dairy farming was practised, while sheep and pigs were also reared. This diet may have been supplemented by the hunting of deer. Farming activities included the cultivation of cereals such as oats, barley and wheat, while local resources such as various wood species were exploited. The excavation revealed evidence that at least two crafts were carried out on site—horn-working using cattle horns and weaving. It was established that the site originated during the eighth century and continued in use until the late twelfth century, but whether this represents periodic or continued settlement is difficult to determine.

## Conclusions

Over 30 sites were discovered during the course of the N4 SIRR excavations; considering the shortness of the route, in particular the rural segment, this is indeed a substantial number. Nearly all were prehistoric in origin, predominantly Neolithic and Bronze Age. The majority of the sites encountered were ritual in nature, and a relatively large number of ritual monuments were investigated. Exceptions included burnt mounds and the middle Bronze Age settlement. Though these prehistoric sites spanned a period of over three millennia, the investigations of these remains clearly indicate that the lives of these prehistoric peoples were laden with symbolism, which was intertwined with their everyday existence. As new beliefs replaced old, many of the intricacies of this symbolism changed little over this long period. It was not until the arrival of Christianity that this long tradition was gradually replaced. Although no ritual deposition was identified in relation to the early medieval ringfort, it appears that these early Christians purposefully avoided disturbing the early Neolithic causewayed enclosure, which was a most fitting tribute to this earliest of monuments.

This publication offers a synopsis of the N4 SIRR excavations and an integrated interpretation of the results in a regional context. It is hoped that it will be a foundation for further study that will add to our understanding of prehistoric society in particular. In relation to the causewayed enclosure at Magheraboy, this monograph is only the initial assessment of this truly remarkable and internationally important monument. In compiling the chapter on Tonafortes it became apparent that within the current corpus of information on ceremonial enclosures there is much misinformation and confusion in relation to these sites. With numerous manifestations stretching from the late Neolithic to the Iron Age and only a handful investigated, classification of these monuments is both fraught and difficult. An integrated approach using excavation, geophysics, aerial photography and fieldwork may help to formulate a more comprehensive classification.

The Bronze Age landscape at Caltragh offers a reasonably comprehensive understanding of settlement during this period and reflects a growing understanding of national patterns. Further work on the domestic economy and agricultural strategies will help to fill out this picture. Overall, the N4 SIRR archaeology has presented some significant insights into the prehistory of the Cúil Irra peninsula and the surrounding region and provides a major contribution to the framework for future prehistoric research.

# Appendix

# Radiocarbon dates from the excavated archaeological sites along the route of the N4 Sligo Inner Relief Road

## Notes

Radiocarbon dates are quoted in conventional years BP (before AD 1950) and the errors for these are expressed at the one sigma (68% probability) level of confidence.

Calibrated date ranges are equivalent to the probable calendrical age of the sample material and are expressed at one sigma (68% probability) and two sigma (95% probability) levels of confidence.

Dates obtained from BetaAnalytical in Florida (Beta lab code) and from University College Dublin (UCD lab code) were calibrated using the IntCal98 calibration programme (Stuiver *et al.* 1998). Dates from the Oxford Radiocarbon Acceleration Unit (OxA lab code) were calibrated using the OxCal programme (Bronk Ramsey 2002). Dates obtained from Groningen (GrA lab code) were calibrated using WinCal25.

### Chapter 3. Burnt stone technology

| Lab code | Site | Sample/context | Yrs BP | Calibrated date ranges |
|---|---|---|---|---|
| Beta-196297 | Tonafortes 2 | Charcoal (*Prunus*) from burnt mound | 3810 ± 40 | 2300–2200 BC one sigma<br>2400–2140 BC two sigma |
| UCD-0240 | Caltragh 1 | Charcoal from a layer of burnt mound material | 3260 ± 45 | 1602–1460 BC one sigma<br>1680–1430 BC two sigma |
| UCD-0240 | Caltragh 1 | Charcoal from a layer of burnt mound material | 3315 ± 50 | 1682–1521 BC one sigma<br>1737–1459 BC two sigma |
| UCD-0237 | Caltragh 2 | Charcoal from burnt mound | 3620 ± 60 | 2118–1884 BC one sigma<br>2195–1861 BC two sigma |
| UCD-0249 | Caltragh 3 | Charcoal from burnt mound | 3650 ± 50 | 2130–1942 BC one sigma<br>2194–1834 BC two sigma |
| Beta-194435 | Caltragh 5 | Charcoal (*Corylus*) from trough C399 | 3350 ± 110 | 1750–1510 BC one sigma<br>1910–1410 BC two sigma |

| | | | | |
|---|---|---|---|---|
| Beta-197658 | Caltragh 6 | Charcoal (*Alnus*) from fill of bowl trough C144 | 3230 ± 60 | 1530–1430 BC one sigma<br>1630–1400 BC two sigma |
| Beta-197659 | Caltragh 7 | Charcoal (*Corylus*) from trough C220 | 2730 ± 60 | 920–820 BC one sigma<br>1000–800 BC two sigma |
| UCD-0241 | Caltragh 10 | Charcoal (*Prunus*) from burnt mound | 3335 ± 50 | 1686–1524 BC one sigma<br>1741–1516 BC two sigma |
| Beta-194430 | Magheraboy 1 | Charcoal (*Corylus*) from burnt mound spread | 3920 ± 70 | 2480–2300 BC one sigma<br>2580–2200 BC two sigma |
| Beta-194429 | Magheraboy 1 | Charcoal (*Quercus*) from fill of pit | 4010 ± 50 | 2580–2470 BC one sigma<br>2630–2450 BC two sigma |
| Beta-194428 | Magheraboy 2A | Charcoal (*Corylus*) from fill of pit C115 | 3620 ± 40 | 2030–1920 BC one sigma<br>2120–1890 BC two sigma |
| Beta-194427 | Magheraboy 2B | Charcoal (*Corylus*) from fill of trough C301 | 2910 ± 60 | 1140–990 BC one sigma<br>1270–910 BC two sigma |

## Chapter 4. The archaeology of Tonafortes

| Lab code | Site | Sample/context | Yrs BP | Calibrated date ranges |
|---|---|---|---|---|
| Beta-196295 | Ceremonial enclosure | Charcoal (*Corylus*) from pit fill | 5200 ± 40 | 4040–3970 BC one sigma<br>4050–3960 BC two sigma |
| Beta-199778 | Ceremonial enclosure | Charcoal from lower ditch fill | 3840 ± 50 | 2400–2210 BC one sigma<br>2460–2140 BC two sigma |
| Beta-196296 | Ceremonial enclosure | Charcoal (*Corylus*) from lower ditch fill | 3400 ± 40 | 1740–1650 BC two sigma<br>1760–1610 BC two sigma |
| Beta-196293 | Ceremonial enclosure | Charcoal (*Prunus*) from lower ditch fill | 1680 ± 40 | AD 340–410 one sigma<br>AD 250–430 two sigma |
| Beta-196294 | Ceremonial enclosure | Charcoal (*Corylus*) from lower ditch fill | 580 ± 40 | AD 1310–1410 one sigma<br>AD 1300–1420 two sigma |

## Chapter 5. The archaeology of Caltragh

| Lab code | Site | Sample/context | Yrs BP | Calibrated date ranges |
|---|---|---|---|---|
| UCD-0247 | Neolithic cremation | Charcoal from cremation | 4540 ± 40 | 3361–3103 BC one sigma<br>3491–3039 BC two sigma |
| UCD-0238 | Cremation 1 | Charcoal from cremation | 2860 ± 45 | 1111–938 BC one sigma<br>1208–903 BC two sigma |

| | | | | |
|---|---|---|---|---|
| UCD-0248 | U-shaped cut C388 | Charcoal from C388 | 2970 ± 60 | 1294–1053 BC one sigma<br>1390–1001 BC two sigma |
| Beta-197656 | Cremation 2 | Charcoal (*Alnus*) from cremation | 3460 ± 80 | 1890–1680 BC one sigma<br>1960–1540 BC two sigma |
| Beta-197657 | Cremation 3 | Charcoal (*Corylus*) from cremation | 3320 ± 40 | 1650–1530 BC one sigma<br>1690–1510 BC two sigma |
| Beta-194432 | House 1 | Charcoal (*Alnus*) from pit | 3220 ± 80 | 1540–1410 BC one sigma<br>1680–1320 BC two sigma |
| Beta-194433 | House 1 | Charcoal (Pomoideae) from pit | 3140 ± 70 | 1490–1380 BC one sigma<br>1530–1260 BC two sigma |
| Beta-194434 | House 2 | Charcoal (*Salix* and *Alnus*) from pit | 3210 ± 40 | 1520–1430 BC one sigma<br>1530–1410 BC two sigma |

## Chapter 6. The early Neolithic archaeology of Magheraboy

| Lab code | Site | Sample/context | Yrs BP | Calibrated date ranges |
|---|---|---|---|---|
| Beta-186488 | Causewayed enclosure | Charred oak (*Quercus*) plank from base of ditch seg. 3 | 5060 ± 70 | 3960–3770 BC one sigma<br>3980–3680 BC two sigma |
| GrA-31961 | Causewayed enclosure | Charred oak (*Quercus*) sapwood from plank at base of ditch seg. 3 | 5085 ± 40 | —————one sigma<br>3980–3780 BC two sigma |
| OxA-X-2173-16 | Causewayed enclosure | Charred oak (*Quercus*) sapwood from plank at base of ditch seg. 3 | 5270 ± 40 | —————one sigma<br>4240–3970 BC two sigma |
| Beta-199989 | Causewayed enclosure | Charcoal (*Corylus*) from northern extent of ditch seg. 3 | 5090 ± 40 | 3960–3800 BC one sigma<br>3970–3780 BC two sigma |
| GrA-31959 | Causewayed enclosure | Charred wood (Pomoideae) from base of ditch seg. 6 | 4915 ± 40 | —————one sigma<br>3780–3630 BC two sigma |
| OxA-16037 | Causewayed enclosure | Charred wood (*Corylus*) from base of ditch seg. 6 | 5014 ± 37 | —————one sigma<br>3950–3700 BC two sigma |
| Beta-199986 | Causewayed enclosure | Charcoal (*Corylus*) from localised deposit in ditch seg. 1, zone 5 | 5030 ± 40 | 3930–3770 BC one sigma<br>3950–3710 BC two sigma |
| Beta-199988 | Causewayed enclosure | Charcoal (*Corylus*) from main fill of ditch seg. 1, zone 5 | 5080 ± 90 | 3970–3770 BC one sigma<br>4040–3660 BC two sigma |

| | | | | |
|---|---|---|---|---|
| Beta-199984 | Causewayed enclosure | Charcoal (*Corylus*) from fill of possible ditch recut C459 | 5160 ± 60 | 3990–3950 BC one sigma 4050–3800 BC two sigma |
| Beta-199985 | Causewayed enclosure | Charcoal (*Corylus*) from middle fill of ditch seg. 2, zone 5 | 5230 ± 60 | 4060–3970 BC one sigma 4230–3950 BC two sigma |
| Beta-199987 | Causewayed enclosure | Charcoal (*Corylus*) from fill of ditch seg. 2, zone 5 | 5150 ± 40 | 3980–3950 BC one sigma 4030–3810 BC two sigma |
| GrA-31960 | Causewayed enclosure | Charcoal (*Corylus*) from a middle fill of ditch seg. 2, zone 5 | 4860 ± 40 | —————one sigma 3710–3530 BC two sigma |
| OxA-16021 | Causewayed enclosure | Charcoal (*Corylus*) from middle fill of ditch seg. 2, zone 5 | 4870 ± 37 | —————one sigma 3710–3540 BC two sigma |
| Beta-186483 | Causewayed enclosure | Charcoal (*Alnus*) from pit C28 | 5130 ± 100 | 4030–3790 BC one sigma 4220–3700 BC two sigma |
| Beta-186484 | Causewayed enclosure | Charcoal (*Corylus*) from pit C40 | 4770 ± 50 | 3640–3520 BC one sigma 3650–3380 BC two sigma |
| Beta-186486 | Causewayed enclosure | Charcoal (*Quercus*) from pit C125 | 5150 ± 110 | 4040–3800 BC one sigma 4240–3700 BC two sigma |
| Beta-186487 | Causewayed enclosure | Charcoal (*Quercus*) from pit C147 | 4880 ± 70 | 3710–3640 BC one sigma 3790–3520 BC two sigma |
| Beta-199990 | Causewayed enclosure | Charcoal (*Corylus*) from pit C92 | 5080 ± 70 | 3960–3780 BC one sigma 3990–3700 BC two sigma |
| Beta-196298 | Causewayed enclosure | Charcoal (*Quercus*) from pit C221 | 4660 ± 40 | 3510–3370 BC one sigma 3620–3360 BC two sigma |
| Beta-196299 | Causewayed enclosure | Charcoal (*Quercus*) from pit C248 | 4670 ± 40 | 3510–3370 BC one sigma 3620–3360 BC two sigma |
| Beta-197649 | Causewayed enclosure | Hazelnut shell (*Corylus*) from pit to NE of ringfort | 4910 ± 40 | 3710–3650 BC one sigma 3770–3640 BC two sigma |
| Beta-197653 | Causewayed enclosure | Charcoal (*Corylus*) from post-hole within ringfort | 4790 ± 40 | 3640–3530 BC one sigma 3650–3510 BC two sigma |

**Chapter 7. The later archaeological sites at Magheraboy**

| Lab code | Site | Sample/context | Yrs BP | Calibrated date ranges |
|---|---|---|---|---|
| Beta-194431 | Pit from site 2A | Charcoal (*Corylus*) from pit fill | 4140 ± 60 | 2870–2590 BC one sigma<br>2890–2500 BC two sigma |
| Beta-186485 | Hut | Charred plank (*Quercus*) from base of slot-trench | 2140 ± 60 | 370–30 BC one sigma<br>350–80 BC two sigma |
| Beta-197650 | Ringfort | Charred grain (*Hordeum*) from internal pit | 1170 ± 40 | AD 790–900 one sigma<br>AD 770–980 two sigma |
| Beta-197651 | Ringfort | Charred grain (*Hordeum*) from internal linear feature | 1240 ± 40 | AD 710–860 one sigma<br>AD 680–890 two sigma |
| Beta-197652 | Ringfort | Charcoal (*Corylus*) from internal hearth | 1130 ± 70 | AD 810–990 one sigma<br>AD 720–1020 two sigma |
| Beta-197654 | Ringfort | Charcoal (*Fraxinus*) from enclosing ditch | 1340 ± 80 | AD 640–770 one sigma<br>AD 570–880 two sigma |
| Beta-197655 | Ringfort | Charcoal (*Corylus/Alnus*) from internal hearth | 830 ± 60 | AD 1170–1270 one sigma<br>AD 1040–1290 two sigma |

# BIBLIOGRAPHY

Aalen, F.H.A., Whelan, K. and Stout, M. 2002 *Atlas of the Irish rural landscape*. Cork University Press.

Alcock, O. and Tunney, M. 2002 Archaeological survey in Sligo. In M. A. Timoney (ed.), *A celebration of Sligo: first essays for Sligo Field Club*, 269–72. Carrick-on-Shannon. Sligo Field Club.

Andersen, N.H. 2002 Neolithic enclosures of Scandinavia. In G. Varndell and P. Topping (eds), *Enclosures in Neolithic Europe*, 1–11. Oxford. Oxbow.

Anon. 1995 *Sligo Abbey. Guide Book*. Dúchas.

Atkinson, R.J.C. 1951 The henge monuments of Great Britain. In R. J. C. Atkinson, C. M. Piggott and N. K. Sandars, *Excavations at Dorchester, Oxon. First report*. Oxford. Ashmolean Museum.

Barfield, L. and Hodder, M. 1987 Burnt-mounds as saunas, and the prehistory of bathing. *Antiquity* **61**, 370–9.

Barley, N. 1995 *Dancing on the grave. Encounters with death*. London. Abacus.

Barrett, G.F. and Graham, B.J. 1975 Some considerations concerning the dating and distribution of ring-forts in Ireland. *Ulster Journal of Archaeology* **38**, 33–45.

Barrett, J.C. 1988 The living, the dead and the ancestors: Neolithic and early Bronze Age mortuary practices. In J. C. Barrett and I. A. Kinnes (eds), *The archaeology of contest in the Neolithic and Bronze Age: recent trends*, 30–41. Department of Archaeology and Prehistory, University of Sheffield.

Becker, C.J. 1973 Problems of the megalithic 'mortuary houses' in Denmark. In G. Daniel and P. Kjaerum (eds), *Megalithic graves and ritual*, 75–80. Moesgard. Jutland Archaeological Society.

Bengtsson, H. and Bergh, S. 1984 The hut sites at Knocknarea North. In G. Burenhult, *The archaeology of Carrowmore. Environmental archaeology and the megalithic tradition at Carrowmore, Co. Sligo, Ireland*, 216–318. Theses and Papers in North European Archaeology 14. Institute of Archaeology, University of Stockholm.

Bergh, S. 1995 *Landscape of the monuments. A study of the passage tombs in the Cúil Irra region, Co. Sligo, Ireland*. Stockholm. Riksantikvarieambet Arkeologiska Undersökningar.

Bergh, S. 2000 Transforming Knocknarea—the archaeology of a mountain. *Archaeology Ireland* **52**, 14–18.

Bergh, S. 2002 Monuments of meaning: role and symbolism of passage tombs in Cúil Irra, Co. Sligo. In M. A. Timoney (ed.), *A celebration of Sligo: first essays for Sligo Field Club*, 65–72. Carrick-on-Shannon. Sligo Field Club.

Bolger, T. 2002 Farrandreg, Dundalk. In I. Bennett (ed.), *Excavations 2000*, 226–8. Bray. Wordwell.

Bradley, R.J. 1993 *Altering the Earth. The origins of monuments in Britain and continental Europe.* The Rind Lectures 1991–1992. Society of Antiquaries of Scotland Monograph Series 8. Edinburgh.

Bradley, R. 1998 *The significance of monuments: on the shaping of human experience in Neolithic and Bronze Age Europe.* London and New York. Routledge.

Breen, T. 2002a Ballyconneely, Clare. In I. Bennett (ed.), *Excavations 2000*, 16–17. Bray. Wordwell.

Breen, T. 2002b AR 49: Ballygirreen ring-ditch. In I. Bennett (ed.), *Excavations 2000*, 16–17. Bray. Wordwell.

Brindley, A. 1999 Sequence and dating in the Grooved Ware tradition. In R. Cleal and A. MacSween (eds), *Grooved Ware in Britain and Ireland*, 133–44. Neolithic Studies Group Seminar Papers 3. Oxford. Oxbow.

Brindley, A.L. and Lanting, J.N. 1990 The dating of *fulachta fiadh*. In V. Buckley (ed.), *Burnt offerings: international contributions to burnt mound archaeology*, 55–6. Bray. Wordwell.

Bronk Ramsey, C. 2002 *Oxcal Calibration Programme v.3.8.* University of Oxford.

Brück, J. 1995 A place for the dead: the role of human remains in Late Bronze Age Britain. *Proceedings of the Prehistoric Society* **61**, 245–77.

Brück, J. 1999 Houses, lifecycles and deposition on Middle Bronze Age settlements in southern England. *Proceedings of the Prehistoric Society* **65**, 145–66.

Buckley, V. (ed.) 1990a *Burnt offerings: international contributions to burnt mound archaeology.* Bray. Wordwell.

Buckley, V. 1990b Experiments using a reconstructed *fulacht* with a variety of rock types: implications for the petro-morphology of *fulachta fiadh*. In V. Buckley (ed.), *Burnt offerings: international contributions to burnt mound archaeology*, 170–2. Bray. Wordwell.

Buckley, V. and Sweetman, D. 1991 *Archaeological Survey of County Louth.* Dublin. Stationery Office.

Burenhult, G. 1980 *The archaeological excavation at Carrowmore, Co. Sligo, Ireland: excavation seasons 1977–79.* Theses and Papers in North European Archaeology 9. Institute of Archaeology, University of Stockholm.

Burenhult, G. 1981 *The Carrowmore excavations—excavation season 1981.* Stockholm Archaeological Reports 8. Institute of Archaeology, University of Stockholm.

Burenhult, G. 1984 *The archaeology of Carrowmore: environmental archaeology and the megalithic tradition at Carrowmore, Co. Sligo, Ireland.* Theses and Papers in North European Archaeology 14. Institute of Archaeology, University of Stockholm.

Burl, A. 1997 *Prehistoric henges.* Risborough. Shire Publications.

Byrnes, E. 2004 Rath, Co. Meath. Bronze Age enclosure. In I. Bennett (ed.), *Excavations 2002*, 428–9. Bray. Wordwell.

Cagney, L. 2004 Report on archaeological investigation of a Neolithic megalithic structure at Ardara, Co. Donegal. Unpublished report submitted to the Department of the Environment, Heritage and Local Government.

Campbell, K. 2002 Mell 5. In I. Bennett (ed.), *Excavations 2000*, 237. Bray. Wordwell.

Carroll, F. 2002 Archaeological excavation of a ringfort and souterrains at Rosepark, Balrothery, Co. Dublin. Unpublished report submitted to the Department of the Environment, Heritage and Local Government.

Case, H. 1973 A ritual site in north-east Ireland. In G. Daniel and P. Kjaerum (eds), *Megalithic graves and ritual*, 173–96. Moesgard. Jutland Archaeological Society.

Caulfield, S. 1983 The Neolithic settlement of north Connaught. In T. Reeves-Smyth and F. Hamond (eds), *Landscape archaeology in Ireland*, 195–215. British Archaeological Reports, British Series 116. Oxford.

Caulfield, S. 1988 *Ceide Fields and Belderrig Guide*. Killala. Morgan Book Co.

Channing, J. 1998 Ballinfad. In I. Bennett (ed.), *Excavations 1997*, 154. Bray. Wordwell.

Clarke, L. and Murphy, D. 2002 Excavation of a Bronze Age enclosure (Site 17) at Lagavooren Townland, Co. Meath. *Ríocht na Midhe* **13**, 18–22.

Cleary, K. 2002 Living with the dead: the deliberate deposition of human remains on Irish Bronze Age settlement sites. Unpublished MA thesis, University College Cork.

Cleary, K. 2005a Skeletons in the closet: the dead among the living on Irish Bronze Age settlements. *Journal of Irish Archaeology* **14**, 23–42.

Cleary, K. 2005b Irish Bronze Age settlements: more than meets the eye? *Archaeology Ireland* **76**, 18–21.

Cleary, R. 1995 Later Bronze Age settlement and prehistoric burials, Lough Gur, Co. Limerick. *Proceedings of the Royal Irish Academy* **95**C, 1–92.

Clinton, M. 2002 Kingstown, Dublin. *Fulacht fiadh*. In I. Bennett (ed.), *Excavations 2000*, 108–9. Bray. Wordwell.

Collins, A.E.P. 1952 Excavations in the sandhills at Dundrum, Co. Down, 1950–51. *Ulster Journal of Archaeology* **15**, 2–30.

Condit, T. 1993 Ritual enclosures near Boyle, Co. Roscommon. *Archaeology Ireland* **23**, 14–16.

Condit, T. 1997a Monknewtown ritual pond. In T. Condit and G. Cooney (eds), *Brú na Bóinne*, 23. Bray. Archaeology Ireland.

Condit, T. 1997b The Newgrange cursus and the theatre of ritual. In T. Condit and G. Cooney (eds), *Brú na Bóinne*, 26–7. Bray. Archaeology Ireland.

Condit, T. and Cooney, G. (eds) 1997 *Brú na Bóinne*. Bray. Archaeology Ireland. (A supplement to *Archaeology Ireland* **41**.)

Condit, T. and Gibbons, M. 1991 A glimpse of Sligo's prehistory. *Archaeology Ireland* **17**, 7–10.

Condit, T. and Simpson, D. 1998 Irish hengiform enclosures and related monuments: a review. In A. Gibson and D. D. A. Simpson (eds), *Prehistoric ritual and religion. Essays in honour of Aubrey*

*Burl*, 45–61. Stroud. Sutton Publishing.

Connolly, M. 1996 The passage tomb of Tralee—a megalithic tomb at Ballycarty, Co. Kerry. *Archaeology Ireland* **38**, 15–17.

Connolly, M. 2001 Hot rock and ritual. *Archaeology Ireland* **58**, 10–12.

Connolly, M. and Condit, T. 1998 Ritual enclosures in the Lee Valley, Co. Kerry. *Archaeology Ireland* **46**, 8–12.

Cooney, G. 2000a *Landscapes of Neolithic Ireland*. London. Routledge.

Cooney, G. 2000b Recognising regionality in the Irish Neolithic. In A. Desmond, G. Johnson, M. McCarthy, J. Sheehan and E. Shee-Twohig (eds), *New agendas in Irish prehistory. Papers in commemoration of Liz Anderson*, 49–65. Bray. Wordwell.

Cooney, G. 2002 From Lilliput to Brobdingnag: the traditions of enclosure in the Irish Neolithic. In G. Varndell and P. Topping (eds), *Enclosures in Neolithic Europe*, 69–82. Oxford. Oxbow.

Cooney, G. 2005 *Fourknocks: a window to a Neolithic world*. Bray. Archaeology Ireland Heritage Guide 28.

Cooney, G. and Grogan, E. 1999 *Irish prehistory. A social perspective*. Bray. Wordwell.

Cotter, E. 2002 Killalough. In I. Bennett (ed.), *Excavations 2000*, 48–9. Bray. Wordwell.

Cotter, E. 2005 Bronze Age Ballybrowney, County Cork. In J. O'Sullivan and M. Stanley (eds), *Recent archaeological discoveries on national road schemes 2004*, 25–35. Dublin. National Roads Authority.

Cotter, E. (forthcoming) Report on the archaeological excavation of a timber circle at Cloonbaul/Kilbride, Co. Mayo.

Coughlan, T. 2000 Butlerstown Little. In I. Bennett (ed.), *Excavations 1999*, 23. Bray. Wordwell.

Coyne, F. 2002 Newtown, Co. Limerick. www.aegisarchaeology.com/osteo.htm.

Cremen Madden, A. 1969 The Beaker wedge tomb at Moytirra, Co. Sligo. *Journal of the Royal Society of Antiquaries of Ireland* **99**, 151–9.

Danaher, E. 2003 Farrendreg. In I. Bennett (ed.), *Excavations 2001*, 262–3. Bray. Wordwell.

Danaher, E. 2004a Archaeological excavation of a *fulacht fiadh* at Ballinaspig More (6), Co. Cork. Unpublished report submitted to the Department of the Environment, Heritage and Local Government.

Danaher, E. 2004b Archaeological excavation of multi-phased *fulachta fiadh* at Ballinaspig More (7), Co. Cork. Unpublished report submitted to the Department of the Environment, Heritage and Local Government.

Danaher, E. 2004c Archaeological excavation of a multi-phased prehistoric site at Ballinaspig More (4), Co. Cork. Unpublished report submitted to the Department of the Environment, Heritage and Local Government.

Danaher, E. 2004d Archaeological excavation of a multi-phased prehistoric site at Ballinaspig More (5), Co. Cork. Unpublished report submitted to the Department of the Environment, Heritage and Local Government.

Danaher, E. 2005 Archaeological excavation of a multi-phased site at Curraheen (1), Co. Cork.

Unpublished report submitted to the Department of the Environment, Heritage and Local Government.

Danaher, P. 1973 Earthwork, Longstone, Tipperary. In http://www.excavations.ie/Pages/Details.php?Year=&County=Tipperary&id=5591

Darvill, T. 1987 *Prehistoric Britain*. London. Batsford.

Darvill, T. and Thomas, J. 2001 *Neolithic enclosures in Atlantic northwest Europe*. Neolithic Studies Group Seminar Papers 1. Oxford. Oxbow.

Davies, O. 1936 Excavations at Dún Ruadh. *Proceedings and Reports of the Belfast Natural History and Philosophical Society* (1935–6), 50–75.

Dempsey, J. 2005 Archaeological excavation of a circular structure at Morett 4, Co. Laois. Unpublished report submitted to the Department of the Environment, Heritage and Local Government.

De Valera, R. and Ó Nualláin, S. 1961 *Survey of the megalithic tombs of Ireland. Volume 1: Clare*. Dublin. Stationery Office.

Dixon, P. 1988 The Neolithic settlements on Crickley Hill. In C. Burgess, P. Topping, C. Mordant and M. Maddison (eds), *Enclosures and defences in the Neolithic of Western Europe*, 75–88. British Archaeological Reports, International Series 403. Oxford.

Doody, M.G. 1987 Ballyveelish, Co. Tipperary. In R. M. Cleary, M. F. Hurley and E. A. Twohig (eds), *Archaeological excavations on the Cork–Dublin gas pipeline (1981–82)*, 9–35. Cork Archaeological Studies 1. University College, Cork.

Doody, M.G. 1993 Bronze Age settlement. In E. Shee-Twohig and M. Ronayne (eds), *Past perceptions: the prehistoric archaeology of south-west Ireland*, 93–100. Cork University Press.

Doody, M.G. 2000 Bronze Age houses in Ireland. In A. Desmond, G. Johnson, M. McCarthy, J. Sheehan and E. Shee-Twohig (eds), *New agendas in Irish prehistory. Papers in commemoration of Liz Anderson*, 135–59. Bray. Wordwell.

Dowd, M. (forthcoming) The use of caves for funerary activity in Neolithic Ireland. *Antiquity*.

Duffy, C. 1996 Derry. In I. Bennett (ed.), *Excavations 1995*, 52–3. Bray. Wordwell.

Dunne, L. and Dennehy, E. 2002 Flemby. In I. Bennett (ed.), *Excavations 2000*, 145. Bray. Wordwell.

Edmonds, M. and Thomas, J. 1991 *The Anglesey Archaeological Landscape Project: first interim report*. Lampeter. St David's University College.

Edwards, N. 1990 *The archaeology of early medieval Ireland*. London. Batsford.

Egan, U., Byrne, E., Sleeman, M., Ronan, S. and Murphy, C. (comps) 2005 *Archaeological Inventory of County Sligo, Vol. I: South Sligo*. Dublin. Stationery Office.

Eogan, G. 1984 *Excavations at Knowth, 1*. Dublin. Royal Irish Academy.

Eogan, G. 1986 *Knowth and the passage tombs of Ireland*. London. Thames and Hudson.

Eogan, G. 1991 Prehistoric and early historic culture change at Brugh na Bóinne. *Proceedings of the Royal Irish Academy* **91**C, 105–32.

Eogan, G. and Richardson, H. 1982 Two maceheads from Knowth, Co. Meath. *Journal of the Royal Society of Antiquaries of Ireland* **112**, 123–38.

Eogan, G. and Roche, H. 1997 *Excavations at Knowth, 2: settlement and ritual sites of the fourth and third millennia BC*. Dublin. Royal Irish Academy.

Eogan, G. and Roche, H. 1999 Grooved Ware from Brugh na Bóinne and its wider context. In R. Cleal and A. MacSween (eds), *Grooved Ware in Britain and Ireland*, 98–111. Neolithic Studies Group Seminar Papers 3. Oxford. Oxbow.

Eogan, J. 1999 Recent excavations at Bettystown, Co. Meath. *Irish Association of Professional Archaeologists Newsletter* **30**, 9.

Evans, E.E. 1953 *Lyles Hill: a Late Neolithic site in County Antrim*. Archaeological Research Publications 2. Belfast. HMSO.

FitzGerald, M. 2006 Archaeological discoveries on a new section of the N2 in Counties Meath and Dublin. In J. O'Sullivan and M. Stanley (eds), *Settlement, industry and ritual*, 29–42. Archaeology and the National Roads Authority Monograph Series 3. Dublin. National Roads Authority.

Fitzpatrick, M. 1998 Johnstown South enclosure. In I. Bennett (ed.), *Excavations 1997*, 199–200. Bray. Wordwell.

Flanagan, L. 2000 *Ancient Ireland: life before the Celts*. Dublin. Gill and Macmillan.

Fredengren, C. 2002 *Crannogs*. Bray. Wordwell.

Gibson, A. 1998 Hindwell and the Neolithic palisaded sites of Britain and Ireland. In A. Gibson and D. D. A. Simpson (eds), *Prehistoric ritual and religion. Essays in honour of Aubrey Burl*, 68–79. Stroud. Sutton Publishing.

Gibson, A. 2000 Circles and henges: reincarnations of past traditions? *Archaeology Ireland* **51**, 11–14.

Gibson, A.M. and Simpson, D.D.A. 1987 Lyles Hill, Co. Antrim. *Archaeology Ireland* **2**, 72–5.

Gillespie, R. 2002 Neolithic house at Gortaroe, Westport, Co. Mayo. *Archaeology Ireland* **59**, 7.

Gillespie, R. 2003 Deerpark East 1. In I. Bennett (ed.), *Excavations 2001*, 277. Dublin. Wordwell.

Goransson, H. 1980 Pollen analytical investigations in Cloverhill Lough, Carrowmore, Co. Sligo, Ireland. In G. Burenhult, *The Carrowmore excavations—excavation season 1980*, 125–38. Stockholm Archaeological Reports 7. Institute of Archaeology, University of Stockholm.

Goransson, H. 1981 Pollen analytical investigations in Ballygawley Lough and Carrowkeel, Co. Sligo, Ireland. In G. Burenhult (ed.), *The Carrowmore excavations—excavation season 1981*, 180–95. Stockholm Archaeological Reports 8. Institute of Archaeology, University of Stockholm.

Goransson, H. 1984 Pollen analytical investigations in the Sligo area. In G. Burenhult, *The archaeology of Carrowmore. Environmental archaeology and the megalithic tradition at Carrowmore, Co. Sligo, Ireland*, 154–93. Theses and Papers in North European Archaeology 14. Institute of Archaeology, University of Stockholm.

Goransson, H. 2002 Pollen analytical investigations in the Sligo area. In M. A. Timoney (ed.), *A celebration of Sligo: first essays for Sligo Field Club*, 85–95. Carrick-on-Shannon. Sligo Field Club.

Gowen, M. 1988 *Three Irish gas pipelines: new archaeological evidence in Munster*. Dublin. Wordwell.

Gowen, M., Ó Néill, J. and Phillips, M. (eds) 2005 *The Lisheen Mine Archaeological Project 1996–8*. Bray. Margaret Gowen and Co. Ltd/Wordwell.

Grogan, E. 2002 Neolithic houses in Ireland: a broader perspective. *Antiquity* **76**, 517–25.

Grogan, E. 2004 The implications of Irish Neolithic houses. In I. Shepard and G. Barclay (eds), *Scotland in ancient Europe*, 103–14. Edinburgh. Society of Antiquaries of Scotland.

Grogan, E. 2005a *The North Munster Project. Volume 1: The later prehistoric landscape of south-east Clare*. Discovery Programme Monograph 6, Vol. 1. Bray. Wordwell.

Grogan, E. 2005b *The North Munster Project. Volume 2: The prehistoric landscape of North Munster*. Discovery Programme Monograph 6, Vol. 2. Bray. Wordwell.

Grogan, E. (forthcoming) Excavations at Tara, Co. Meath, by Seán P. Ó Ríordáin: the Rath of the Synods. UCD Archaeological Monographs.

Grogan, E. and Eogan, G. 1987 Lough Gur excavations by Seán P. Ó Ríordáin: further Neolithic and Beaker habitations on Knockadoon. *Proceedings of the Royal Irish Academy* **87**C, 299–506.

Grogan, E. and Roche, H. 2002 Irish palisaded enclosures—a long story. In A. Gibson (ed.), *Behind wooden walls: Neolithic palisaded enclosures in Europe*, 24–7. British Archaeological Reports, International Series 1013. Oxford.

Grogan, E. and Roche, H. 2005 The prehistoric pottery from Balregan 1, Co. Louth (03E0157). Unpublished report for Irish Archaeological Consultancy Ltd.

Grogan, E. and Roche, H. 2006 The prehistoric pottery assemblage from Lowpark, Co. Mayo. Unpublished report for Mayo County Council.

Grogan, E., O'Donnell, L. and Johnston, P. (forthcoming) *The Bronze Age landscapes of the Gas Pipeline to the West: an integrated archaeological and environmental assessment*. Bray. Margaret Gowen and Co. Ltd/Wordwell.

Hanley, K. 2000a Gortnaboul. In I. Bennett (ed.), *Excavations 1999*, 16. Bray. Wordwell.

Hanley, K. 2000b Lisdoonvarna Water Supply Scheme. *Fulachta fiadh*. In I. Bennett (ed.), *Excavations 1999*, 18. Bray. Wordwell.

Hanley, K. 2002 Knocksaggart. In I. Bennett (ed.), *Excavations 2000*, 32–3. Bray. Wordwell.

Harding, J. 2003 *Henge monuments of the British Isles*. Stroud. Tempus Publishing.

Hartwell, B. 1998 The Ballynahatty Complex. In A. Gibson and D. D. A. Simpson (eds), *Prehistoric ritual and religion. Essays in honour of Aubrey Burl*, 32–44. Stroud. Sutton Publishing.

Hayden, A. 1995 Kilnacarrig. In I. Bennett (ed.), *Excavations 1994*, 85. Bray. Wordwell.

Healy, F. 2004 Hambledon Hill and its implications. In R. Cleal and J. Pollard (eds), *Monuments and material culture. Papers in honour of an Avebury archaeologist: Isobel Smith*, 15–38. East Knoyle. Hobnob Press.

Hencken, H. O'Neill 1939 A long cairn at Creevykeel, Co. Sligo. *Journal of the Royal Society of Antiquaries of Ireland* **69**, 53–98.

Henry, M. 2002 Magheraboy and Caltragh. Monitoring. In I. Bennett (ed.), *Excavations 2000*, 307. Bray. Wordwell.

Herity, M. 1971 *Glencolumbkille: a guide to 5,000 years of history in stone*. Glencolumbkille. James Dwyer.

Herity, M. 1974 *Irish passage tombs: Neolithic tomb-builders in Ireland and Britain, 2500 BC*. Dublin. Irish University Press.

Herity, M. 1975–6 Carrownaglogh. Pre-bog field system. In T. G. Delaney (ed.), *Excavations 1971*, 15. Belfast. Association of Young Irish Archaeologists.

Horne, P., MacLeod, D. and Oswald, A. 2002 The seventieth causewayed enclosure in the British Isles? In G. Varndell and P. Topping (eds), *Enclosures in Neolithic Europe*, 115–20. Oxford. Oxbow.

Hunt, J. 1974 *Irish medieval figure sculpture 1200–1600*. Dublin. Irish University Press.

Jeffrey, P. 1991 Burnt mounds, fulling and early textiles. In M. A. Hodder and L. H. Barfield (eds), *Burnt mounds: hot stone technology*, 97–102. Sandwell Metropolitan Borough Council.

Jones, C. 1996 Parknabinnia, Co. Clare. In I. Bennett (ed.), *Excavations 1995*, 5. Bray. Wordwell.

Jones, C. 1997 The Final Neolithic/Early Bronze Age on the Burren, a brief review of the evidence. *The Other Clare* **21**, 36–9.

Jones, C. 2003 Neolithic beginnings on Roughan Hill and the Burren. In I. Armit, E. Murphy, E. Nelis and D. D. A. Simpson (eds), *Neolithic settlement in Ireland and western Britain*, 188–94. Oxford. Oxbow.

Jones, C. and Gilmer, A. 1999 Roughan Hill, a Final Neolithic/Early Bronze Age landscape revealed. *Archaeology Ireland* **47**, 30–3.

Joubert, S. 2002a Caltragh, Site 6. *Fulacht fiadh*. In I. Bennett (ed.), *Excavations 2000*, 299. Bray. Wordwell.

Joubert, S. 2002b Caltragh, Sites 2 and 3. *Fulachta fiadh*. In I. Bennett (ed.), *Excavations 2000*, 298. Bray. Wordwell.

Joubert, S. 2003 Tonafortes, ceremonial enclosure. In I. Bennett (ed.), *Excavations 2001*, 375–6. Bray. Wordwell.

Kelly, F. 1998 *Early Irish farming: a study based mainly on the law-texts of the 7th and 8th centuries AD*. Early Irish Law Series IV. Dublin Institute for Advanced Studies.

Kiely, J. 2003 Coolgariff. In I. Bennett (ed.), *Excavations 2001*, 168. Bray. Wordwell.

Kilbride-Jones, H.E. 1950 The excavation of a composite Early Iron Age monument with 'henge' features at Lugg, Co. Dublin. *Proceedings of the Royal Irish Academy* **73**C, 107–27.

Lewis-Williams, D. and Pearce, D. 2005 *Inside the Neolithic mind: consciousness, cosmos and the realms of the gods*. London. Thames and Hudson.

Limbert, D. 1996 Irish ringforts: a review of their origins. *Archaeological Journal* **153**, 243–90.

Linnane, S. 2003 Report on the excavation of Bronze Age activity at Tullyallen, Co. Louth. Unpublished report submitted to the Department of the Environment, Heritage and Local Government.

Linnane, S. 2004 Report on the excavation of Bronze Age activity at Agherton Road, Co. Derry. Unpublished report submitted to the Department of the Environment, Heritage and Local Government.

Logue, P. 2002 Ballynashallog and Ballynagard, Co. Derry, Neolithic settlement. In I. Bennett (ed.), *Excavations 2000*, 53–4. Bray. Wordwell.

Lynn, C.J. 1975 The dating of raths: an orthodox view. *Ulster Journal of Archaeology* **38**, 45–7.

Lynn, C.J. 1987 Deer Park Farms, Glenarm, Co. Antrim. *Archaeology Ireland* **1** (1), 11–15.

Lynn, C.J. 1994 Houses in rural Ireland, AD 500–1000. *Ulster Journal of Archaeology* **57**, 81–94.

Lynn, C.J. 2005 Settlement and disease: a plague on all your raths. *Archaeology Ireland* **74**, 14–17.

McCarthy, M., Quinn, A. and Carroll, M. 2000 Castleview. In I. Bennett (ed.), *Excavations 1999*, 25. Bray. Wordwell.

McConway, C. 1998 Dooradoyle. In I. Bennett (ed.), *Excavations 1997*, 114. Bray. Wordwell.

McConway, C. 2000 Tullahedy, Co. Tipperary, Neolithic landscape. In I. Bennett (ed.), *Excavations 1998*, 203–4. Bray. Wordwell.

MacDermot, C.V., Long, C.B. and Harney, S.J. 1996 *Geology of Sligo–Leitrim*. Dublin. Geological Survey of Ireland.

McLoughlin, C. 2001 Rathmore burnt mound complex. *Archaeology Ireland* **58**, 4.

McLoughlin, C. 2003 Rathmore. In I. Bennett (ed.), *Excavations 2001*, 428. Bray. Wordwell.

Mallory, J.P. 1993 A Neolithic ditched enclosure in Northern Ireland. In J. Pavúk (ed.), *Actes de Xii Congrès International des Sciences Prehistoriques et Protohistoriques*, 415–18. Nitra. UIPPS.

Mallory, J.P. and Hartwell, B. 1984 Donegore. *Current Archaeology* **92**, 271–5.

Malone, C. 2001 *Neolithic Britain and Ireland*. Stroud. Tempus.

Megaw, J.V.S. and Simpson, D.D.A. 1979 *Introduction to British prehistory*. Leicester University Press.

Mercer, R.J. 1990 *Causewayed enclosures*. Risborough. Shire Archaeology Ltd.

Mitchell, F. and Ryan, M. 2001 *Reading the Irish landscape*. Dublin. Town House.

Mount, C. 1998 Ritual, landscape and continuity in prehistoric County Sligo. *Archaeology Ireland* **45**, 18–21.

Mount, C. 1999 Excavation and environmental analysis of a Neolithic mound and Iron Age barrow cemetery at Rathdooney Beg, County Sligo, Ireland. *Proceedings of the Prehistoric Society* **65**, 337–71.

Murphy, D. 2001 N18/N19 Ballycasey to Dromoland Road Improvement Scheme. Unpublished report prepared by Archaeological Consultancy Services Ltd.

Murphy, D. 2002 Site J, Richmond, Co. Tipperary. *Fulacht fiadh*. In I. Bennett (ed.), *Excavations 2000*, 323. Bray. Wordwell.

Murphy, D. 2003 Carrigohane 1. In I. Bennett (ed.), *Excavations 2001*, 34. Bray. Wordwell.

Mytum, H. 1992 *The origins of Early Christian Ireland*. London. Routledge.

Nelis, D. 2002 Northern Motorway Site No. 3, Sheephouse, Co. Meath. In I. Bennett (ed.), *Excavations 2000*, 265. Bray. Wordwell.

Newman, C. 1993a 'Sleeping in Elysium'. *Archaeology Ireland* **25**, 20–3.

Newman, C. 1993b The show's not over until the Fat Lady sings. *Archaeology Ireland* **26**, 8–9.

O'Connell, M. and Molloy, K. 2001 Farming and woodland dynamics in Ireland during the Neolithic. *Biology and Environment: Proceedings of the Royal Irish Academy* **101**B, 99–128.

O'Conor, K.D. 1998 *The archaeology of medieval rural settlement in Ireland*. Discovery Programme Monograph 3. Dublin. Royal Irish Academy.

Ó Donnchadha, B. 2003 M1 Dundalk Western Bypass. Site 116, Balregan 1 and 2. Unpublished report for Irish Archaeological Consultancy Ltd.

O'Donovan, E. 2002 Rathbane South. In I. Bennett (ed.), *Excavations 2000*, 200–1. Bray. Wordwell.

O'Donovan, J. 1840 Ordnance Survey (OS) Letters.

Ó Drisceóil, C. 2002a Site 2, Coolfore. In I. Bennett (ed.), *Excavations 2000*, 215. Bray. Wordwell.

Ó Drisceóil, C. 2002b Site 3, Newtown-Monasterboice. In I. Bennett (ed.), *Excavations 2000*, 238. Bray. Wordwell.

Ó Drisceóil, C. 2003 Balgatheran Site 4. Late Neolithic ritual/settlement site, Co. Louth. In I. Bennett (ed.), *Excavations 2001*, 255–7. Bray. Wordwell.

Ó Drisceoil, D. 1988 Burnt-mounds: cooking or bathing? *Antiquity* **62**, 671–80.

O'Hara, R. 2003 Report on the excavation of a Bronze Age house at Colp, Co. Meath. Unpublished report submitted to the Department of the Environment, Heritage and Local Government.

O'Kelly, M.J. 1954 Excavations and experiments in ancient Irish cooking-places. *Journal of the Royal Society of Antiquaries of Ireland* **84**, 105–55.

O'Kelly, M.J. 1984 *Newgrange. Archaeology, art and legend*. London. Thames and Hudson.

O'Kelly, M.J. 1989 *Early Ireland. An introduction to Irish prehistory*. Cambridge University Press.

O'Neill, J. 2001a Excavation of a Bronze Age house in Kilmurry North, Co. Wicklow. www.mglarc.com/projects/kilmurry_north.htm.

O'Neill, J. 2001b A glimpse of Wicklow's past. *Archaeology Ireland* **58**, 30–1.

Ó Néill, J. 2003 Kilmurry North. Bronze Age settlement. In I. Bennett (ed.), *Excavations 2001*, 424–5. Bray. Wordwell.

O'Neill, J. 2003–5 *Lapidibus in igne calefactis coquebatur*. The historical burnt mound 'tradition'. *Journal of Irish Archaeology* **12/13**, 79–85.

O'Neill, T. 2003 Archaeological excavation of a ringfort at Ballycasey More, Co. Clare. Unpublished report submitted to the Department of the Environment, Heritage and Local Government.

Ó Nualláin, S. 1972a A Neolithic house at Ballyglass near Ballycastle, Co. Mayo. *Journal of the Royal Society of Antiquaries of Ireland* **102**, 49–57.

Ó Nualláin, S. 1972b Ballyglass, Co. Mayo. In T. Delaney (ed.), *Excavations 1972*, 20–2. Belfast. IAPA.

Ó Nualláin, S. 1989 *Survey of the megalithic tombs of Ireland, Vol. V, Co. Sligo*. Dublin. Stationery Office.

Opie, H. 1994a Kildorragh, County Leitrim—*fulacht fiadh* and roundhouse. In I. Bennett (ed.), *Excavations 1994*, 53. Bray. Wordwell.

Opie, H. 1994b Tully, County Leitrim—*fulacht fiadh*. In I. Bennett (ed.), *Excavations 1994*, 53. Bray. Wordwell.

Opie, H. 1996 Carrowgobbadagh ringfort. In I. Bennett (ed.), *Excavations 1995*, 77–8. Bray. Wordwell.

Ó Ríordáin, S.P. 1951 Lough Gur excavations: the Great Stone Circle (B) in Grange townland. *Proceedings of the Royal Irish Academy* **54**C, 37–74.

Ó Ríordáin, S.P. 1995 *Antiquities of the Irish countryside* (5th edn, revised by R. de Valera). London and New York. Routledge.

O'Sullivan, A. 1988 *The archaeology of lake settlement in Ireland*. Discovery Programme Monograph 4. Bray. Wordwell.

O'Sullivan, M. 1986 Approaches to passage tomb art. *Journal of the Royal Society of Antiquaries of Ireland* **116**, 68–83.

O'Sullivan, M. 1993a *Megalithic art in Ireland*. Dublin. Townhouse.

O'Sullivan, M. 1993b Recent investigations at Knockroe passage tomb. *Journal of the Royal Society of Antiquaries of Ireland* **123**, 5–18.

O'Sullivan, M. 1998 Retrieval and revision in the interpretation of megalithic art. *Archaeological Review from Cambridge* **15** (1), 37–48.

O'Sullivan, M. 2005 *Tara: the Mound of the Hostages*. Bray. Wordwell.

O'Sullivan, M. and Downey, L. 2006 Quern stones. *Archaeology Ireland* **76**, 22–5.

Oswald, A., Dyer, C. and Barber, M. 2001 *The creation of monuments. Neolithic causewayed enclosures in the British Isles*. Swindon. English Heritage.

Phelan, S. 2003 Whitewell, Co. Westmeath. Unpublished report for Margaret Gowen and Co. Ltd.

Piggott, S. and Piggott, C.M. 1939 Stone and earth circles in Dorset. *Antiquity* **13**, 138–58.

Pollard, J. 1997 *Neolithic Britain*. Risborough. Shire Archaeology.

Power, D. 1990 *Fulachta fiadh* in County Cork. In V. Buckley (ed.), *Burnt offerings: international contributions to burnt mound archaeology*, 13–17. Bray. Wordwell.

Power, D., Byrne, E., Egan, U., Lane, S. and Sleeman, M. (comps) 1992 *Archaeological Inventory of County Cork, Vol. 1: West Cork*. Dublin. Stationery Office.

Power, D., Byrne, E., Egan, U., Lane, S. and Sleeman, M. (comps) 1994 *Archaeological Inventory of County Cork, Vol. 2: East and South Cork*. Dublin. Stationery Office.

Power, D., Byrne, E., Egan, U., Lane, S. and Sleeman, M. (comps) 1997 *Archaeological Inventory of County Cork, Vol. 3: Mid Cork*. Dublin. Stationery Office.

Power, D., Lane, S., Byrne, E., Egan, U. and Sleeman, M. (comps) 2000 *Archaeological Inventory of County Cork, Vol. 4: North Cork, Part 1*. Dublin. Stationery Office.

Power, D., Lane, S., Byrne, E., Egan, U. and Sleeman, M. (comps) 2000 *Archaeological Inventory of County Cork, Vol. 4: North Cork, Part 2*. Dublin. Stationery Office.

Proudfoot, V.B. 1970 Irish raths and cashels: some notes on origin, chronology and survivals. *Ulster Journal of Archaeology* **33**, 37–48.

Pryor, F. 2002 *Seahenge: a quest for life and death in the Bronze Age*. London. Harper Collins.

Pryor, F. 2003 *Britain BC. Life in Britain and Ireland before the Romans*. London. Harper Collins.

Raftery, B. 1972 Irish hillforts. In C. Thomas (ed.), *The Iron Age in the Irish Sea province*, 37–58. London. Council for British Archaeology.

Raftery, B. 2000 *Pagan Celtic Ireland. The enigma of the Irish Iron Age*. London. Thames and

Hudson.

Richards, C. 1996 Henges and water: towards an elemental understanding of monumentality and landscape in Late Neolithic Britain. *Journal of Material Culture* **3**, 313–36.

Roche, H. 2004 The dating of the embanked stone circle at Grange, Co. Limerick. In H. Roche, E. Grogan, J. Bradley, J. Coles and B. Raftery (eds), *From megaliths to metals. Essays in honour of George Eogan*, 109–16. Oxford. Oxbow.

Roche, H. and Eogan, G. (forthcoming) A re-assessment of the enclosure at Lugg, County Dublin, Ireland. *Festschrift for Barry Cunliffe*. Oxford.

Roche, H. and Grogan, E. 2006 Kilbride, Co. Mayo (05E0833). Unpublished report for Archaeological Consultancy Services Ltd.

Russell, I. 2004a Report on archaeological excavation of a *fulacht fiadh* at Curraheen (4), Co. Cork. Unpublished report submitted to the Department of the Environment, Heritage and Local Government.

Russell, I. 2004b Report on archaeological excavation of burnt mound activity at Curraheen (5), Co. Cork. Unpublished report submitted to the Department of the Environment, Heritage and Local Government.

Russell, I.R. and Corcoran, E. 2002 Excavation of a possible Bronze Age enclosure at Kilsharvan Townland, Co. Meath. *Ríocht na Midhe* **13**, 32–4.

Rynne, E. 1964 Ring-forts at Shannon airport. *Proceedings of the Royal Irish Academy* **63**C, 245–77.

Saville, A. 2002 Lithic artefacts from Neolithic causewayed enclosures: character and meaning. In G. Varndell and P. Topping (eds), *Enclosures in Neolithic Europe*, 91–105. Oxford. Oxbow.

Seaver, M. 2000 Broadlough 2. In I. Bennett (ed.), *Excavations 1999*, 186–7. Bray. Wordwell.

Schmid, E. 1972 *Atlas of animal bones*. Amsterdam. Elsevier.

Sheridan, A. 2001 Donegore Hill and other Irish Neolithic enclosures: a view from outside. In T. Darvill and J. Thomas (eds), *Neolithic enclosures in Atlantic northwest Europe*, 171–89. Neolithic Studies Group Seminar Papers 6. Oxford. Oxbow.

Sheridan, A. 2007 Appendix 3: The bone belt hook from Bargrennan Pit 2. In V. Cummings and C. Fowler, *From cairn to cemetery: an archaeological investigation of the chambered cairns and early Bronze Age mortuary deposits at Cairnderry and Bargrennan White Cairn, south-west Scotland*, 112–24. British Archaeological Reports, British Series 434. Oxford.

Sheridan, J.A. 1985/6 Megaliths and megalomania: an account, and interpretation, of the development of passage tombs in Ireland. *Journal of Irish Archaeology* **3**, 17–30.

Simpson, D.D.A. 1996 Ballygalley houses, Co. Antrim, Ireland. In T. Darvill and J. Thomas (eds), *Neolithic houses in northwest Europe and beyond*, 123–32. Oxbow Monograph 57. Oxford.

Simpson, D.D.A., Conway, M. and Moore, D. 1994 Ballygalley, Co. Antrim. In I. Bennett (ed.), *Excavations 1993*, 1–2. Bray. Wordwell.

Simpson, D.D.A., Weir, D.A. and Wilkinson, J.L. 1994 Excavations at Dun Ruadh, Crouck, Co. Tyrone. *Ulster Journal of Archaeology* **54–5**, 36–47.

Smith, I. 1965 *Windmill Hill and Avebury: excavations by Alexander Keiller 1925–1939*. Oxford.

Clarendon Press.

Stevens, P. 1998 Killoran 10, Co. Tipperary. In I. Bennett (ed.), *Excavations 1997*, 174–5. Bray. Wordwell.

Stevens, P. 2005 Killoran 10, Co. Tipperary. In M. Gowen, J. Ó Néill and M. Phillips (eds), *The Lisheen Mine Archaeological Project 1996–8*, 292–4. Bray. Wordwell.

Stout, G. 1991 Embanked enclosures of the Boyne region. *Proceedings of the Royal Irish Academy* **91**C, 245–84.

Stout, G. 1997 *The Bend of the Boyne. An archaeological landscape*. Dublin. Country House.

Stout, M. 1997 *The Irish ringfort*. Dublin. Four Courts.

Stout, M. 2000 Early Christian Ireland: settlement and environment. In T. Barry (ed.), *A history of settlement in Ireland*, 81–109. London. Routledge.

Stout, M. and Stout, G. 1997 Early landscapes: from prehistory to plantation. In F. H. A. Aalen, K. Whelan and M. Stout (eds), *Atlas of the Irish rural landscape*, 31–63. Cork University Press.

Stuiver, M. and Reimer, P.J. 1993 Extended 14C data base and revised CALIB 3.0 14C age calibration program. *Radiocarbon* **35**, 215–30.

Stuiver, M., Reimer, P.J., Bard, E. *et al.* 1998 IntCal98 Radiocarbon Age Calibration, 24,000–0 cal BP. *Radiocarbon* **40** (3), 1041–83.

Sweetman, P. 1976 An earthen enclosure at Monknewtown, Slane, Co. Meath. *Proceedings of the Royal Irish Academy* **76**C, 25–72.

Sweetman, P.D. 1985 A Late Neolithic/Early Bronze Age pit circle at Newgrange, Co. Meath. *Proceedings of the Royal Irish Academy* **85**C, 195–221.

Thomas, J. 1991 *Rethinking the Neolithic*. Cambridge University Press.

Thorn, R.H. 1985 *Sligo and West Leitrim Field Guide No. 8*. Dublin. Irish Association for Quaternary Studies.

Tierney, M. 2002a Ballymaley. In I. Bennett (ed.), *Excavations 2000*, 17. Bray. Wordwell.

Tierney, M. 2002b Ballymaley–Corrovorrin. In I. Bennett (ed.), *Excavations 2000*, 17. Bray. Wordwell.

Tierney, M. 2002c Graigueshoneen. *Fulacht fiadh*. In I. Bennett (ed.), *Excavations 2000*, 336–7. Bray. Wordwell.

Timoney, M.A. (ed.) 2002 *A celebration of Sligo: first essays for Sligo Field Club*. Carrick-on-Shannon. Sligo Field Club.

Tobin, R. 2002a Dromvane. In I. Bennett (ed.), *Excavations 2000*, 47. Bray. Wordwell.

Tobin, R. 2002b Teadies Upper. In I. Bennett (ed.), *Excavations 2000*, 52–3. Bray. Wordwell.

Varndell, G. and Topping, P. 2002 *Enclosures in Neolithic Europe*. Oxford. Oxbow.

Waddell, J. 1990 *The Bronze Age burials of Ireland*. Galway University Press.

Waddell, J. 1998 *The prehistoric archaeology of Ireland*. Galway University Press.

Wailes, B. 1990 Dún Ailinne: a summary excavation report. *Emania* **7**, 10–21.

Weir, D. 1995 A palynological study of landscape and agricultural development in County Louth from the second millennium BC to the first millennium AD. *Discovery Programme Reports* **2**, 77–126. Dublin. Royal Irish Academy.

Whittle, A., Healy, F. and Bayliss, A. (forthcoming) *Gathering time. Dating the early Neolithic enclosures of southern Britain and Ireland*. Oxford. Oxbow.

Woodman, P.C. 1978 *The Mesolithic in Ireland*. British Archaeological Reports, British Series 58. Oxford.

Woodman, P.C. 2000 Hammers and shoeboxes: new agendas for prehistory. In A. Desmond, G. Johnson, M. McCarthy, J. Sheehan and E. Shee-Twohig (eds), *New agendas in Irish prehistory. Papers in commemoration of Liz Anderson*, 1–10. Bray. Wordwell.

Wood-Martin, W.G. 1882–92 *History of Sligo* (3 vols). Dublin.

Zajac, S. 2000 Clare. In I. Bennett (ed.), *Excavations 1999*, 227. Bray. Wordwell.

# INDEX